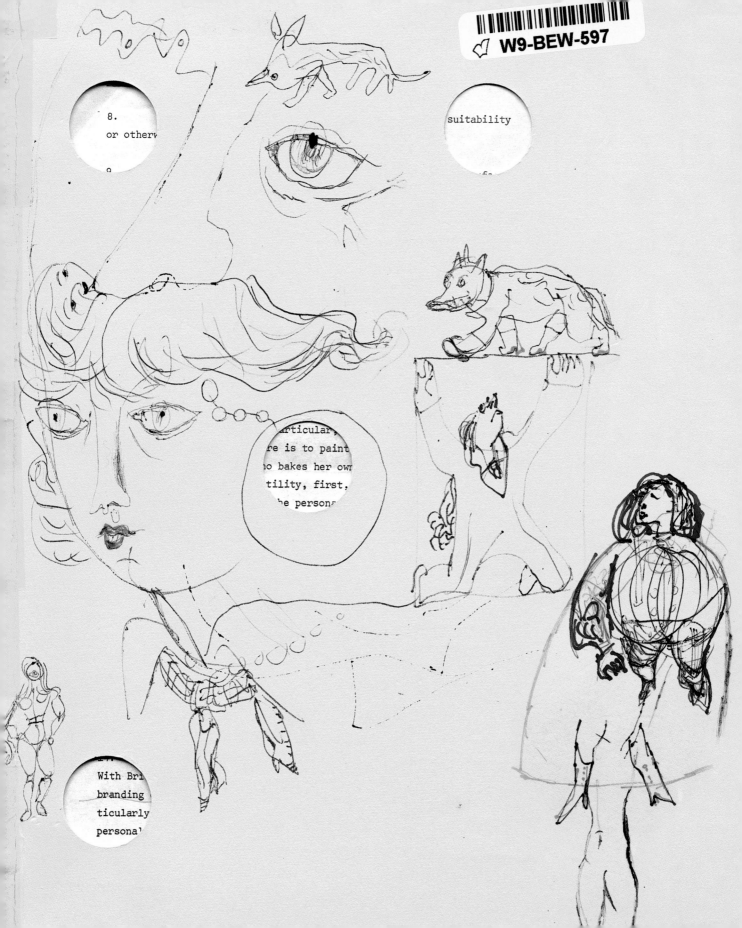

8.

or otherw

suitability

articular,
re is to paint
o bakes her own
tility, first,
he persona

With Bri
branding
ticularly
persona

*Doodles taken from
Schleger's correspondence
blotter 1950s and '60s*

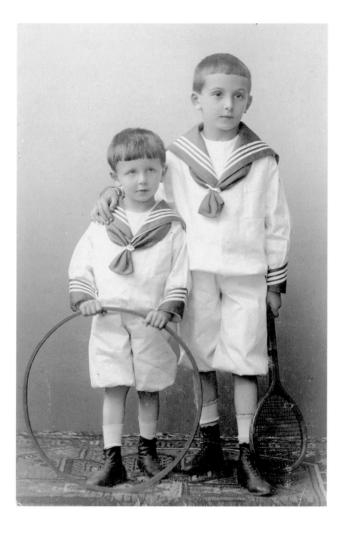

Schleger aged about four with his elder brother

Hans Schleger—*a life of design* by Pat Schleger

foreword by Paul Rand

ZERO

Princeton Architectural Press New York

Published by

Princeton Architectural Press

37 East Seventh Street

New York, NY 10003

For a catalog of books published by Princeton Architectural Press,
call toll free 800.722.6657 or visit www.papress.com

Published simultaneously in the United Kingdom by Lund Humphries

Special thanks: Nettie Aljian, Ann Alter, Amanda Atkins, Jan Cigliano, Jane Garvie,
Mark Lamster, Nancy Later, Mia Ihara, Clare Jacobson, Leslie Ann Kent, Anne Nitschke,
Lottchen Shivers, Tess Taylor, Jennifer Thompson, Mark Unterberg, and Deb Wood
of Princeton Architectural Press—Kevin C. Lippert, publisher.

Cataloging-in-Publication Data for this title is available from the Library of Congress

ISBN 1-56898-273-9

Printed and bound in Singapore

The comments made about the work throughout the book are mine,
unless otherwise credited. *Pat Schleger*

for Hans with my love

I have thought of this book as a kind of scrapbook of pictures and words, which together tell a story and build an impression of the kind of man Schleger was.

In order to do this I have called on the memories of many people. Reawakening the past in this way has brought to life some half-forgotten friendships and deepened others. There are too many to name here but I would like to thank them all. And in particular those without whose support or encouragement or financial assistance or skill this book would not have been possible: Maria Schleger, Lalli Draper, Virginia Foden, Valerie Riddell-Carre, Derek Birdsall, Alan Fletcher, James Aldridge, Walter Herdeg, Margret Rey, Caroline Royds, Max Eilenberg, Chris Brown, and Paul Evans.

Even before Hans Schleger and Associates came into being Schleger had assistants who helped him. He was a teacher at heart and liked the concept of apprenticeship. Many people passed through the studio before finding their own particular path in the field of design, others contributed in a variety of ways. Naturally some people became more involved than others and stayed for longer, and many are still my friends today. Those whose names I can remember are listed below. My apologies to those I have left out – do get in touch.

Claire Blake-Kelly/Davies
Lenore Blegvad
Pauline Boty
Judy Brook
Ann Cave/Hecht
Yashwant Chaudhary
Ben Comley
Betty Cripps
David Cripps
Eugenie Dodd
Robin Dodd
Virginia Field/Foden
Paola Fletcher
Don Foster
Malcolm Frost
Rosemary Fry/Quantock
Ruth Gill
Prue Grice
John Harrison

Hermann Hecht
Steve Hill
Pat Hutton
Michael Johnson
Margaret Knott
Erica Matlow/Kavanagh
Pat Maycock/Schleger
Molly Magee
Gay Middleton
Anthea Nicholson/Lingeman
Vinod Patel
Audrey Parker
Irene Reeve
Valerie Riddell-Carre
Sarah Rogers/Montgomery
Ingeborg Rørhus
Georges Tran
Lucy Ward

Acknowledgements

Now that the gestation period is over and the book is born, I want to thank, in particular, Fiona MacCarthy for her unerring support and brilliantly perceptive introduction; David Bernstein, who wrote with insight and professionalism about a man he never met; Ken Garland who remembers Hans with such warmth, humour and admiration; the two Lund Humphries Lucys, Lucy Myers and Lucy Clark, for their patience and expertise and Keith Allison and the MRM Graphics team. Pat Schleger OCTOBER 2000

Grateful acknowledgement is made to the following who, in some instances, granted permission to reproduce works, photographs and writing.

page 10	and pages 42-3, 46-7, 56-7, 62-5, 78, 96-101. By kind permission of London's Transport Museum.
page 23	and pages 36-8, 40-43,45, 47-51, 53, 56-7, 61-7, 69, 71, 73, 104, 146, 181, 183-4, 187, 194-5, 197, 203, 224, 237. Photographs by Heini Schneebeli.
page 33	Photographs by David Cripps.
pages 38-9	and pages 45, 73, 140-4. Shell-Mex and BP Limited.
page 44	Photograph of Shell lorry. The National Motor Museum, Beaulieu.
page 48	and pages 49-51. The Post Office Heritage Services, London.
pages 52-3	The Imperial War Museum, London.
page 60	Vogue/The Condé Nast Publications Ltd.
pages 68-9	Martini Rossi S.A.
pages 70-1	The National Railway Museum, York.
page 83	Prof. M. Pohl of Deutsche Bank Archive.
page 86	and pages 87-91. Penguin Books Ltd., London.
pages 105-6	The Gazette of the John Lewis Partnership, London.
pages 222-3	William Grant & Sons International, Ltd.

Contents

Foreword *by Paul Rand*

Hans Schleger was a graphic designer before the concept of graphic design was invented. A book about his work, with glimpses of his life, is surely the kind of inspiration that is so terribly needed today, and which especially the younger generation eagerly awaits. I am honoured to introduce the work that businessmen of the past accepted, designers respected, and from which, hopefully, designers of the future will benefit.

It was at the Arts Club in Dover Street soon after World War II that Hans Schleger and I first met. The occasion was marked by two memorable events: one, my first encounter with warm beer, the other, experiencing the warm affection of Hans Schleger. It was only a short time after we left the club that we were walking arm-in-arm along Piccadilly, destined to be friends.

Universality was one of his outstanding characteristics, manifest both in the variety of styles his work exhibited and in the many kinds of art he appreciated and collected: the frescoes of Piero della Francesca, the drawings of Pascin, the weavings of the ancient Copts, the masks of the Dogon. This all-embracing quality revealed itself as well in the genuine affection he showered on so many with whom he came in contact. He was generous, too, in material ways. At the slightest indication of interest in a given subject he would, if he could, present an appropriate book or object to his guest. One wondered how he could part with things that he obviously loved no less than did his lucky recipient.

Schleger was not a typical commercial artist. This is not to say that he lived in an ivory tower, nor that his work was merely *artistic*. Keenly concerned with questions of aesthetics, he was equally concerned with problems of business. He was as versed in the art of selling as he was in the art of Art. It was his practical viewpoint which determined the diverse paths his work took. The different styles he practised in no way indicate a lack of direction or an otherwise haphazard approach to a problem. They demonstrate,

rather, a genuine sensitivity to the multiple needs of visual communication.

He was one of the first to pioneer modern design as we know it today. I was still attending to my school books when he first visited America in the 1920s. It was only by chance that I came across his work in 1928 in a copy of *Gebrauchsgraphik*. And it was only a short time before his death that I sent him the cover from that issue, which I had saved all those years. It was a drawing of a horse's head in gold, emerald green and black.

Equally memorable to me was the trademark he did for Weber and Heilbroner, an American men's clothier, which, I believe, is as vital today as the day it was conceived. I keep it in my treasure chest of great marks of our time.

Schleger believed in his craft as much as in his art. A product of the *old school,* he worked for many years in the time when easy methods, rub-down letters and photographic aids were not part of the artist's tool kit. His drawings of the 1920s are as fresh today as his much later work. They exude elegance, grace and humour, which distinguished not only much of his work but also the man himself.

In today's climate of computers, fashions and trends, the world of design needs an antidote like Hans Schleger, to teach the blind to open their eyes, and to search, not for passing novelty, but for enduring quality.

Marion and Paul Rand, with Hans in the middle, having tea on the front steps of the Schleger flat.

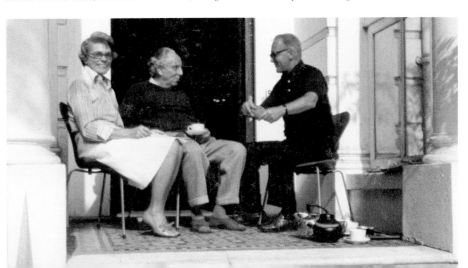

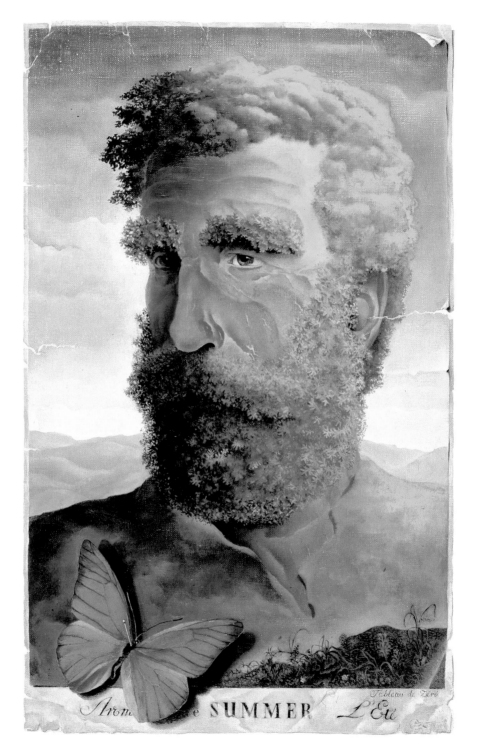

The Green Man, 1939

Hans Schleger — the art of desire

Fiona MacCarthy

Hans Schleger was one of the supreme practitioners of the floating world of dreams, desires, possession and consumption. His pioneering work was done in the 1920s and 1930s, the heroic age of modernist advertising and publicity design. His own valiant history of personal upheaval is typical of these interwar decades of political uncertainty and artistic dislocation. Apart from a brief period in Berlin in the late 1920s, Schleger — who was Jewish, born Schlesinger — was never to practise in his native Germany. The vivacious European modernism of his work in New York in the 1920s and in Britain from the mid-1930s has an underlying wariness. The consummate elegance is tinged with melancholy. The wit and amiability verges on self-parody. The brilliance of his work has a haunting, strange ambivalence. Schleger's is an exile's art: sharply observant, bitter-sweet.

Schleger was an intensely urban artist, attuned to the movement, the glamour and the squalor, the shifting skylines and the hidden mysteries of the twentieth-century metropolis. His response to the compelling exuberance of cities dated back to his childhood in Berlin, where the Schlesinger family lived from 1905. Berlin had then only relatively recently become the capital of Germany and was in what seemed an unstoppably expansionist phase. The city's mood of effervescence at the time of Schleger's childhood is vividly described in the autobiography of his near-contemporary George Grosz: 'In Berlin people were progressive … there was wonderful theatre, a gigantic circus, cabarets and revues. Beer palaces were as big as railway concourses, wine palaces which occupied four floors, six-day (cycle) races, futuristic exhibitions, international tango competitions.'* Schleger too became aware that such large-scale pursuit of pleasure verged on the grotesque.

The careers of Hans Schleger, born in 1898, and the savagely intransigent artist and political satirist Georg Grosz were in some ways remarkably parallel. Both were of a generation disillusioned and embittered by personal experience of the inhumanities of the First World War. Schleger had served in the German Pioneer Corps on the Western Front and was awarded the Iron Cross, which he later threw away in a gesture of disgust. Both Schleger and Grosz were taught by the same professor, Emil Orlik, at the Kunstgewerbeschule in Berlin. Eventually Grosz was to follow Schleger on his path of exile to the States. Schleger, like Grosz, was an exquisite draughtsman. He used small human figures in almost cartoon-like sequence, in some of the most famous of his early ads, to express the idiosyncrasy of the individual holding out against the forces of mass production and mass destructiveness. But Schleger's vision of society was fundamentally a benign one. His despair never became so bleak as that of Grosz.

He enrolled at the Berlin Kunstgewerbeschule after leaving the army, in 1919. This was the same year in which Walter Gropius founded the Bauhaus at Weimar. During the time that Schleger was a student, the Kunstgewerbeschule became equally imbued with what were later to be defined as Bauhaus principles. There was a similar urge to break down boundaries between fine art, craft, industrial

* Grosz, George, *Autobiography*, quoted Frank Whitford, *The Berlin of George Grosz*, catalogue of exhibition at the Royal Academy, London, 1997

design and architecture, and to integrate the study of art and science. The ruling philosophy absorbed by Schleger was that, in any civilised society, art was vital to everyday life and social betterment. Schleger always held a strictly moralistic view of the role of the artist in the spread of information and the perfecting of commodity. Another Bauhaus principle he consistently adhered to was simplicity of concept, a reduction to essentials. He had confidence that 'limitation produces form', and the purposeful line became almost a religion. By 1919 he had decided to use the name Schleger in preference to Schlesinger, a few years later he was signing his work Zero – reductionist principles ruled his personal life too.

At the same time Schleger was susceptible to the irrational impulses rampant in Berlin at this period of widespread expressionist experiment in art, in theatre and film. The First International Dada Fair was held in Berlin in 1920, and Robert Wiene's film-manifesto *Das Kabinett des Dr. Caligari* opened out new possibilities for cinematic form. Schleger's first professional job, as designer of publicity and sets for John Hagenbeck's Berlin film company, launched him into the new world of modernist cinema. Hagenbeck, whose father was the founder of the well-known zoo in Hamburg and whose half-brother ran a circus, specialised in films featuring animals. No doubt this encouraged the strongly anthropomorphic tendencies in Schleger's later work. An early design, recently rediscovered in the archive (p.36), is a poster by Hans Schleger for *Aus eines Mannes Mädchenjahren*, a film about a sex change. He remained fascinated by ideas of altered states.

These early years in Berlin indoctrinated Schleger into the language of dreams, as interpreted by Freud and his followers. He was intrigued by new techniques of visual persuasion, with their roots in behavioural sciences and the analysis of desire, and he came to a profound understanding of the territory in the human mind and psyche where history and memory are intertwined. 'Trees, stones, clouds, textures, the secret life in old engravings and in dreams are tireless teachers.'* The retrieval of the image buried deep in human consciousness was to be the basis of Schleger's art.

2

In 1924 Schleger embarked on an oil tanker in Bremen, bound for the USA. This was partly a response to Berlin's economic downturn. New levels of inflation in Germany, especially threatening to the middle classes, were hardly conducive to advertising and publicity design. But his exit from Berlin should be seen in more positive terms as a search for a new *modus vivendi*, an adventure, at a time when modernist designers were entranced by images of mobility and speed. Liners loom and train tracks speed the traveller to far-off destinations in the posters of Schleger's admired contemporary, the French graphic artist A.M.Cassandre.

His reactions to what he described as 'the great ant hill' of a city were, as always with Schleger, nervily ambivalent: 'New York is like a woman: forgetful, complicated and hard to please for the one – simple, motherly and childlike with another.'**
It was a city in which his already immensely sophisticated art could flourish. He opened his own office on Madison Avenue, and two years after his arrival was already being recognised in the German professional journal *Gebrauchsgraphik*

* Schleger, Hans, *Art & Industry*, London, March 1949
** Schleger, Hans, 'Hans Schleger chats about New York', *Gebrauchsgraphik*, Berlin, 1930

as 'the *Wunderkind*, Hans Schleger, the young Berlin graphic artist, who is of all the post war émigré artists the most successful.'* He was not yet twenty-eight.

Although the States had a fine indigenous tradition of graphic art, flourishing in the late nineteenth and early twentieth century in the seductive coloured lithographic posters of Will Bradley and Edward Penfield, this had lapsed by the 1920s into a relative conservatism. As Paul Rand's account of Schleger's influence makes clear (p.8), he was one of the very earliest designers to bring European modernist principles and techniques to the USA, and his work in New York marked the beginning of a movement that led to the proficiency of Rand himself, to Saul Bass and Milton Glaser and the extraordinary assurance and inventiveness of graphics in America in the years immediately after the Second World War.

Schleger's work in New York was almost entirely focused on magazine and newspaper advertising for luxury commodities: fur coats and chocolates, men's suitings. One of his earliest and now most famous series, the ads for the men's outfitters Weber and Heilbroner (p.119), uses what were then advanced techniques in integrating line drawing and photography, merging text and image, and in introducing an acutely simplified and yet irresistibly witty symbol: the three linked Homburg-hatted men about the city. Schleger learned to employ such highly memorable, sympathetic symbols to create the reflexes of desire and, having created it, to sustain it by using the same symbol in another permutation. He despised the one-off, ephemeral effect. For Schleger the real interest was always in the way his images lingered in the mind.

His success in New York was a matter of the modernist glamour he attached to the commodity in that aspirant age of skyscrapers and jazz. The illustrations for Park & Tilford Candies (p.133) and for Gunther Furriers (p.128), in which the elongated, graceful, fur-swathed female figures gently satirize the luxuries they advertise, are drawn with a wonderful elegance of line. In Schleger's magazine ad for Ben Lewis Shoes (p.130), terrified human faces gaze out of toppling buildings with a sense of urban drama corresponding to that of Fritz Lang's film *Metropolis*. Schleger knew that the luxury of progress had its price.

He returned to Berlin in 1929, to be married to his cousin Annemarie Mendelsohn. The Wall Street Crash was another factor in Schleger's decision to move back to Germany. Schleger found work as an art director in the Berlin office of the London advertising agency W.S.Crawford, whose founder, William Crawford, was a progressive spirit of modernist conviction. His philosophy of advertising was volubly expounded in the booklet *How to succeed in Advertising* which became the handbook of that burgeoning profession: 'Advertising is a great force when it is used for the good of the people – the common man and common woman. He, the ordinary man, is the focal point of all our endeavours. It is he who makes history. It is he, who by buying, creates trade and work and wealth.'**

Terence Prentice, Hans Schleger,
Tony Page, from left to right probably at
Crawford's, Berlin, c1930.

Crawford's had recently had notable successes with their campaigns for the Chrysler Corporation and for Eno's Fruit Salt. This was the basis for their new expansion into Europe. Schleger's work for the Berlin office is exemplified by

* Editorial in *Gebrauchsgraphik*, Berlin, February 1926
** Crawford, W.S., *How to succeed in advertising*, London, 1931

13

his ads for Hudnut, the perfumier (p.137). Here his confident use of airbrush illustration to arrive at images of covetable decadence does as much as Kurt Weill's cabaret songs to conjure up the atmosphere of between-the-wars Berlin.

Schleger gained much from his short period at Crawford's. His own sense of the seriousness of his profession was reinforced by William Crawford's visionary outlook. He made invaluable friendships with Crawford's London art director, Ashley Havinden, and with Edward McKnight Kauffer, the American-born designer based in England, the most versatile and powerful graphic artist of his generation, who worked part-time for Crawford's from 1927 to 1929.

Although as a professional Anglophile, Hans Schleger was so imbued with the style of the English upper classes that New Yorkers assumed he was familiar with London, this was not in fact the case. Ashley Havinden – an English gentleman personified, who might have stepped straight out of one of Schleger's illustrations – was to be an important professional ally when at last Schleger came to England at the start of what was to be a considerable influx of Jewish artistic émigrés from central Europe. Schleger arrived in London in 1932.

3

The history of British design would be quite different had it not been for the arrival of so many variously talented artists, architects and designers in the middle and late 1930s. These were the victims of Nazi intolerance, escaping from repressive European regimes. Although some were disappointed by the professional opportunities available in a Britain still largely traditional in outlook, and the leaders of the European modernists soon travelled on, mainly to the USA, the fact that artists and architects of the calibre of Eric Mendelssohn, Walter Gropius, Marcel Breuer and Laszlo Moholy-Nagy had been practising in Britain, even briefly, effected a long-term change of perspective, and the impact of the émigré graphic artists and typographers was to prove particularly strong.

Graphics were a special case because there was already a habit of interchange between Britain and the continent, dating back to the private press movement of the early twentieth century. For example, Eric Gill, protégé of Count Kessler, had a high reputation in Germany through his work for Insel Verlag. Because of many personal links built up through the years in the relatively cosmopolitan worlds of publishing and print, Britain was more prepared to be receptive to central European typographers and graphic artists than to product designers or architects.

Part of an office, probably at Crawford's in Berlin, with a display of work Schleger had done in New York and Berlin. Marcel Breuer's club armchairs are in the foreground.

Prominent amongst the designers to be permanently absorbed into the English arts establishment were Berthold Wolpe, type and lettering designer, who came to England from Germany in 1935; F.H.K.Henrion, graphic designer and poster artist, who arrived from Germany via Paris in 1936; and George Him, illustrator and cartoonist, who travelled from Poland in the following year. The revered German-Swiss typographer Jan Tschichold, whose influential book *Die Neue Typographie* was published in Berlin in 1928, worked in England from 1947 to 1949 as chief designer to Penguin Books, having spent the war years in neutral Switzerland. He was succeeded in this post by Hans Schmoller, another German émigré. These were designers who, like Schleger himself, fundamentally affected the development of British graphics in the postwar years.

Hans Schleger's entrée was, of course, made particularly easy by his earlier connections with Crawford's. McKnight Kauffer was generous in introducing Schleger's work in London, organising an exhibition for him in 1934 at the gallery within Lund Humphries publishing house in Bedford Square – the gallery in which Jan Tschichold's first London showing was held in the following year. Schleger and his wife were now living in a penthouse flat in Swan Court, Chelsea, adjacent to that occupied by McKnight Kauffer and the American textile designer Marion Dorn. They shared in a social life that networked its way through the London artistic and intellectual avant-garde. McKnight Kauffer was instrumental in securing an important early commission for Schleger by introducing him to Jack Beddington, advertising manager of Shell Mex and BP.

The advent of large-scale poster advertising in Britain in the 1930s brought Schleger new creative opportunities. His first commission from Jack Beddington, a 48-sheet poster for BP Ethyl Petrol (p.38), completed soon after his arrival in England, in 1934, shows his enjoyment of new freedoms in his treatment of the modernist obsession with mobility. The poster has an almost cinematic quality in its evocation of speed and the smooth ride.

Four years later Schleger was involved, again through Beddington, in what has since become a famous Shell-Mex campaign: a collection of posters for use on Shell's petrol delivery lorries, commissioned from a number of leading artists and designers on the theme *These Men Use Shell*. Schleger's design is by far the most authoritative. His subject is *Journalists*, for which he has produced a solemn and semi-surreal montage of the far-sighted reporter with his head above the clouds which owes something to the metaphysical dream landscapes of de Chirico and surely even more to Schleger's apprehension of the rapidly darkening politics of Europe. Beddington was later to pay tribute to Hans Schleger, in a letter written to Serge Chermayeff, maintaining that Schleger and McKnight Kauffer were 'the two men who really taught me more than any book, experience or people that I knew.'*

The delicate eroticism of Hans Schleger's ads for Charnaux Corsets (p.146), based on his own photographs from the nude model, is achieved through sophisticated visual techniques of superimposition. Schleger creates a mid-1930s dream world of dawning possibility. These are flexible women, in their perforated latex, diving,

* Jack Beddington to Serge Chermayeff, 24 May 1949. For full text, see p.254

swooping, stretching, bearing messages of sexual athleticism. With their bows and arrows, and their Amazonian overtones, Schleger's single-breasted women in corsets are amongst the most subtle and delicious images of growing female empowerment in the interwar years.

In his work of this period Schleger exploits the 'strangely familiar' images of surrealism in triggering hitherto unidentified desires. He saw how surrealism 'touches significant but hidden memories, motives and moods.'* His way of tapping into these secret recesses of the mind is tantalizingly effective in Schleger's design *The Green Man* (p.10), one of a number of posters he produced in the 1930s for Christian Barman of the London Transport Executive and, in my view, the most wonderfully evocative of all the images in Schleger's œuvre. His portrait of a man bursting into foliage, with leafy eyebrows and a magically bushy beard, is a potent reminder of Greek myths, in which humans can be instantaneously spell-bound into trees. It also conjures the wayward magnificence of Guiseppe Arcimboldo's Italian Renaissance portraits of fruit-and-vegetable visaged men. The pinioned butterfly in the bottom left-hand corner is a poignant symbol of the political fragility of Schleger's own time. The oil painting for this poster was started in 1938 and the poster went into production the following year. Declaration of war in autumn 1939 meant that it was never used.

There is a considerable irony in the fact that Britain's war with Schleger's native land at last gave him the scope for art with social purpose towards which he had been working all his life. From 1941 Hans Schleger – along with the British-born designer Abram Games and his fellow émigré F.H.K.Henrion – was the graphic designer most relied on by British government departments in spreading the messages of war. His genius for economy conveyed the sense of urgency in such government directives as *Eat Greens Daily* (p.52) and *Telephone Less* (p.49). Schleger's superb design sophistication emerges in his London Transport poster *In the Blackout* (p.56): here his pair of city men in hats, a favourite motif from pre-war life, underlines the terrifying oddity of wartime, the residue of the normal in conditions of stark abnormality.

Schleger's humour surfaces unexpectedly. The GPO wartime poster *Address Your Letters Plainly* (p.48), in which a semi-human post box admonishes the public, is a fascinating hybrid of European modernism and the amiably self-mocking style of British whimsy soon to reveal itself at the Festival of Britain in the Lion & Unicorn Pavilion and the Emmett train. Schleger's talking post box paves the way for his later – and remarkably successful – house style for Mac Fisheries, in which the fish himself extols the virtues of his kind. These ads show the deep understanding of the fantastical underside of British humour, as exemplified by Edward Lear and Lewis Carroll, which Hans Schleger had by then acquired.

Schleger's work in the postwar period was impelled by his belief in the desirability of knowledge. His appointment in 1951 as design consultant to Mather and Crowther, one of the leading London advertising agencies, involved him in disseminating information on the most recent developments in science and technology. Schleger's innate curiosity and intellectual breadth is evident in

* Schleger, Hans, *Art & Industry*, London, March 1949

the images he evolved for Fison's chemical fertilisers (p.158), with their careful balance of text and line drawing and their skilful use of quasi-historic illustration to suggest the dependence of even the most technologically amazing new advances on the researches of the past. Schleger's series of press ads for ICI's Terylene (p.169) express brilliantly, through his use of photographs of photophysical harmonic traces taken by the famous Swiss scientist Professor Gysi, the possibilities inherent in a new man-made material.

Schleger enlarged the British visual vocabulary with his postwar corporate identity design. Through the 1950s he and F.H.K.Henrion stand out as the leading practitioners, one might almost say the pioneers, of the co-ordinated visual image running through the whole range of a company's activities from advertising, merchandising and packaging to company architecture, liveries and vans. Schleger's work for the retail chain Mac Fisheries, extending through 300 branches all over the country, is a prime example of its period. If Schleger's early supremacy in corporate identity was to be eclipsed as the profession of design management expanded over the next decades, this was, I think, because he regarded himself primarily as an artist, refusing to transform himself into a businessman.

Schleger had a deep respect for the man-made mark. He had studied the meaning of the visual symbol in religious and metaphysical contexts, tracing its evolution back as far as Egyptian murals and Babylonian seals. He was fascinated by the ease with which the visual image transcended barriers of nationality and language, maintaining that 'the feelings evoked by certain images and symbols go far deeper than we might care to admit and move sometimes outside the scope of everyday rational thinking.'* Schleger's *Bus Stop* sign of 1935 (p.98), his modernised version based on Edward Johnston's original London Transport typeface, summons up a responsive frisson for the generations of those who have waited for red buses in the streets of London. Many of his postwar trademarks – the contemporary tree for Finmar Furniture (p.190), the interlocking initial letters for John Lewis Partnership (p.107) – can evoke whole sequences of suddenly sharp memories, like the replaying of a half-forgotten tune.

Schleger was a bird of passage, an artist as explorer who believed in 'living for constant search and growth'**, and who rose to the top of his profession in three countries: Germany, America and Britain. It is not perhaps surprising that so many of his most successful symbols were of birds: birds perching, roosting, preening; birds triumphantly in transit, wheeling through the air. In London, in 1956, he made a second marriage, to the graphic designer Pat Maycock, an exceptional professional and personal partnership that brought two much loved daughters.

The very early symbol he designed for Deutsche Bank in 1929 (p.83) – the iconic eagle, formalised and threatening – had transmuted by the end of his career into the much gentler and more optimistic symbol of the dove first devised by Schleger for the Edinburgh Festival of 1966 (p.85). The dove, bearer of peace and cultural understanding between nations, can be taken as a sign of Schleger's personal mythology. It is one of his beautiful and memorable images: the bird above the castle and the city, flying free.

* Schleger, Hans, 'The Function and Limitation of the Trade Mark', *IPA News*, June 1962. For full text, see p.76

** Schleger, Hans, 'Education – a time for Discovery', paper delivered at World Conference on Design, Tokyo, May 1960. For full text, see p.213

Biography of Hans Schleger

Pat Schleger

Hans Schleger was born in Kempen, Prussia, on the 29 December 1898 into a Jewish family. In those days Prussia bordered part of the Russian empire and Hans' father, who was a doctor, had one or two patients over the border. He had to change trains to visit them as the Russian gauge of track was different from the German.

Drawing of one of Hans' teachers.

Hans had an elder brother called Walter and when Hans was about six the family moved to Berlin where his father continued his practice until his death in 1932. The family name was Schlesinger but Hans had shortened that to Schleger by the time he was twenty, whilst his brother, who was a successful film scriptwriter, called himself Schlee.

As a very rebellious schoolboy Hans sat at the back of the class drawing his schoolmasters and paying little attention to lessons, except under pressure. At home his father used to lock him into his surgery in the afternoons to make sure he did his homework. It was perhaps the influence of his father, of whom he was very fond, that stimulated his professional diagnostic approach to design problems later on. As a schoolboy he began to collect posters, reproductions of drawings and paintings. His heroes were men like Lucien Bernhardt, Gulbransson, Cassandre, Pascin, Cézanne and Modigliani, and later the artists and cartoonists of magazines like *Simplicissimus*, *Querschnitt* and *Bon Ton*.

Hans next to the coachman being met to spend the Easter holidays at Gutow – 1911.

Hans' uncle on his mother's side, Emil Mendelsohn, owned a large estate called Gutow, in a part of Prussia which is now Poland. Hans spent many school holidays there and loved it. He learned to ride at Gutow and remained fond of horses all his life, he drew them well, enjoyed riding, going to the races and betting on horses. The farm workers at Gutow were all Poles and spoke only Polish. At harvest time when all was finished there were great celebrations, dancing, singing and drinking; Herr Mendelsohn would stand outside with his wife while the peasants came up to them one by one, to kiss the hem of his coat and the hand of his wife.

The land in that part of Poland is completely flat with vast fields of corn edged by big woods full of deer and smaller animals – ideal places for catching rabbits and hares as well as for shooting deer. *Hasenbraten* was always one of Hans' favourite meals – a roast hare with strips of bacon fat threaded through the meat.

Herr Mendelsohn inspecting the fields.

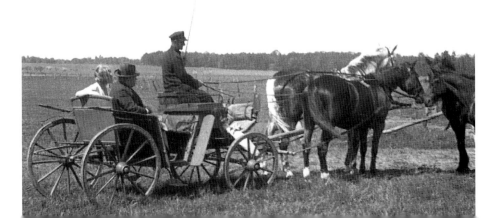

Hans on the horse, with his cousins:
Helmuth, Annemarie and Hans-Martin.

The house was surrounded by parkland with a variety of trees, including horse chestnuts. A man-made waterway ran through the park and a not inconsiderable mound had been created from digging out the waterway, from the top of which Herr Mendelsohn could survey the farm land and see what was going on. Hans said sometimes he would take a carriage and get his coachman to drive straight through a field of ripening corn, if there was something he had observed that needed sorting out. But in spite of his autocratic behaviour he seems to have been respected by the farm workers.

I visited Gutow in 1995 with my daughter and son-in-law. The house had been pulled down and there were piles of bricks littered amongst the trees, but it was being rebuilt. I picked up part of a patterned tile to have a memento of this place which Hans had loved. When I got home I was peering at an old photo of Hans' cousins when they were little and realised that they were standing on a tiled floor which matched the piece I had, by chance, picked up. When autumn came Hans would invariably put a couple of chestnuts in his overcoat pocket which became shinier and shinier through the winter. When I saw those chestnut trees at Gutow, I felt I knew why he had always had chestnuts in his pocket. The links with his childhood were quite private.

In 1916 Hans faked his age and tried to join the German Flying Corps but they guessed he was too young and sent him home. However, by 1917 he was in the Pioneer Corps laying telephone lines in no-man's land. He said he did not want to kill anyone and that is why he chose engineering work. His father became an army doctor. I think Hans' time in the First World War changed his values for life. He said it was often men who were looked down upon by society, like pimps and working-class soldiers, who would risk their own lives to rescue the wounded, not the officers and gentlemen. He was automatically given an Iron Cross at the end of the war – he threw it away in disgust.

Hans was never at the Bauhaus, though it has been said that he was. He went to the Kunstgewerbeschule in Berlin and also attended drawing classes given by Emil Orlik, a renowned draughtsman and etcher, who told Hans he would never become an artist as he was too keen on having a good time. I think this remark did hurt him and may have been one reason why he decided to work commercially. Later, when he was in New York, a gypsy on Coney Island read his palm and said, 'You make the money, you spend the money, you never keep the money.' So perhaps there was a grain of truth in what the grand and serious Orlik had said to him.

The First World War forced the young to question their parents' values and in many respects they justifiably found them wanting. The fact that Germany was defeated is important in respect of the Bauhaus because it might not have been possible had the Kaiser been victorious – he was opposed to modern art. Germany's political system was transformed in 1919, and in this atmosphere the Bauhaus could make a new start. The underlying principles of the movement were: the development of the artist rather than his product; the breaking down of barriers between fine and applied art; research into, but not preoccupation with, form and

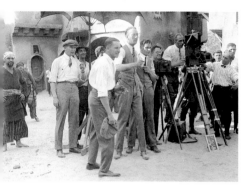

On the set. Hans in the front, holding a cap.

Drawings for the New Yorker.

materials. Hans' own approach to design was never far removed from Bauhaus principles and later on in his working life, when he had the opportunity of being in at the beginning of planning and art directing campaigns for large companies, this became apparent. He never wanted to come to any new problem with preconceived ideas of how to solve it – this is one of the reasons his own work has no set style.

Hans' first job after leaving art school was for John Hagenbeck who owned a film company in Berlin. Hagenbeck's half-brother ran a circus and looked after the famous zoo in Hamburg, founded by their father, who had also started a lucrative business in Ceylon as an animal fancier. This is why so many of the Hagenbeck films were based on romantic stories set in Africa or the Far East, featuring animals. Hans designed everything from film sets to publicity material. He was very proud that one critic mentioned the extravagance of going on location to Morocco for such a rotten film, when in fact Hans had designed all the sets in Berlin. It was fashionable in those days to hire English actresses for the main parts. Hans remembered a scene where the star in question was meant to have her leg bitten by a crocodile. She refused and they tried to persuade her by saying that of course the crocodile would be heavily sedated and it was perfectly safe. The crocodile was carried onto the set, but the actress, still uneasy, picked up a broom handle and put it between its jaws, there was a horrid crunch – the scene was cut.

In 1924 Hans decided to go to America and bought a ticket on an oil tanker sailing from Bremen to New York. He loved the sea and thoroughly enjoyed the three-week journey, even though the Captain nearly threw him overboard for climbing the mast one day. New York is one of the few big cities where the water is so deep that ships can sail right to its centre. Seeing Manhattan Island for the first time from a boat is still breathtaking, but then it must have really seemed like arriving in a new world. With only schoolboy English and little money Hans very nearly starved – he was reduced to picking half empty cartons of milk out of dustbins. However, he refused to take jobs like car-washing and being a waiter; he was determined only to accept work which was in some way connected to his own. One day he answered an ad for a magazine paste-up man. At the interview the boss, after looking at his work, asked him why he had applied, adding, 'You are far too good for this job.' Hans replied, 'I want to eat,' so he was taken on. This was his first break, he worked all day and stayed on in the evenings doing drawings for other clients. The magazine let him have space to advertise his talents and he soon took off, gathering enough work, from complete advertising campaigns to humorous drawings for the *New Yorker*, to set up on his own. He took an office on Madison Avenue and said he was the first man to have an advertising studio in that street, at No. 270. He worked on many fashion accounts and became well known for drawing the typical Englishman. His clients did not know he had never been to England.

In February 1926 the editor of *Gebrauchsgraphik*, Professor Frenzel, wrote an article about German commercial artists working in America, *freshmen* as he

Hans riding on Long Island.

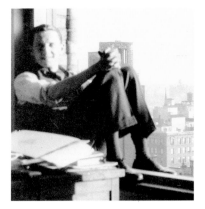

Hans on the windowsill of his
office on Madison Avenue.

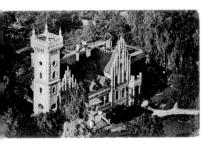

The house at Henningsdorf, called
'The Castle' by the villagers.

put it. He talked of some of the difficulties they encountered and then wrote of Hans '…and now we come to the *Wunderkind*, Hans Schleger, the young Berlin graphic artist, who is of all the postwar émigré artists the most successful. We saw in Berlin in 1922 two very promising posters for the *Hagenbeck Film Company*, then he completely disappeared from my view. It was Frederic Kendall, the editor of *Advertising & Selling* who brought him to my attention. He had helped Schleger to gain experience in an advertising firm and learn the American way. Schleger, however, came already equipped with enough knowledge to be a success in America. He is young, is an outstanding draughtsman, speaks and writes perfect English and is an unusually pleasing and adaptable youngster. Mr Kendall said "One need not look after this delightful young man, he grows on his own like a radish."'

In the summer months Hans used to rent a room on Long Island. He would work in New York until one or two in the morning when it was much cooler. Then he would take the train back to Long Island, spend the morning swimming or riding along the sand and be back in his office at about two in the afternoon.

New York in the 1920s was throbbing with life, very receptive to new ideas in every field and eager to feed on innovations of all kinds. Irving Berlin and George Gershwin, among others, were writing musicals and songs, Louis Armstrong and Cab Calloway were playing blues and jazz in small bands in Harlem. Artistically, groups from different social and ethnic backgrounds and nations mixed freely – no one was excluded.

It was in New York that Hans began to use his pseudonym Zero. Another article on his work in New York appeared in *Gebrauchsgraphik* in 1928, giving an amusing interpretation of Zero, which perhaps emphasises the speed at which he gained a reputation for himself. 'When Hans Schleger decided to sign his work with this name he was, so he declares, absolutely on the brink of nothing. A young man alone in a new country, with no money, no commissions, no patronage and very little hope. It really did not matter if he described himself as nobody. Noughts only acquire importance when they are ranged behind something.' The article went on to say 'The first work which was signed Zero already attracted much attention in America, for Zero attempted at the very beginning to lead America to new graphic forms.' However, almost forty years later Hans wrote of the Zero himself, 'I have always resisted the temptation to give a literary meaning to my nom-de-plume signature. It is pictorial and analysis would destroy it – it just happened.'

In five years Hans had become incredibly successful in the advertising world but after the Wall Street crash in October 1929, when thousands literally lost their shirts, he set sail for home. In December of that year he married Annemarie Mendelsohn, his first cousin, with whose family he had spent so many holidays as a child. The wedding was at Henningsdorf, a large estate near Breslau, where Emil and Ilse Mendelsohn had moved from Gutow, which was now being managed by their eldest son. Hans and Annemarie lived in Berlin and Hans worked at Crawford's, the English advertising agency, as an art director. Berlin was still a mecca for foreign artists, especially the English, and Hans became friendly with

a group of them who worked at Crawford's, Ashley Havinden, Tony Page and especially Terence and Betty Prentice. This was the Berlin of *Goodbye to Berlin*, cabaret at its best, Marlene Dietrich, a time of excitement, frantic enjoyment, economic chaos, frustration and deprivation.

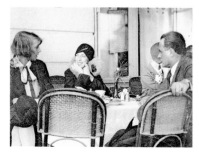

Frenzel's girlfriend (left), Annemarie and Professor Frenzel at a café in Berlin.

Margret Rey, who later with her husband created the famous children's books in America, *Curious George*, first met Hans at Crawford's in Berlin in 1929. She wrote me a long letter after Hans died in 1976, recalling her friendship with him. In it she wrote, 'I got a beginner's job at Crawford's and from the start he took me under his wings and I learned everything I know about that from him and a lot more. And very soon we became close friends and I met the *Kleine*' who became just as close a friend. I remember that during vacations she took me up to her father's estate in Poland and I had a crush on her brother. Finally they kicked me out of Crawford's because there was no more work (Hitler was in the offing). Hans, as I remember, left for England quite soon after, feeling earlier than most people where things were going in Germany. He always had a sixth sense.' She concludes that this letter '…does not contain the essence of it, which is what a tremendous influence Hans was on my way of thinking and development and whole outlook on life. I think without having met him when I was so young, I would not have become what I did and might have stayed a little provincial girl from Hamburg.' Many young people working for Hans in the Studio in London, including myself, have felt the same.

Racecourse, Berlin.

Hans once heard Goebbels addressing a small crowd in a *Biergarten*. Dressed in a dirty raincoat with his hands in his pockets, he was powerful and convincing, a man who spoke with authority. Hans was not interested in politics at that time and resented their intrusion: 'An artist should be left alone to get on with what he can do,' he said. He left Berlin for London in 1932, arriving on a foggy November afternoon – he fell in love with the place and stayed for the rest of his life.

These were the golden years of imaginative patronage with Jack Beddington at Shell, Frank Pick of London Transport and later Christian Barman, who then moved to British Rail, and Sir Stephen Talents at the Post Office. African sculpture, Picasso, Braque, Matisse, Modigliani were among the sources of inspiration and influence for commercial artists at that time. W.H.Auden and T.S.Eliot wrote copy for advertising. Fine and applied art were never closer than in those years before and just after the Second World War, and the poster was one of the main vehicles for its expression.

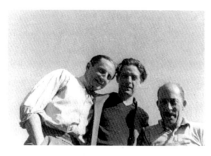

Hans, Kauffer, Jack Beddington, from left to right.

In London Hans met Ted McKnight Kauffer and Marion Dorn. They both became close friends and Kauffer, who had a very generous spirit, introduced Hans to many of his clients such as Charnaux, London Transport and Shell. Having begun his London life in a modest bedsit in Clanricarde Gardens, Notting Hill, Hans and Annemarie moved into a penthouse flat in Swan Court, Chelsea with Ted and his girlfriend Marion as neighbours across the landing. They had great times together socialising and going to the races. Terence and Betty Prentice, whom Hans had known in Berlin, were part of this set.

* Nickname for Hans' wife.

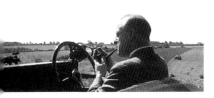

Tom Purvis at the wheel, photo taken by Hans.

Motoring in the 1930s was a novelty and fun. Tom Purvis, renowned for his poster designs, invited Hans on one of his working trips up north. They travelled in Purvis' open sports car, stopping for Purvis to sketch and take photos of places for posters, which allowed Hans time to take photos of him. Subsequently, in 1933, Hans wrote an article on his work for *Gebrauchsgraphik*. By then he was a regular contributor to the magazine, writing two more articles in the same year. One was about an Advertising and Marketing Exhibition at Olympia attended by George V, Queen Mary and the Prince of Wales, who came to see how advertising could boost trade with the Empire and so help to alleviate the depression. The other was about Jack Beddington's modern approach to advertising for Shell.

Hans decided that England was the country he wished to make his home and was naturalised in 1939, Christian Barman of London Transport was his sponsor. He was worried, however, that the name Schleger/Zero connected him to Germany, and as the political situation worsened he began to sign some work Rapier, which was a translation of his middle name Degenhard. Hans's mother came to London for a visit; she loved the shops in Regent Street especially *Libértys* as she pronounced it. Although Hans had never been particularly close to her, feeling that she preferred his elder brother, he tried to persuade her to move to London. She replied, 'You can't transplant an old tree, besides what would the Nazis want with an old lady like me?' In 1941 she was taken on the first transport train from Berlin to Minsk, where she arrived on 18 November. The exact date of her death is not known.[*]

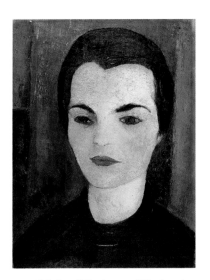

Painting of Martha, one of Hans' cousins.

In 1938 Hans started to work on a painting for London Transport. The theme was summer, similar to his *Autumn* poster, (p.47). The idea was to encourage the public to enjoy the parts of the countryside which were available by using the Underground. He propped up a canvas on the back of a wooden chair and began painting *The Green Man* (p.10), a dreamlike vision of summer. He said it was a wonderful way of taking his mind off the impending crisis. He showed it to Christian Barman who accepted it. It was printed but never used because of the war. However, it was published in the 1940 edition of the *Penrose Annual*. Hans often wished he had become a painter and chiefly in the 1930s and '40s painted several portraits of friends, family and clients.

When war was finally declared design work came to an abrupt halt. For about two years he was very short of money as well as being worried about coping mentally with another war. Hans left London and rented a cottage in Cobham, Surrey, for ten shillings a week. He was recommended by a friend to see a psychoanalyst called Dr Willi Hoffer, who had been a disciple of Freud in Vienna. The analysis became enormously important to Hans and he saw Dr Hoffer on a regular basis for many years. In fact when we decided to get married in 1956 Hans went to see Dr Hoffer for his opinion on our decision. Dr Hoffer said to him, 'I think Pat can take care of you now.' Hans never spoke about the break-up of his marriage to Annemarie, but from diaries he kept at the time it appears that it upset him deeply. The divorce came through in 1943.

By 1941 work was picking up as many Government departments began to realise

[*] Although after the war Hans was informed of her death, he never knew the details.

that well-designed publicity had an important role to play in communicating all kinds of necessary information to the public of a country at war – from *Grow Your Own Food, Careless Talk Costs Lives,* to *Telephone Less*. During the war Hans met George Him, an émigré from Poland. He and his design partner Jan Lewitt had already established their reputation in Poland. George, like many Poles, spoke about eight languages including Yiddish. He had a great sense of humour and was an academic as well as being an illustrator/designer. He and Hans spent evenings together while bombs were falling on London. Hans painted a portrait of George at this time (p.61). Later, when Hans and I were married, George invariably spent Christmas Day with us, enjoying the goose as well as the company of our children, who often dressed up and invented a little show for us after lunch. He had no children of his own and found this a particular delight. George was a large man and came to dinner quite frequently at a time when I had a young Austrian girl called Ursula helping me with the children. She could make the most superb *Apfelstrudel* and George would ring up and ask what we were having for supper; if it included *Strudel* he would starve all day.

Lalli, photographed on holiday in Ischia by Hans.

The cottage in Cobham had been the lodge of an estate. It was surrounded by woodland and was quite isolated, although a main road ran past it on one side. The garden was Hans' place of relaxation. He planted flowers, shrubs, trees and, while the war was on, grew vegetables. This half-acre of land became his mini-Gutow and roses were one of his delights. When living in an apartment in Berlin he had nurtured a large roof garden of pots and green indoor plants. While working on the ATS campaign during the war with copywriter Mary Gowing, Hans had a design assistant from the agency called Ruth Gill, fresh from Chelsea School of Art. She shared Hans' love of gardening and they became close friends. There were riding stables near Cobham and Hans started riding again with friends he knew locally. Hans' brother Walter came to London, rather reluctantly – he had been doing so well in Berlin writing for films. He often stayed with Hans in Cobham and had found work doing the accounts for the Mount Royal Hotel at Marble Arch.

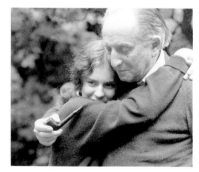

Hans and Maria in the cottage garden at Cobham.

Later, with our daughters Maria and Lalli, we spent many summer weekends in the cottage, often taking their cousins or friends with us. A sandpit was dug out in one corner of the lawn which was used as a little pool when they were older; the children ran around hosing each other or playing in the woods. The house had few amenities. Climbing roses grew over two of its walls and a creeper covered the shed which housed an outside loo. The bath was in the kitchen facing a window and from the bath you could look out into the garden at a big scotch pine tree, hedges of laurel and rhododendron and azaleas on the lawn. Although the cottage was so close to London, the atmosphere Hans created there was one of peace and privateness.

In 1947 Hans moved into 14 Avenue Studios, Sydney Mews, an old block of studios behind the shops in the Fulham Road at South Kensington. (They were named Avenue after a double row of lime trees which had been planted leading up to Hyde Park at the time of the Great Exhibition in 1851.) This was where

Hans worked until his death in 1976. I am still living and working there now.

Many of Hans' clients became friends and Bill Bernhardt, who managed the AOA* campaign, was no exception. This was Hans' first big account after the war. Working on an advertising campaign of this size, he needed another assistant – adaptations in those days were all pasted up by hand. He asked Brian Robb, a well-known illustrator who taught at Chelsea School of Art, if he could recommend a student for the job. I was one of two sent along for an interview and got the job because Hans liked my handwriting. I arrived feeling very nervous, and there was Hermann Hecht bustling about, beaming at me, telling me where to sit and what to get on with. Hermann had arrived in England as a sixteen-year-old refugee in 1939. He was first interned on the Isle of Man, then worked in a factory in Leeds, after that he took a job censoring letters for the US army in Germany. He eventually ended up in London with aspirations towards a career in design of some kind. He met a relative of Hans' who put them in touch with each other. Hans became Hermann's father figure, and the young man's apprenticeship not only included learning about design and typography but also about life. It was through Hermann that I became known as Pat. I had arrived at the studio as Marigold Maycock and he commented, 'What a ghastly name, haven't you got another one?' I replied, 'Yes, Patricia'. 'Oh, that's much better, we'll call you Pat.'

In 1950 Hans was invited to teach for a year at the Chicago Institute of Design by Serge Chermeyeff. The school had been started by Moholy-Nagy, so for Hans it was like being asked to teach at the Bauhaus. There he met and made friends with Konrad Wachsmann, who ran the architecture department, Hugo Weber, an abstract expressionist painter, and the photographer Harry Callahan. Mies van der Rohe was also teaching there at the time and once invited Hans to his flat for drinks. Hans was stunned by his collection of modern art, which included some beautiful paintings by Klee. Hans said Mies made the stiffest Martini he had ever had. Konrad always stayed with us on his lecture trips to London and he and Hans would talk far into the night.

After Hans returned from Chicago he made an arrangement with the advertising agency Mather and Crowther to work for them on a freelance basis, which lasted from 1952 to 1964. Hans was given big company accounts like Mac Fisheries, Fisons, ICI and Grants Standfast Whisky to name but a few. A steady stream of my friends from Chelsea came to work in the studio – Judy Brook, Ann Cave, Lucy Ward. Over the years people came from other art schools – especially the Central School and the London College of Printing where Tom Eckersley was head of Graphic Design. At any one time there were about eight of us working in the studio and in the early days Hermann became what would now be called studio manager, but there was never really any feeling of a hierarchical system. We were all part of the Schleger studio family. We ate lunch together taking it in turns to be responsible for the meal. At Christmas time Mathers sent a Fortnum & Mason's hamper to the studio which included a turkey. We had a huge meal together, gave each other presents, writing in-studio messages on them, and ended

The studio in 1956 with only a ladder to the gallery.

The studio in about 1968.

* American Overseas Airlines

the evening with brandy and corny jokes. This party invariably turned out to be more fun than the one we all went home to. Each Monday morning we took it in turns to light the studio stove. It was a grand-looking dysfunctional old monster and it was quite an art to get it alight. Eventually, when we had to admit that all the heat from it was going up the chimney, the Science Museum came and hauled it out as a specimen of the type of stove that had been on display at the Great Exhibition of 1851. If we had a campaign presentation to finish we would often work until four in the morning. At about ten, Hans would take us to a Spanish restaurant across the road, then we would come back and carry on. We were all sent home in taxis and told not to come in until twelve the next day.

Hans invested in a rather grand loudspeaker made of wood to improve the sound of his record collection. We often listened to music while we worked, it was my introduction to twentieth-century composers like Prokofiev and Stravinsky and to American jazz giants like Thelonius Monk, Woody Herman and Fats Waller. We played classical and kitsch as well, from Wagner to Viennese waltzes. Ann Cave, one of my Chelsea friends, who later married Hermann Hecht, took her music-listening seriously and could not abide it as wallpaper. She tolerated most of it but once when Kirsten Flagsted was singing arias from *Tristan and Isolde* she burst into tears and ran out of the studio. I chased after Ann down the Fulham Road and promised her we would never play it again.

By now Hans and I had fallen in love and were having a clandestine affair though I had a suspicion that Hermann had guessed. We were married in a Methodist Church in London on my birthday in 1956. Walter Herdeg the founder-editor of *Graphis* magazine was Hans' best man. There was a small party in the studio afterwards consisting of my immediate family and everyone who was working in the studio at the time. I had already asked Hans if he wanted children because, if he had not, I felt I could not marry him as I knew I wanted babies – I threatened to become a missionary in Africa instead. He became a father for the first time at the age of fifty-eight and it made him exceedingly happy. He was fascinated to watch our two daughters growing up and being a father was very important to him.

There is no doubt that Hans' professional life as a designer and his personal life were an integrated whole. Partly because in the early days the Studio was also his home and partly because I did not stop working after we married, so the children grew up knowing everyone in the Studio, especially those who became our babysitters. Most of Hans' assistants came straight from art school. They were young and unattached, keen to learn, to throw themselves into the work and Hans liked being involved in their development. He was a patient teacher, though not with a capital T. The architect Stefan Buzas, who we first met while working on the Finmar Furniture account in 1952, was also drawn into the Schleger studio family and was a frequent visitor, bringing us all delicious cakes for tea, an expression of his Viennese charm. Like many of our friends he was a Jewish émigré. He designed the interiors of the showroom and the shop for Finmar. He and Hans became great friends – they shared a knowledge and enjoyment of central European culture from Schnitzler to Schiele and admired and respected the subtle elegance and visual awareness of each other's work.

Photo of Pat that Hans kept in his wallet.

Later, when we had the British Sugar account and were working on their livery designs, we used to order photo-prints of the lettering for the sides of the tankers actual size so that we could put it on the floor and re-space each letter to our liking. Virginia Foden who worked with us then remembers one awful day when a messenger staggered into the studio with an absolutely enormous roll of prints. Her heart sank as she realised the letters were double the size they should have been. Hans was working upstairs, and she went to confess, fully expecting to get the sack. After hearing what had happened he said to her, 'Well, you know what it says in the Bible – go and sin no more.'

Sarah Montgomery recently wrote to me about the time she spent in the studio:

> I was a very raw, naïve twenty-year-old. This was my first job interview. Hans immediately put me at ease. As we talked in his upstairs office, I could hear the bustle of the studio downstairs, wanting very much to be part of it. Hans questioned me, looked at my portfolio in his delightful, gentle yet absolutely perceptive way. When he offered me a job (I think it paid £10 a week!) I was speechless and walked out of the studio in a daze. I had a job with one of the most respected, talented designers in the world.

> So I became one of Hans' *Kinder*. All his employees became his children, to be encompassed by his great warmth and generosity of spirit. His creative life was very much part of his family life. He and his wife Pat genuinely wanted his *Kinder* to be part of their larger social life and I soon came to know them and their children Maria and Lalli.

> I benefited in so many ways from the five years I worked for Hans. As a designer, I learned about the creative process. Hans took lavish time (in terms of today's standards) to allow the right solution to emerge; he encouraged group participation at all levels of the design process; he showed us how a great designer gathers influences from art of all ages and cultures. I learned that patience and persistence are crucial to the design process.

> I worked for Hans at three different times over a period of five years. As I grew up and went to live in the USA, from time to time I returned to work and socialise with Hans and Pat. We developed a deep friendship which continues to this day with Pat. I consider myself extraordinarily lucky to have started my thirty-one-year career with Hans and to have been influenced by such a talented and wonderful person.

Hans had a renaissance-like breadth of knowledge helped by working in three different countries. He was always there, it seemed, when innovative and exciting work was being created. His interests were catholic: psychology, architecture, gardening, antiquities and ethnic art, and graphology. But above all he was interested in people, not because they were 'somebody' but for their own sake. Hans said of design, 'It does more than catch the eye. It can touch and hold the elusive heart.'[*] That is not only true of design, it is what happened to me after we met and Hans made my life immensely richer.

* Schleger, Hans, *Art & Industry*, London, March 1949. For full text, see p.234.

Sketches from 1919 onwards

Jill Nye – the daughter of Vernon Nye,
advertising manager of Shell
c1937

Caroline Royds – a niece
1973

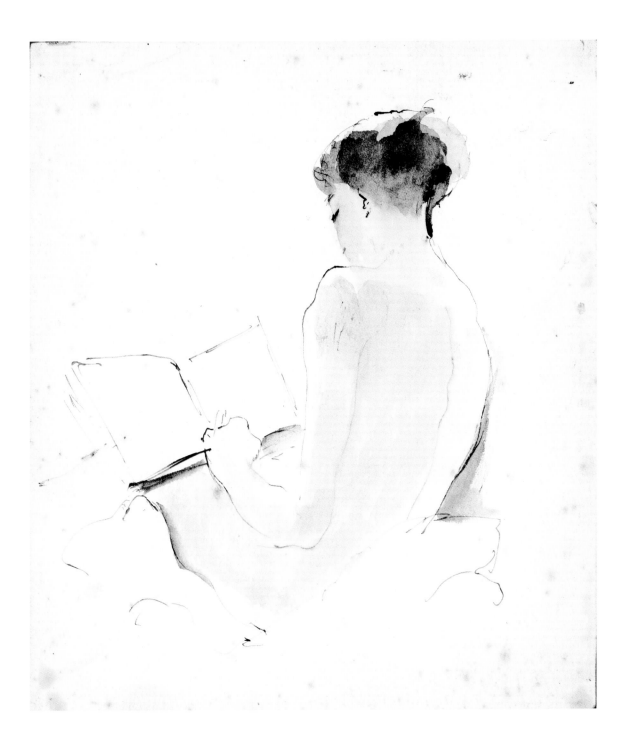

*Drawings done by Schleger
in Sotheby's catalogues during
auctions*

Saul Bass remembers Sotheby's auctions with Hans

Hans nurtured my interest in archaeological artifacts and turned it into a passion. There was a period when assignments brought me to London frequently. I always checked with Hans so I could time the trip to coincide with a Sotheby's auction. He reserved seats at the U-shaped viewing table up-front, where the artifacts up for bid were passed by its occupants. The table seated about twenty, almost all dealers. It was not an entirely comfortable arrangement. The dealers didn't like to see two potentially good customers buying direct. But they were civil.

It was so exciting. Of course, I was in good hands. Hans had an impeccable eye, a reductive and pure visual point of view. We also shared an interest not just in the past, but the very, very distant past. What was delicious, was the mystery and unreality of it all. The most intriguing culture was the one about which we knew something, but not everything. The less the better. That left holes we could fill with fantasy and imagination. Aside from their startling beauty, his selections carried with them a special kind of mystery – the unknown that reaches a very deep hidden place. Their ambiguity was challenging, involving, potent. They forced tension, and bespoke a life.

The major part of my collection came from those auctions. I haven't been to a Sotheby's auction since Hans died. It wouldn't be the same.

120 A colourless gla:
flattened rim, 6¼in. (15.9cr
mostly with mound-sha
(11.1cm.)/9¼in. (23.5cm.),

121 A pale-green g
and out-folded lip, 4½in.
(11.7cm.) *diam.*; a circula
with incurving edge, 3¼in.
form decorated with spira
Century A.D.

122 A pale-green gl:
lip, zone of wheel-cut deco
glass Flask on circular pa
flutes and twin trailed yel:
diminutive greenish glass
(4.1cm.), *cracked, all 1st-2i.*

123 A bluish-green gl
body and slender neck me
attached to everted lip, 5½.
mound-shaped body, 7¼in. (:
body and in-folded lip, *mar
A.D.*

231 A FINE LACONIAN COLUMN KRATER, the body with a plain black-glaze, reserved meander round rim, dots above and below, rays round base, and two black-glazed bands round foot, 12⅜in. (31.5cm.), c. 550 B.C.

(*See* ILLUSTRATION)

Day of Sale :

Monday, 27th March, 1972

AT TWO-THIRTY P.M. PRECISELY

EGYPTIAN ANTIQUITIES

Various Properties

An Ancient Egyptian pale green glazed composition Ushabti Figure of typical mummified form, with nine horizontal lines of text, 8⅝in. (21.9cm.), 26th Dynasty

20th May, 1968

ural Relief carved
ngs, 11in. (28cm.);
nt, 9¾in. (24.8cm.);
nt, originally with
ragment of a relief
!cm.), c. 1000 A.D.
(4)

nted, arcaded top,
l and carrying her
throne her mount
w her feet, flying
y 9¼in. (23.5cm.),

*Some of the antiquities
in the studio ▷*

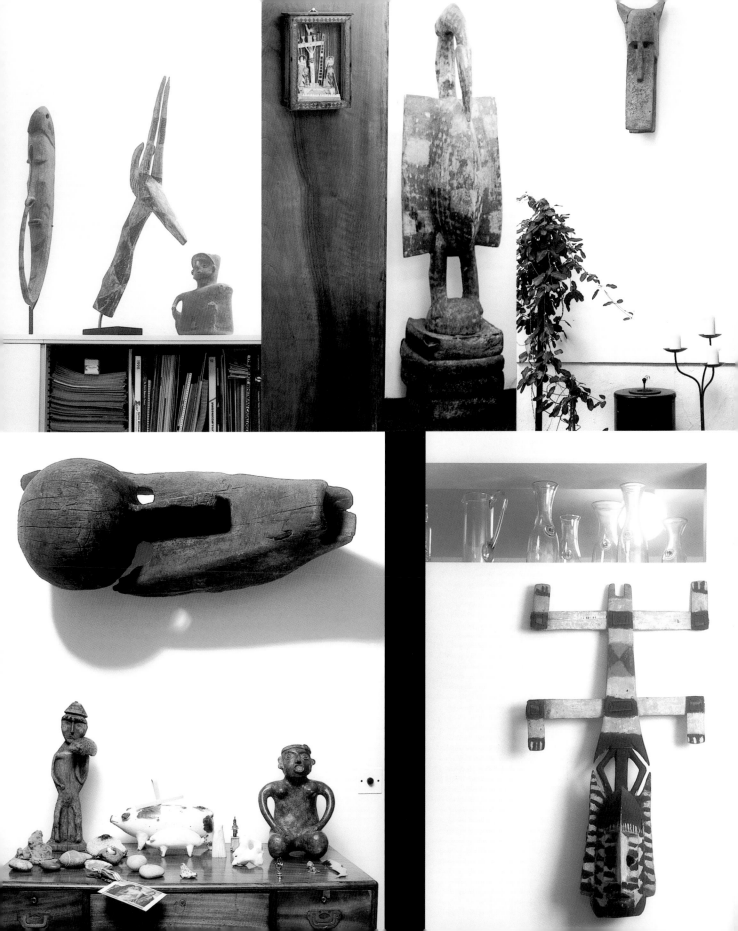

Chronology

1898
Born Hans Leo Degenhard Schlesinger, on 29 December in Kempen, Prussia. The second son of Eduard Schlesinger, a medical doctor and his wife, Bianca, née Mendelsohn.

1905
The family moved to Berlin.

1917-18
Fought in the German Army on the Western Front in the First World War.

c1919-22
Student at Berlin Kunstgewerbeschule, taught by Emil Orlik, a leading artist. Began to sign his name Schleger from 1919.

1919-24
Worked for Hagenbeck Film Co., in Berlin, designing sets, publicity, posters and their trademark.

1924-9
Adopted the pseudonym Zero in 1924. Worked in New York, rapidly establishing himself as a leader in the Modernist approach to advertising, opening his own office on Madison Avenue.

1926
His work began to be published by Professor Frenzel in the Berlin magazine of international commercial and advertising art, *Gebrauchsgraphik*.

1929
Returned to Germany and married his cousin, Annemarie Mendelsohn.

1929-32/3
Worked at Crawford's advertising agency in Berlin as an art director.

1932/3
Moved to London, introduced to new clients by his friend Ted McKnight Kauffer.

1933-76
Worked in London as a freelance designer and design consultant.

1934
Exhibition of work at Lund Humphries' offices in Bedford Square, London.

1939
Naturalised as a British citizen.

c1940
Began psychoanalysis with Dr Willi Hoffer, one of Freud's students.

1943
Divorced from Annemarie Mendelsohn.

1946
Publication of *The Practice of Design*, designed by Schleger.

1950-51
Visiting Associate Professor, Institute of Design and Technology, Illinois (successor to the Bauhaus).

1951-62
Design consultant to the advertising agents Mather and Crowther.

c1954
Hans Schleger and Associates formed.

1955
Became a member of AGI (Alliance Graphique Internationale).

1956
11 February married Pat Maycock.

1957
Daughter Maria born.

1959
Daughter Helen born.
Elected RDI (Royal Designer for Industry).

1960
Keynote speaker at World Design Conference, Tokyo.

1976
Died 18 September, London.

1

Aus eines Mannes Mädchenjahren

A man's years as a girl

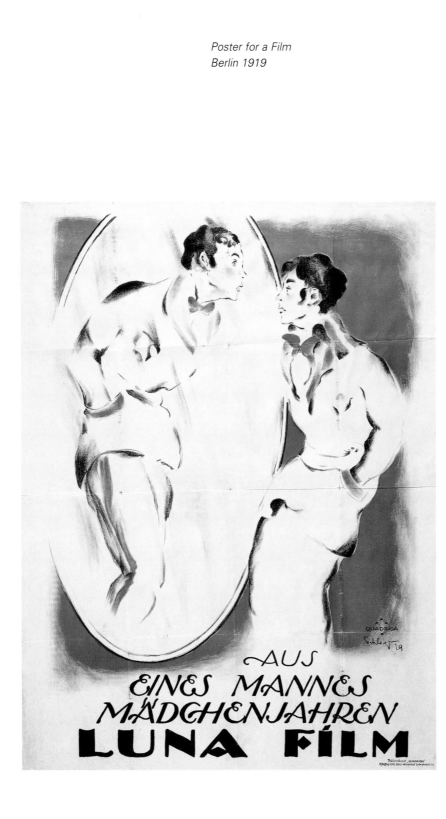

AUS EINES MANNES MÄDCHENJAHREN
LUNA FILM

I found this poster folded up in an A3 file long after Hans died. It is the earliest example of his work which I have and is dated 1919, so he was still at art school when he did it. (The lettering would have been put in by the printer.) Hans greatly admired the work of Pascin, especially his drawings, and his influence is clearly seen in this poster.

After the First World War, Germany was in turmoil but it was a time of great artistic freedom until Hitler classified this rebirth as degenerate. The German film industry was a part of this new freedom and their films mirrored the social changes which were happening, and in Berlin every kind of sexuality was possible.

This film, a true story, was about a sex change. Martha Baer, a popular student, was an intellectual who had her own circle, then she suddenly disappeared. Two years later the same person reappeared as Karl Baer.

Apparently when the baby was born the doctor was not sure of Baer's sex. After some deliberation he classified her as a girl and that was how she grew up. Gradually she realised that she was a man: she became attracted to women and felt this was not as a lesbian. She went to a famous Jewish doctor who specialised in sex change operations.

Karl Baer wrote a book about his story. He obviously felt it unwise to sign it with his own name and when it was reprinted in 1993 the author was still credited as *N.O.Body*. No copy of the film can be found.

Poster and ticket for an Advertising Ball
Berlin 1932
Huge costume balls were popular in many
of the major German cities at this time. A big
night of fun and a way of art and commerce
coming together. Animating inanimate
objects in a humorous and friendly way is
an effective method of getting the message
across. (See posters on pp.48 and 68.)

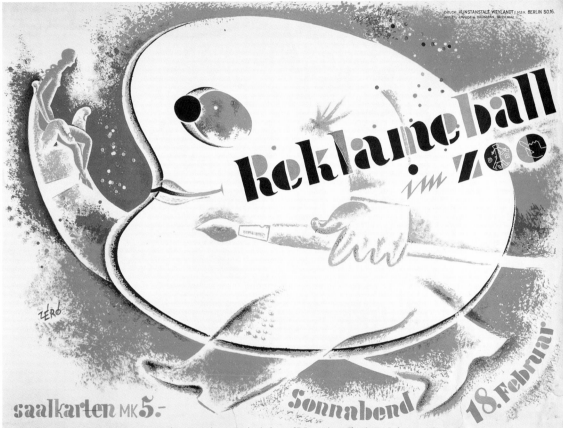

Poster
BP Ethyl petrol 1934

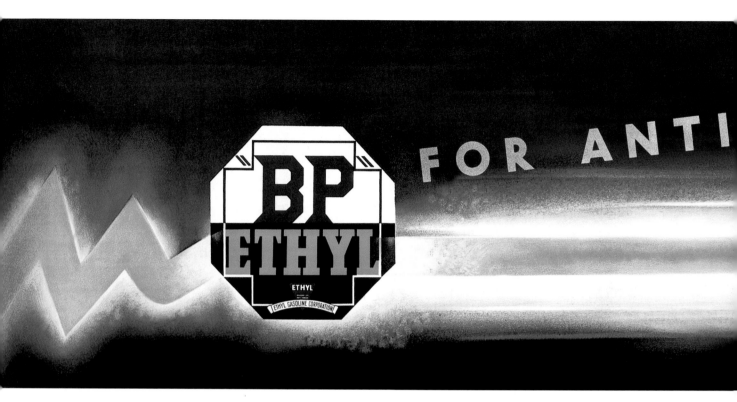

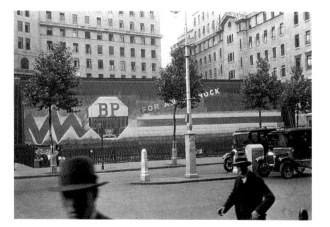

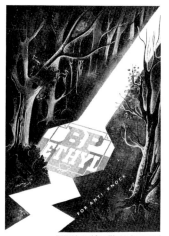

KNOCKING is one of the audible signs that your petrol is poor in quality ● It means lack of power, poor acceleration and an overheated engine ● Therefore use "BP" Ethyl — the petrol is pure and volatile and the Ethyl fluid is the finest anti-knock specific known

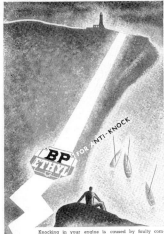

Knocking in your engine is caused by faulty combustion — poor petrol. By using "BP" Ethyl you remove both these causes: the Ethyl in it controls combustion, and the petrol itself is first-grade, and comes from wells and refineries which are owned and controlled by a British company.

This was the first 48-sheet poster which BP (British Petroleum) produced. It was commissioned by Jack Beddington almost as soon as Schleger arrived in London. Twenty-four years later the visual interpretation of speed was still emphasised in the Stop for Super Shell and Go poster, (p.72).

Schleger took several photos of the poster on different sites when it was first posted.

The advertising campaign imaginatively stressed the strong design element of the poster, which in an abstract way expressed the smooth driving enjoyed by using a good petrol.

THE
HIGHWAY CODE

The designer Ashley Havinden wrote at the time, 'This picture is surrealist in that the imposition of eyes and ears for heads underlines the necessity for super-awareness on the part of pedestrians in traffic. Also, such an unusual visual idea brings an interest and curiosity appeal into a subject which would otherwise make dull poster material.' Havinden goes on to say of the exhibition, which Schleger also designed, 'The Highway Code is a brilliant example of very difficult material admirably co-ordinated. The designer clarifies by simple visual analysis an abstract notion of behaviour.'

The exhibition was to show in visual terms some of the reasons for the advice given in the Highway Code and examples of the results caused by disregarding it. Wired glass gave the information panels dignity, importance and a feeling of spaciousness. Each design dramatically emphasised the important points from the Code. Materials used were as far as possible actual road and traffic materials. Roadside guard rails, a black and white traffic column, traffic lights at the entrance and the floor linoleum was inlaid with white rubber letters and traffic arrows – all chosen for their inherent functional beauty and simplicity. A small scene, *Accidents are caused by cutting in,* was produced using repainted toy cars. The Minister for Transport opened the exhibition and over 40,000 copies of the Highway Code were taken home.

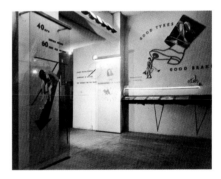

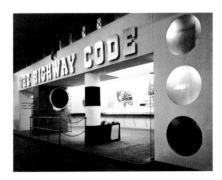

other. The use of the Underground symbol as a wrist watch quietly emphasises that the trains ran on time.

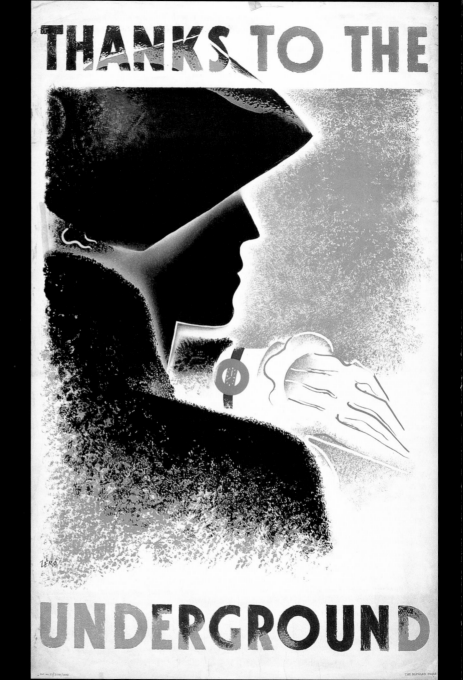

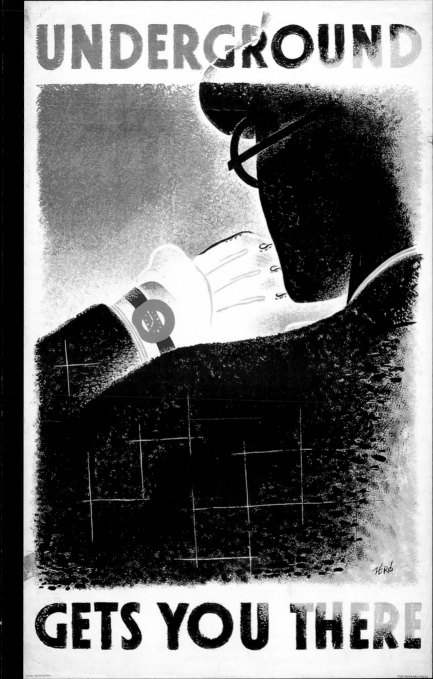

Journalists – these men use Shell

In the 1930s petrol was a relatively new commodity. *These Men Use Shell* was one of a series of posters commissioned by Jack Beddington, the advertising manager of Shell-Mex Co. They appeared on the sides of their petrol wagons and were referred to as lorry bills.

Three very good principles were at work here. First, to ask artists to make paintings from a list of given professions, to be used as posters, (Shell gave Sutherland his first commission). Secondly, these posters were on sale to the public, very cheaply, who could then cut the message away and have a painting on the wall at home – art reaching a much wider audience. The posters were also sent to schools. Finally, Beddington was opposed to roadside advertising, which turned out to be good business as it enhanced Shell's image as a company which cared about the countryside and became a strong piece of propaganda for them.

Schleger wrote an article about Beddington and Shell advertising for the graphic magazine *Gebrauchsgraphik* in 1933, where he praised their approach to artists. In it he says, 'Beddington regards it as an advantage to work with artists, discussions never arise which begin with the familiar words "couldn't we put in this or that just here". Instead, young talented artists are called into collaboration, for instance Constanduros not yet twenty years of age, whose work had not been shown at any exhibition. Thus a collection has come into being, the value and richness of which is conditioned by the variety of temperament which has had an opportunity to work itself out at will. It runs the whole gamut from the lyric lightness of Gardiner, Du Plessis, Constanduros, by way of Armstrong, Sutherland, Dobson, to the impressive forthrightness of that poet of the poster, McKnight Kauffer.'

Beddington said of Schleger in 1958, 'He is the best of all advertising designers.' The admiration was mutual. Schleger always remembered and often referred to Beddington's achievement for Shell and BP. Beddington's vision of modern advertising was revolutionary in the early 1930s and he never lost his belief that publicity must touch the imagination of the public to be effective.

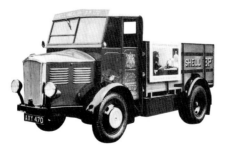

Poster
Shell-Mex & BP Limited
1938

The first sketch for the poster
found recently on the back of
a small photo, amongst some
of Schleger's papers.

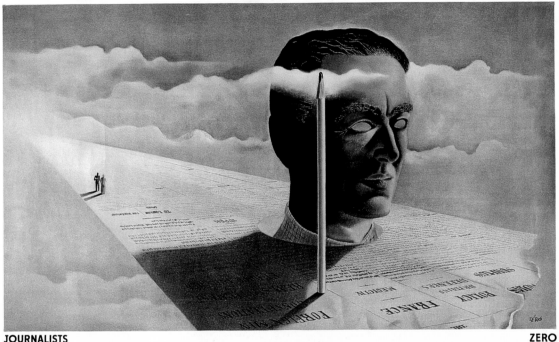

THESE MEN USE SHELL

JOURNALISTS ZERO

YOU CAN BE SURE OF SHELL

Wartime posters
GPO (General Post Office)
1941-3

Unlike today when people are encouraged to use the telephone, services then were very limited, and only a skeleton staff remained in these essential jobs. Gentle persuasion, humour, animating inanimate objects, all contributed to Schleger's positive approach to the public. And the friendly chef – was he not a precursor of the cheerful Mac Fish character (p.182)?

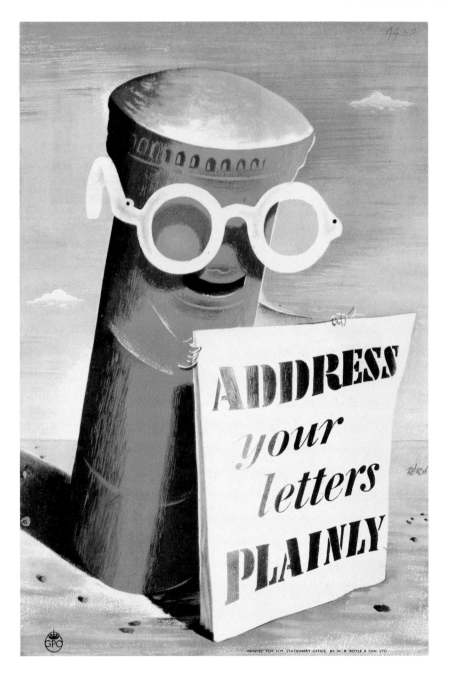

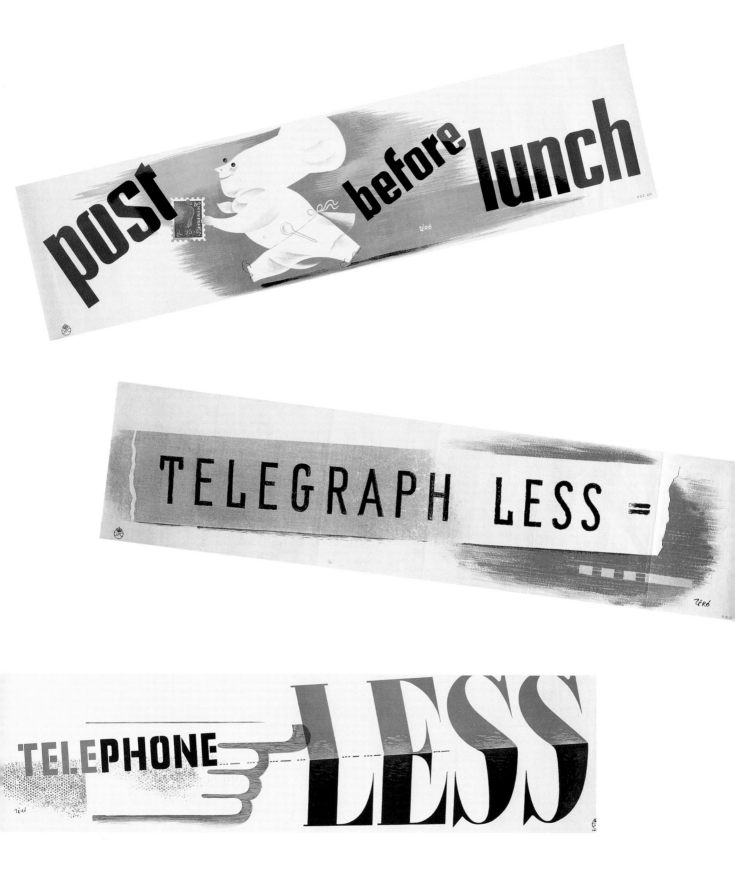

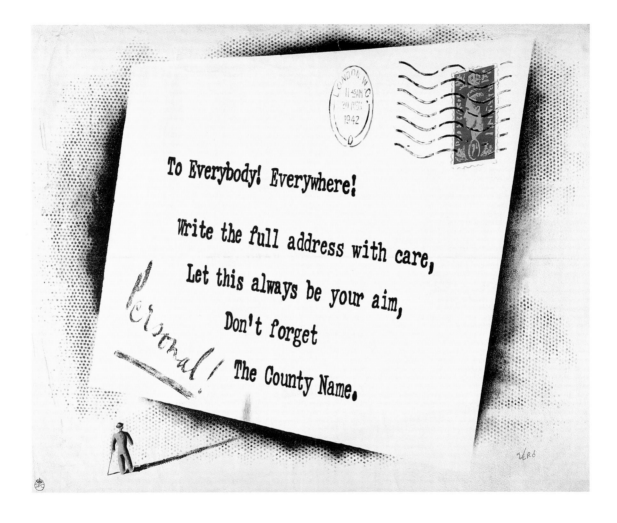

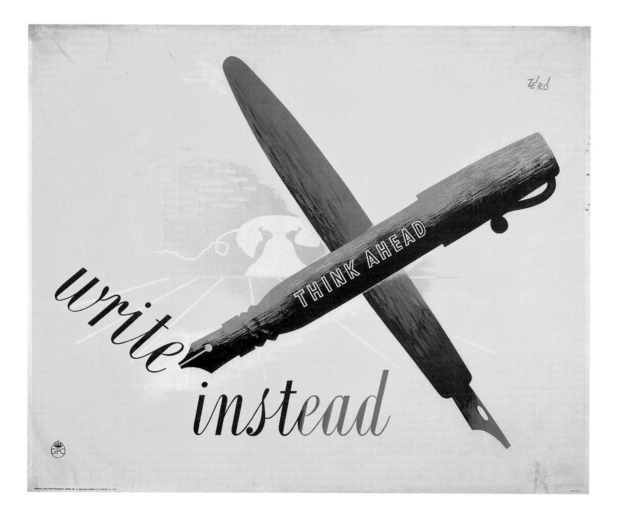

51

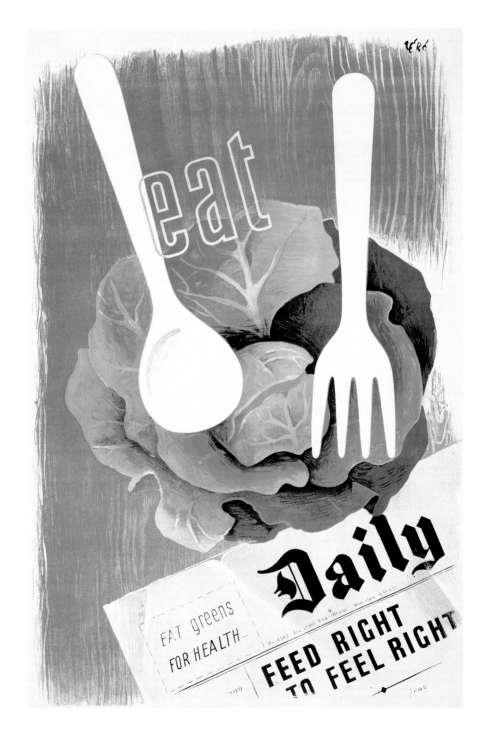

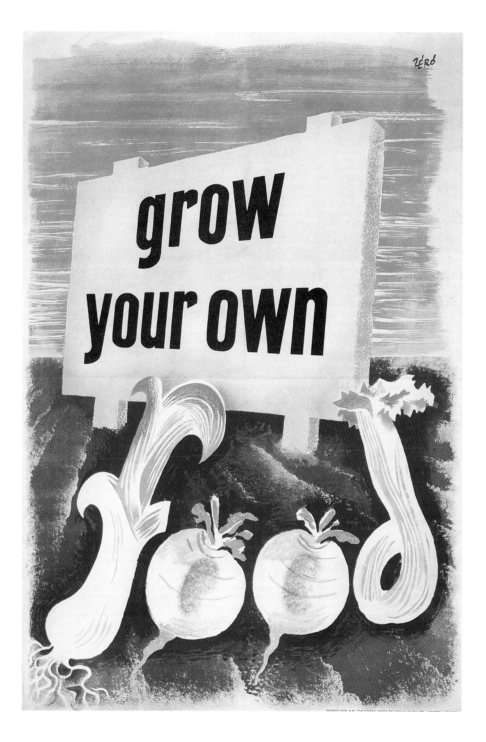

Mary Gowing writes in *Art & Industry* of the ATS campaign 1943-5

Schleger from his earliest days has been concerned to express 'the face of the firm' in any advertising he undertakes …

The ATS recruiting scheme on which he and I collaborated during the war was a case in point. Here, indeed, was *at first* a face so ugly that it had, as it were, to be lifted and transformed. The Service, through a number of misunderstandings and misfortunes that were by no means its own fault, had become discredited. There was in fact a *whispering campaign* against it. Men in particular, whether as brothers or boyfriends, husbands or fathers, were against their womenfolk joining it. 'If Winston Churchill takes my wife', I heard a man say, 'I'll shoot her,' and I'm sure he meant it! Yet recruitment and coupon figures later showed that it was when the scandal and gossip was at its very height that our campaign turned the tide of public opinion and literally opened the flood gates to that desperately needed recruitment.

How was this face created? By a straight, strong, warm approach to conscience. *Out of Fashion* said a message flung across a fashion photograph (that we owed to the co-operation of *Vogue*). By immense readability, by absence of all cynicism, all advertisingese, together I think we managed to give that face the wholesome sincerity and strength of character to which it was in the main entitled.

Schleger was extremely proud of the ATS campaign, he considered it his contribution to the war effort. It is also a good example of his attitude towards advertising. Firstly, you must find the right psychological approach to the problem. Only then can design and copy together dramatise the message, so that it is seen, read and hopefully acted upon.

Gowing and Schleger working on the ATS campaign late at night. Schleger had the idea for the headline 'out of fashion', Gowing wished she had thought of that one herself.

Gowing was a partner of the advertising agency John Tait and Partners. She and Schleger worked extremely well together on a number of accounts including the ATS campaign. He admired her knowledge and skill in advertising, her brilliant copywriting and her forthrightness. She had been a VAD nurse in the First World War as an innocent teenager. After that experience of mud and blood, she always called a spade a spade; she was also a Mancunian. One of her great assets was that she understood her own sex and realised that most men had no idea how women feel and what motivates them. She also knew that the war was changing all this – women were doing men's jobs in the armed forces and in factories. They were unlikely to return to the nursery and kitchen sink as their only functions in life when it was all over. John Tait ran a series of single column ads during the war about this very question of the changing role of women and how advertising agencies needed to change in response.

Below are a few quotes from this series, Gowing wrote the copy for them, Schleger did the drawings.

'A man who was in love with a woman, once wrote a poem to her which began, *I wish I lived behind your eyes.*'

'Does any man really believe that he is intimately acquainted with all the fine shades of thought that pass through any woman's mind?'

'Men, I think, have made a world of their own. Once they kept that world to themselves, now they are sharing some of their secrets … they are asking women to help on work they used to do alone.'

'Until the advertising man can put his hand on his heart and say, "Gentlemen, I have a feminine touch," campaigns addressed to women and prepared by men, will waste a high percentage of the advertiser's appropriation.'

"think of the tanks . .

and the men that must man them. Try and remember that every soldier who can man a tank or handle a gun must do so.

That is why you are needed in the A.T.S. on radiolocation, ack-ack batteries, to drive and take despatches, to cook and cater . . . all to free men for tanks and guns.

There's been a great tank battle in Libya, planned for months ahead. That's why the country has been asking you to volunteer . . Tanks in the end will drive Germany to her knees. We need you in thousands to free more and more men to man tanks, to service and repair them. We want you in the A.T.S. for a man-size job !"

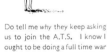

Do tell me *why* they keep asking us to join the A.T.S. I know I ought to be doing a full time war job . . . but why so specially in the A.T.S.?

Post this to-day for a booklet which answers all your questions

Address it to The Auxiliary Territorial Service, AG18/ Hobart House, Grosvenor Gardens, London, S.W.I. Please send me full story of life in the A.T.S. and details of the opportunities it offers. This does not commit me in any way.

Mrs./Miss

Address

Age.........(in confidence)

ATS

Unsealed envelope, penny stamp.

The Army is one man short until you join the ATS

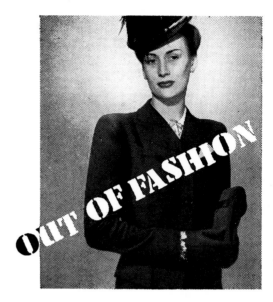

OUT OF FASHION

Are you living a selfish life, thinking selfish thoughts, spreading complacency and thoughtlessness? If so you are dangerously out of fashion. You lack imagination. Russian women in slacks and smocks are fighting in the trenches. German women in ersatz overalls work side by side with men to make the barges with which they hope to invade Britain. *Your* place is in the Army, helping to strengthen our own war machine against the gathering German menace. You can still choose your war job . . . join the A.T.S. Soon that choice may be no longer open to you. Time is very short !

CUT THIS OUT AND POST IT TODAY

Address it to The Auxiliary Territorial Service, AG18/ Hobart House, Grosvenor Gardens, London, S.W.I. *Please send me full story of life in the A.T.S. and details of the opportunities it offers. This does not commit me in any way.*

Mrs./Miss

Address

Age (in confidence)

ATS

Adventure through Service

Unsealed envelope, penny stamp.

Posters for the Blackout
London Transport
1943

The sudden plunge into blackout conditions brought the LPTB immense problems for which solutions were quickly found. But one problem which calls for continued masterly handling is that of teaching people to avoid blackout accidents.

The problem of guiding the public is not static. Lighting conditions have been eased. The public may use more brilliant torches than were formerly permitted. These changes reduce some dangers, increase others. The flashing of torches in the faces of bus drivers is one that has been increased, because of the greater brilliance permitted. The road posters urge people to wear or carry something white; to hail a bus or tram by shining a torch on to the hand; and to be sure the bus or tram has stopped before alighting.

The rail posters advise passengers to pause before leaving the station's light for the darkened street (blast walls outside certain stations has permitted better lighting of stairways and booking halls, and makes the contrast with the blackout greater). Schleger's approach to his task is typical of him. The posters were intended to guide the public. Therefore, they must win the co-operation of the public. They must be strong enough to interrupt but persuasive enough to gain goodwill, and direct enough to give instant guidance.

The obvious thing seemed to be to use plenty of black, but Schleger questions the obvious. In this instance, his questioning led him to decide that there should be plenty of light in the posters so that their message was seen as blackout approached. The appeal should be positive. Schleger's posters, therefore, have the air of saying, not 'Don't' but 'Please do.' The British temperament reacts against 'Don't' but tends to respond to 'Please do.'

from an article in World's Press News, 1943

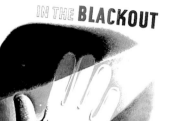

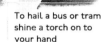

To hail a bus or tram shine a torch on to your hand

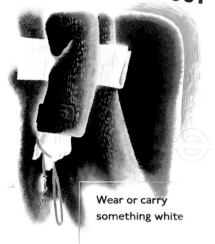

Wear or carry something white

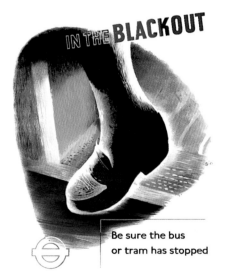

Be sure the bus or tram has stopped

IN THE **BLACKOUT**

Pause as you leave
the station's light

A Norwegian-American ABC
American Office of War Information
London c1944

This small leaflet was distributed to the Norwegian people to promote good relations and understanding between the two nations before the Americans moved into Norway. It was approached in a humorous and friendly way which would surely have eased the tensions arising from what might have been seen as an invasion of American forces, albeit a friendly one.

A translation of the pages shown:

c China was in the war on Norway's and America's side. The Japanese had declared war on China long before the Germans invaded Norway. But the brave Chinese never surrendered.

d Dams are found in America as well as in Norway. The water is dammed and is used for electricity, to supply light and heating and for use in factories.

k Commandos fight as bravely as Vikings.

l Landing craft are used by Commandos in action.

m Able seamen form the crew on warships. They have torpedoed submarines so that Norwegian sailors can take supplies all over the world.

n New York is the largest city in America. Arriving by ship visitors catch their first glimpse of the Statue of Liberty, welcoming them to this city of skyscrapers.

s Skis are more widely used in Norway than in America. For this reason Norwegian skiers had to teach American soldiers to ski and to fight on skis.

t Tankers are built for carrying oil. Oil is vital in wartime. Norwegian tankers have carried oil throughout the war in spite of the threat from submarines.

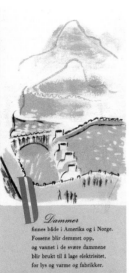

China har vært med i krigen
på Norges og Amerikas side.
Lenge før Tyskland overfalt Norge
hadde japanerne begynt krig mot China.
Men de tapre kineserne har aldri gitt seg.

Dammer
finnes både i Amerika og i Norge.
Fossene blir demmet opp,
og vannet i de svære dammene
blir brukt til å lage elektrisitet,
for lys og varme og fabrikker.

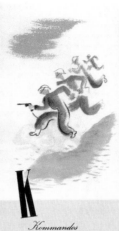

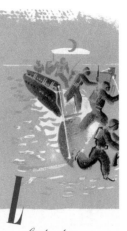

Kommandos
er like gode til å slåss
som vikingene var.

Landingsbåter
kalles de båtene Kommandos bruker
når de er på tokt.

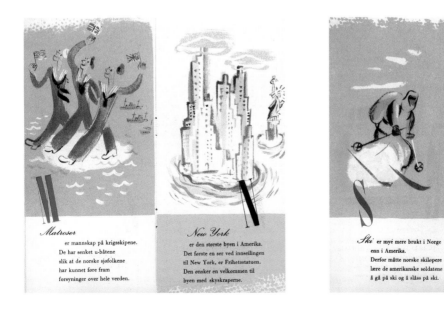

Matroser
er mannskap på krigsskipene.
De har senket u-båtene
slik at de norske sjøfolkene
har kunnet føre fram
forsyninger over hele verden.

New York
er den største byen i Amerika.
Det første en ser ved innseilingen
til New York, er Frihetsstatuen.
Den ønsker en velkommen til
byen med skyskraperne.

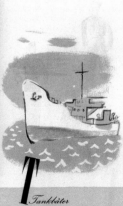

Ski er myé mere brukt i Norge
enn i Amerika.
Derfor måtte norske skiløpere
lære de amerikanske soldatene
å gå på ski og å slåss på ski.

Tankbåter
er bygget for frakting av olje.
Olje er viktig når det er krig.
De norske tankbåtene har ført oljen
fram gjennom hele denne krigen
trass i faren fra u-båtene.

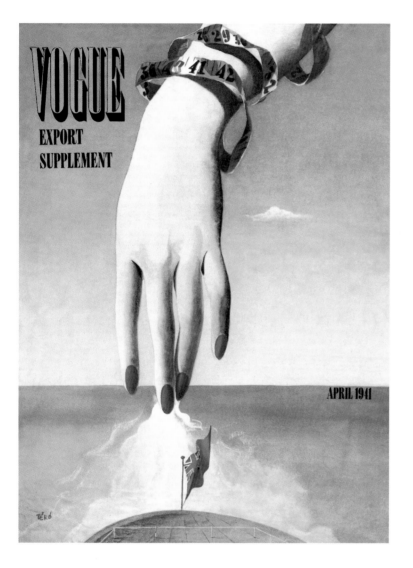

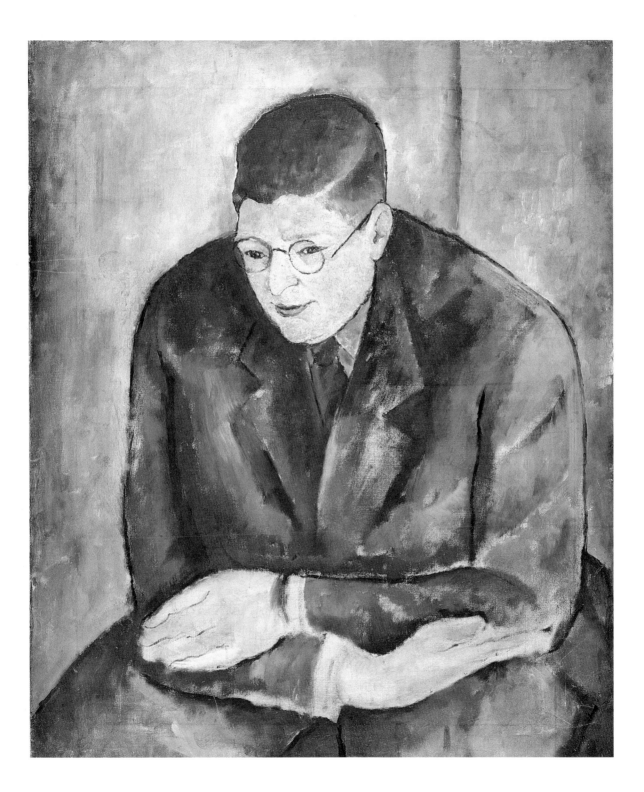

Posters and Advertisements
London Transport
The posters were designed to be hung
as a pair in Underground stations.
1946

If you drive yourself you know what his driving
is like and how good his road manners are.
If you are a passenger on his bus you only know
that you are sitting in a very safe place.
Two ways of saying that he has earned every bit
of his reputation—and continues to earn it.

LONDON TRANSPORT

With one eye on the platform and the other on the clock
he sends the starting signal. Punctuality, and safety too,
hinge upon his quiet mastery of the job. As train after train
slides out to time the peak-hour crowds soon dwindle.

Hands at your service

The Lost Property Office in Baker Street is his
workshop. Every night a fleet of vans brings to
his door the 1,001 things that London forgot
that day. Yet by the time you visit him, deft
fingers have made order out of amazing chaos.
And you, of course, thought it was easy.

LONDON TRANSPORT

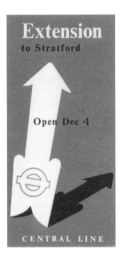

*Posters and a leaflet cover
for the Central Line extensions
London Transport
1946-7*

wait till it stops

**before getting on or off
a bus or tram**

Issued by the Royal Society for the Prevention of Accidents, Terminal House, 52 Grosvenor Gardens, London, S.W.I. Printed by LOXLEY BROS. LTD.

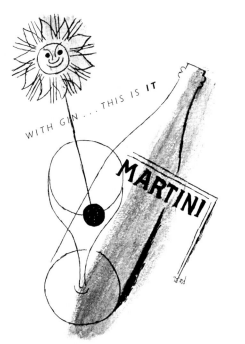

MARTINI VERMOUTH
matured and bottled in ITALY by Martini & Rossi SA

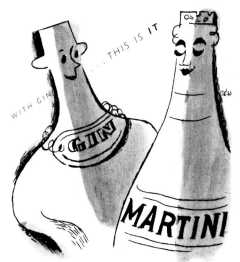

MARTINI VERMOUTH
matured and bottled in ITALY by Martini & Rossi SA
Sole importers A. O. Morandi & Co. Ltd. London, S.W.I

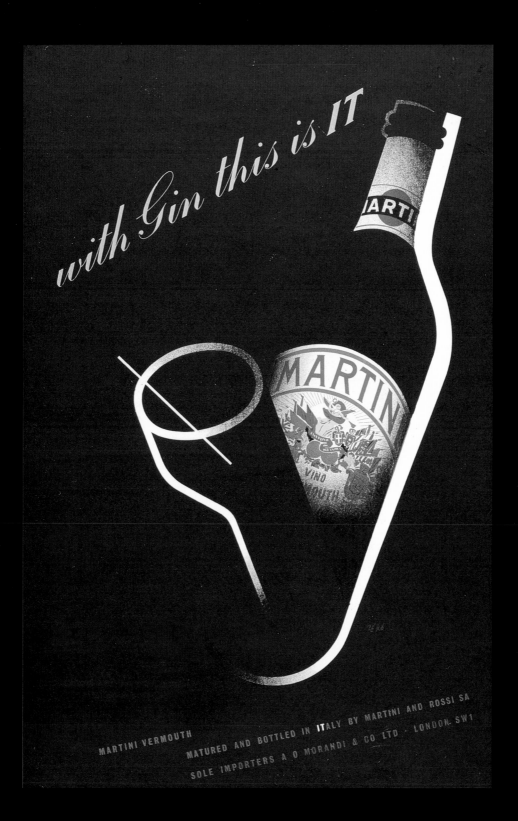

Booklet, front and back covers
The Railway Museum, York
British Transport Commission

Poster

1958

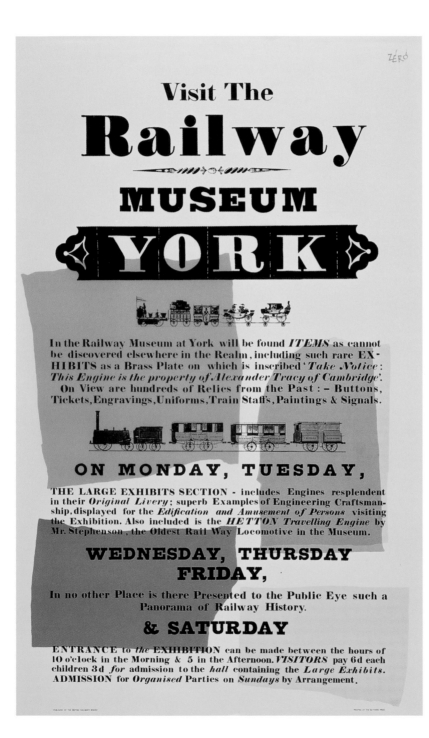

ZÉRÓ

Visit The
Railway
MUSEUM
YORK

In the Railway Museum at York will be found *ITEMS* as cannot be discovered elsewhere in the Realm, including such rare EX-HIBITS as a Brass Plate on which is inscribed '*Take Notice*: *This Engine is the property of Alexander Tracy of Cambridge*'. On View are hundreds of Relics from the Past : – Buttons, Tickets, Engravings, Uniforms, Train Staffs, Paintings & Signals.

ON MONDAY, TUESDAY,

THE LARGE EXHIBITS SECTION - includes Engines resplendent in their *Original Livery*; superb Examples of Engineering Craftsman-ship, displayed for the *Edification and Amusement of Persons* visiting the Exhibition. Also included is the *HETTON Travelling Engine* by Mr. Stephenson, the Oldest Rail Way Locomotive in the Museum.

WEDNESDAY, THURSDAY
FRIDAY,

In no other Place is there Presented to the Public Eye such a Panorama of Railway History.

& SATURDAY

ENTRANCE to *the* EXHIBITION can be made between the hours of 10 o'clock in the Morning & 5 in the Afternoon. *VISITORS* pay 6d each children 3d *for* admission to the *hall* containing the *Large Exhibits*. ADMISSION for *Organised* Parties on *Sundays* by Arrangement.

This poster was designed in 48-sheet, 16-sheet and 6 bus sizes. The two men in the poster were featured in an advertising campaign which had started the previous year. They were an art director and an account executive at the agency, Mather and Crowther, who handled the account. Photographs of them were rephotographed in order to get the effect of distortion by speed. The change in the angle of the message also intensifies the movement.

2

The Function and Limitation of the Trade Mark
written by Hans Schleger for IPA News June 1962

I want to discuss, not the trade mark in isolation, but rather the place of the trade mark in the whole concept of communication. I am thinking mostly of visual trade marks – as distinct from name trade marks.

My work in advertising is almost exclusively concerned with the communication of images and messages of companies. Trade marks come into this, and I have designed a few. A trade mark is valuable property, and it is necessary to protect it. The human instinct to communicate is the basis of one of the functions of the trade mark. The making of pictures has had a meaning from the beginning of civilisation. Images were probably first used for religious and magical purposes.

Looking back to the emergence of so-called modern man we find that he now appears to us as a designer of images, but not just as a maker of pictures for their own sake. The bison painted on the walls of caves something like 20,000 years ago was probably meant to bring about success in hunting. We find similar superstitions today, as for instance, the habit of having mascots to bring good luck and success in love, war or business.

Emblems
Egyptian murals and Babylonian seals show men wearing animal masks, which were recognisable emblems of a tribe or family, like hereditary totems; perhaps to make clans recognisable and so to prevent the inter-marriage of close relatives. This sort of identification still continues and has always been the primary concern of heraldry.

Ancient seals (for closing jars), bearing symbols – a form of packaging – are the first marks of personal ownership. They are a link between prehistoric pictorial *writing* and the emblem or trade mark of today. Pictographs, the earliest form of writing, began in Mesopotamia, Egypt and Crete. Chinese calligraphy, now highly developed, is based on the writing of signs as distinct from that of sounds. Early signs were influenced by the writing materials available, by the need or desire for rapidity and by aesthetics, so that they became progressively abstract. Symbols and emblems have no alphabet, but rather depend on a visual vocabulary.

Tracing the importance of symbols during the beginnings of human activities makes it perhaps easier to realise the power of images in our own time. The feelings evoked by certain images and symbols go far deeper than we may care to admit and move sometimes outside the scope of everyday rational thinking.

Hidden conflict
Fraser in *The Golden Bough* tells us that primitive man believed that what is sacred may also be dangerous; the crocodile is most sacred to one tribe, but at the same time they consider it hateful and to be the bringer of bad luck. The man who has such contradictory feelings is, of course, in a state of unstable equilibrium. I mention this in relation to certain experience with people who may bring to a design similar ambivalent feelings. They are attracted by a design and yet at the

same time are afraid of it. This conflict does not come into the open, because it remains in the unconscious and is usually rationalised.

A picture connects with people and things. One hesitates to destroy a picture of a person to whom one is close. Pictures are thought to come to life: in miraculous images of the Madonna, the 'Miracle' play, the picture of Dorian Gray – and they can be thought to heal or protect, as in the case of the medals of St Christopher. Because rational thought rejects this strong sense of the reality of the image, it remains as an unconscious factor. We are still rooted in the past. A true design is not the product of fancy; it is based on work through which is discovered the pictorial expression of a concept. As trade and communication are becoming world-wide, the image grows into a truly international language.

Visual communication

Visual communication can be a most penetrating form of communication. It is easily retained in the memory. People who live in adjoining countries, divided as often as not by a political or arbitrary frontier, may in some way be as far apart as people who live thousands of miles away. But once one begins to realise how vast is the number of objects which are universal and recognisable by all people, how very large the visual vocabulary already in existence, one begins to appreciate the possibilities of symbolic communication (Olivetti is one example, international traffic signs another). Communication, however, presupposes the ability and willingness to receive the transmitted message, and this varies enormously. It is conditioned by age, sex, upbringing, prejudices, environment, and other factors.

The best trade marks are seen and recognised – and not translated. Their impact can be deep, and after a while they become permanently absorbed by the person receiving them, unless a subconscious resistance interferes.

Strength

Another example of the effective strength of visual communication is a psychological one. Few men like to be told what to think or how to act. A traffic warden who commands may make a man rebellious: but the silent visual command in red, yellow or green is followed without much resistance. A trade mark should not be *fashionable*, because fashion is ephemeral, but it can represent the essence of machines or of efficiency, of a new age with new power, in which electronics and atomic energy are replacing the cogwheel-mentality of the nineteenth century.

Before considering the designer's task, I quote Paul Rand, the American designer: 'Symbols are a duality. They take a meaning from causes – good or bad. And they give meaning to causes – good or bad. The flag is a symbol of a country. The cross is a symbol of a religion. The Swastika was a symbol of good luck until its meaning was changed. The vitality of a symbol comes from effective dissemination ... it needs attending to to get attention. The trade mark is not a sign of quality – it is a sign of *the* quality... Ideally trade marks do not illustrate they indicate...'

Simplicity and restraint

An outstanding design solution is the Japanese flag, consisting apparently of a red circular shape of pure form and colour. It could not in itself be a trade mark or a

symbol. Containing this orange ball in a white field made it into a unique design. It is perhaps the simplest and strongest flag, proving that even a single, basic design element, handled with creative imagination, can successfully help to represent a group.

The designer's task, begins with imposing his own limits. Self-imposed restraint results in simple form. The simple and abstract design can become almost a 'new letter of the alphabet'. The designer should first limit his theme and remember how strong an influence symbols exert. Designers should aim to suppress irrelevance and express the essence.

Birds are a theme which run right through Schleger's career. From his early work for Deutsche Bank to the Edinburgh Festival symbol, designed towards the end of his life. Bird symbols have been grouped together with several more illustrative birds. The swans are from a strip poster for the London Underground 1938.

W. Raven & Company Limited
Sock manufacturers
1947
The Raven trademark was an important
element of Schleger's work for this company,
which was an early example of corporate
identity (p.174).

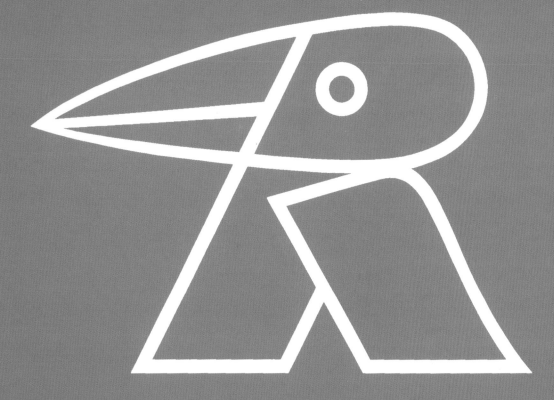

Trademark
Byrkmeyr
Makers of tarpaulins and waterproof cloth
1945

BIF (British Industries Fair)
Device designed for advertisements for
London Transport on the theme
'What's on in London'.
1936

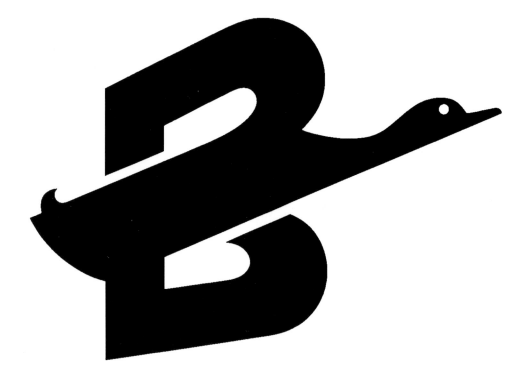

Ullstein – publishers
Design for a frontispiece to a
comprehensive article about Ullstein's
approach to their own advertising. The copy,
layout and selection were by Schleger.
An owl was the publisher's symbol.
Gebrauchsgraphik February 1931

TEXT & LAYOUT

ZERO

TYLL

ULLSTEIN

Trademark
Deutsche Bank
The first modernised version. Historically
interesting as it no longer included the royal
crown above the eagle's head.
Used from 1929 to 1937

Brochure cover
Hiddensee
a summer resort on the Baltic Sea
c1930

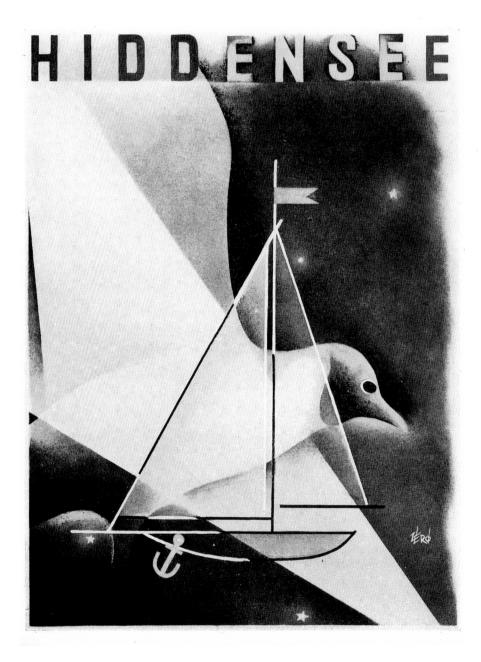

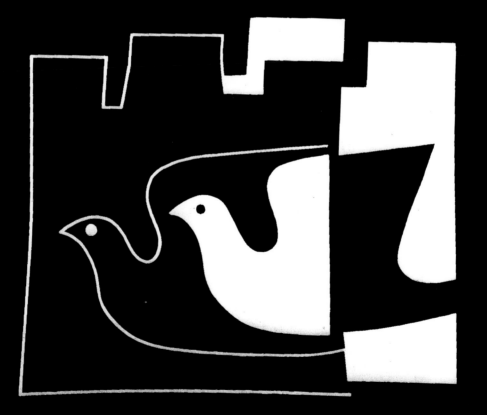

Symbol
Penguin Books
Peregrine – 'egg-head' books
1960

Symbol
Penguin Longman
Kestrel – hardback children's books
1974

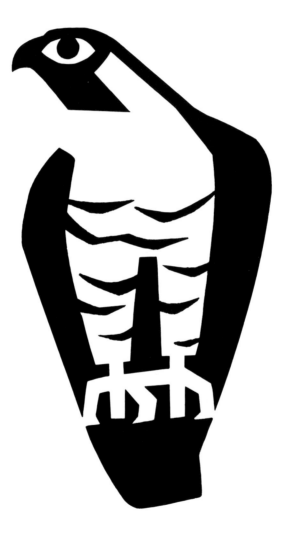

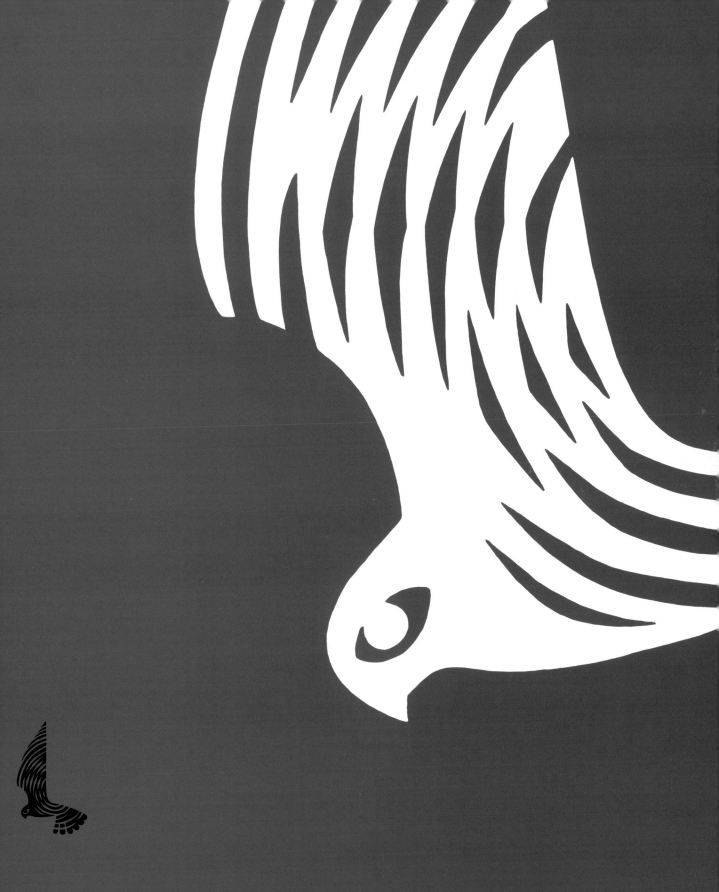

Symbol
Allen Lane –The Penguin Press
An imprint for hardback books
1965
(The stationery is shown overleaf)

Symbol
Penguin Books
Education section 1968

Allen Lane The Penguin Press Limited Vigo Street London W1

Allen Lane The Penguin Press

Vigo Street London W1 telephone 01 734 0047

chairman Sir Allen Lane Hon D Litt Hon LLD Hon MA directors A Godwin H F Paroissien A M Walker

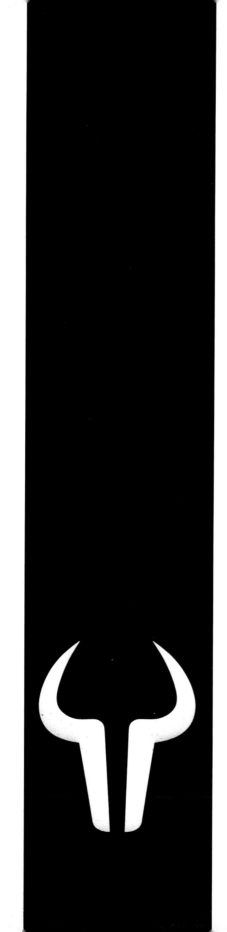

Symbol
Hutchinson Publishing Group
1974
A radical approach to the bull, away from the delightful calligraphic bull by Reynolds Stone which was used until Hutchinson became a much larger company. The image of a complete bull did not work very well on the spines of books.

An extract from a letter Schleger wrote to the managing director after the symbol had been accepted by the board in June 1974.

I feel that successful design depends so much on mutual understanding and your attitude has been most essential to the outcome. Mr Perman and I discussed the next steps and I said to him that I am of course as interested in the life of the designs as if they were children. However, once you have acquired the copyright of the designs you are obviously free to use and apply them without our co-operation if you wish. On the other hand everything has been so pleasant and harmonious that we should welcome it if we could work together on building up a corporate image.

Symbol ▷
The Helios Press
c1945-9
Basic shapes in juxtaposition which are connected to each other, but in an abstract way. The relationship is based on the symbol for the sun and a triangle, which forms the bowl of the P for press.

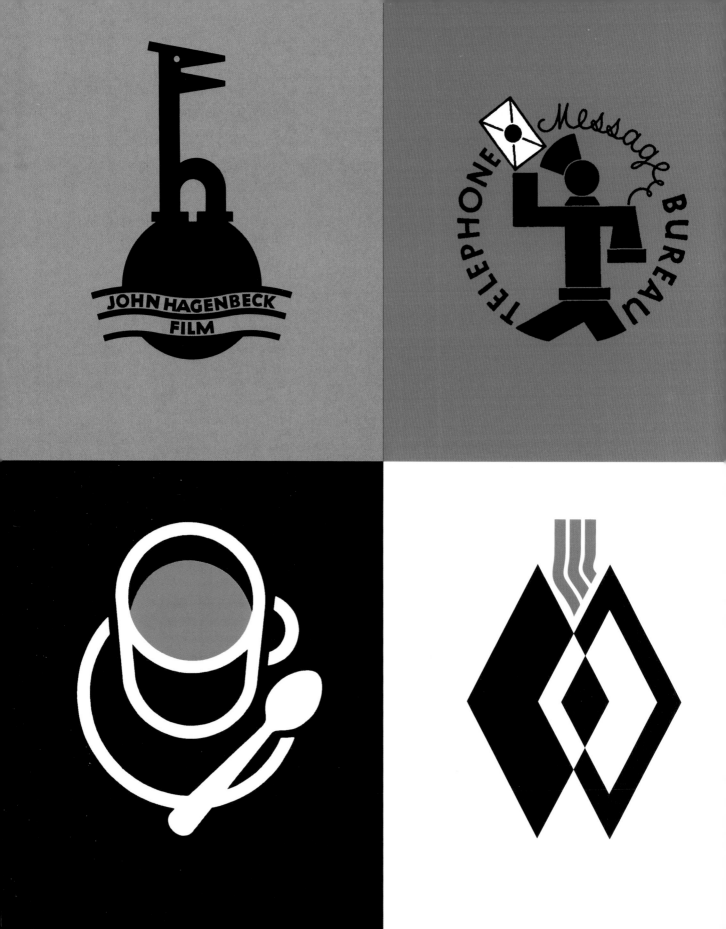

Trademark
John Hagenbeck Film Company
c1921
The Hagenbecks are a Hamburg family who founded the famous zoo, where for the first time many of the animals were enclosed rather than caged. Karl Hagenbeck, the founder, was also an animal dealer who travelled the world for his stock. The film company was started by one of his sons. Their films were romantic stories set in exotic places, featuring wild animals.

Trademark
Telephone Message Bureau
New York
c1927

Trademark
W. Raven & Company Limited
Socks for men
c1949

Lighted sign for a café
British Railways Board
A sign with no words was the task. It was to help visitors from abroad arriving at London's main line stations, and also to eliminate the confusion which arises in a busy area where there are too many written directives.
c1957

Trademark
Coal Utilisation Council
This symbol was called the burning black diamonds.
1947

Trademark
A cattle remedy, probably designed for a German company.
c1932

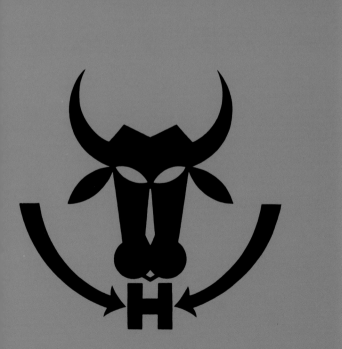

**The Bus Stop signs
London Passenger
Transport Board
1935-7**

In 1935 Frank Pick, chief executive
of London Transport, commissioned
Schleger to modernise the bus stop sign.
During their discussion Schleger asked
him where the symbol had originated
and Pick replied, 'We do not know who
did it, a rough sketch was found on
someone's desk and it was said that it was
based on the Plimsoll line, the load line
on all ships.'

Using Edward Johnston's typeface, also
commissioned by Pick in 1916, Schleger
created London Transport's first modern
version of this fine symbol.

It was decided, when this redesign took
place, to create a request stop in addition
to the bus stop sign. A great deal of
design experimentation was done, when
this important move forward was made.
Some key elements of the final design
being to keep all the capital letters the
same height. By doing this the broken
lines, which filled in the difference in
height between the first and last capital
letters, were eliminated, as well as the
border line around the old symbol. The
two bus stop signs remained an important
feature of London streets for over fifty
years.

The ethos of Frank Pick's policy for
London Transport was to create a modern
transport system which ran efficiently
and also looked modern; it became
synonymous with London. The red buses
were London's veins running through the
city. Pick's legacy to us today is that he
commissioned contemporary architects,
artists and designers to create a cohesive
image for London Transport, decades
before the phrase corporate identity was
invented.

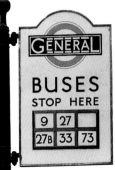

*Cast iron bus stop
showing the old design 1921*

*Bus stop at Hyde Park Corner
with the new design 1938*

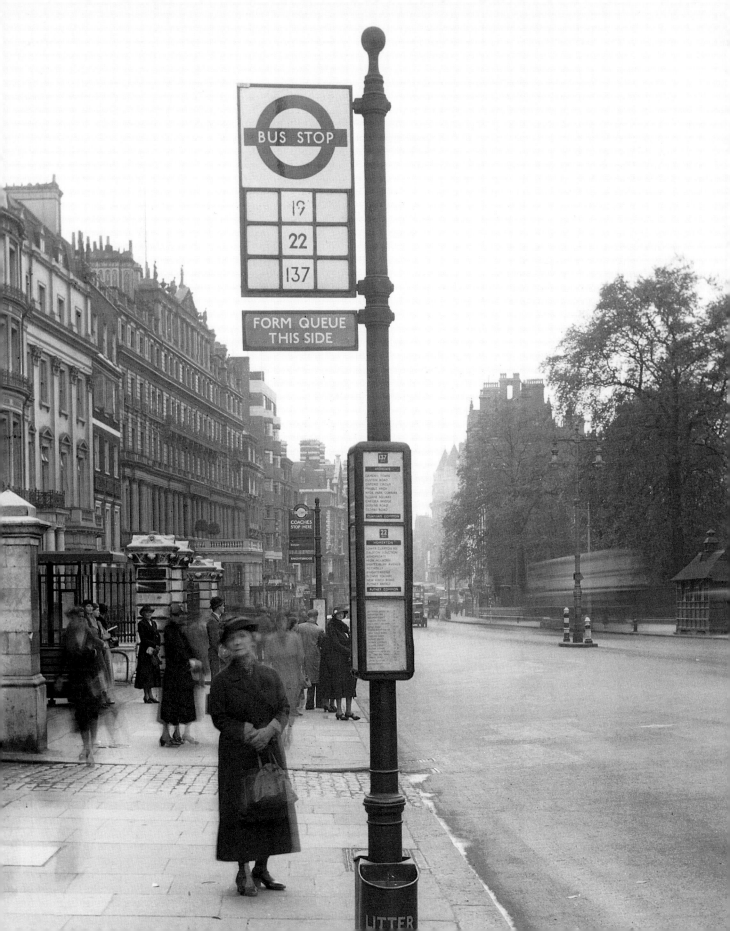

The Bus Stop signs
1935-7

Symbol and message were integrated thus making for quick recognition and memory retention. The words 'Bus Stop' sit within the circle of the sign, which focuses the eye on the words and allows them to float within the horizontal shape.

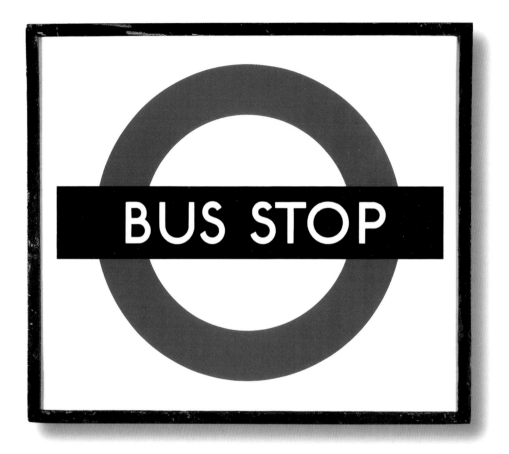

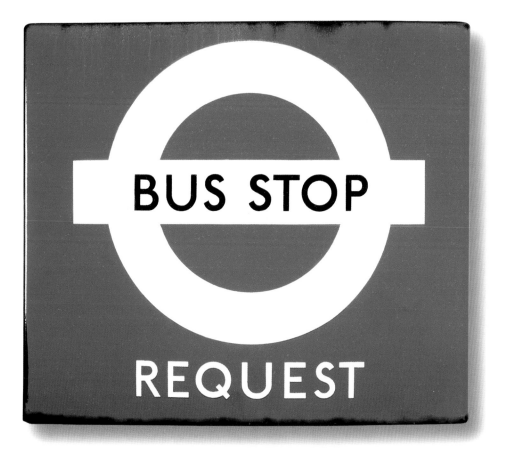

The Request Stop sign, with its strong red background, was easy to see at a distance and easily distinguishable from the Bus Stop.

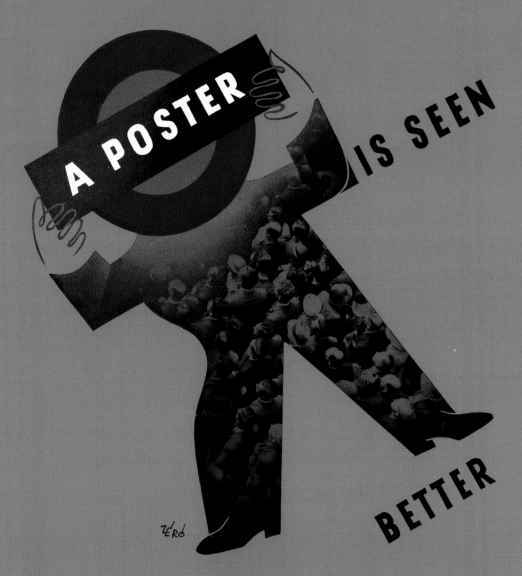

A POSTER IS SEEN BETTER

THROUGH

Underground posters are read by responsive folk who are keen to buy goods and service of every kind. Passengers number 446 million a year, a market advertisers can reach easily and profitably. The Commercial Advertising Officer will gladly quote. 55 Broadway S·W·1· VICtoria 6800

THE UNDERGROUND

**The symbol for the
Design Centre 1955**

A symbol was needed for the Design Centre for British Industries, which was situated in the Haymarket, London. The symbol had to connect the Council of Industrial Design to the new centre and express the concept of quality and selection. It had to be suitable for reproduction in black and white, colour, in relief and in display lighting, and finally in a wide range of sizes. Essentially simple, the final design has about it that rare quality of inevitablity.

Some of the many rough sketches made when developing the symbol.

It is built out of the basic shapes which are always at the designer's disposal — a circle, square and triangle. The symbol uses the eye as the focal point and as the human element of discernment. A fine outline was added to the final version, to prevent one of the basic elements, the triangle, from becoming a directional arrow. A good symbol like this one is a condensed message without words which should be universally understandable.

from Design Magazine, 1955

*Poster (overleaf)
The Design Centre
c1956*

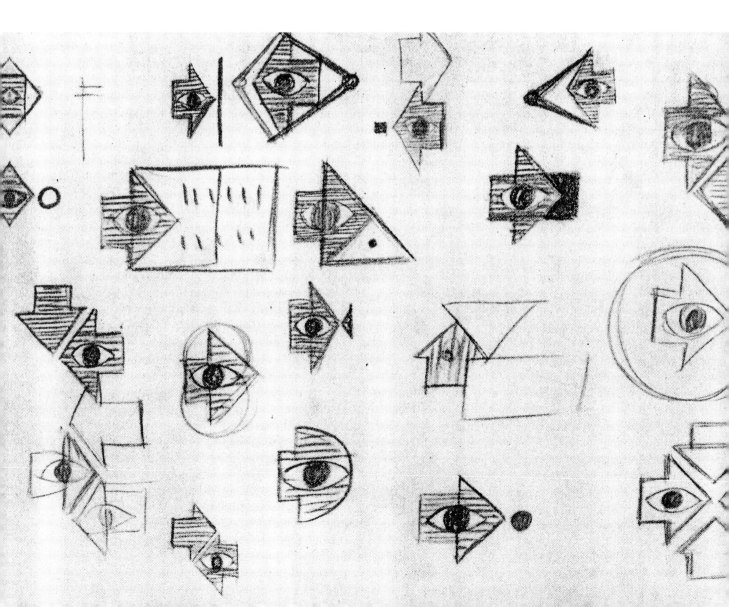

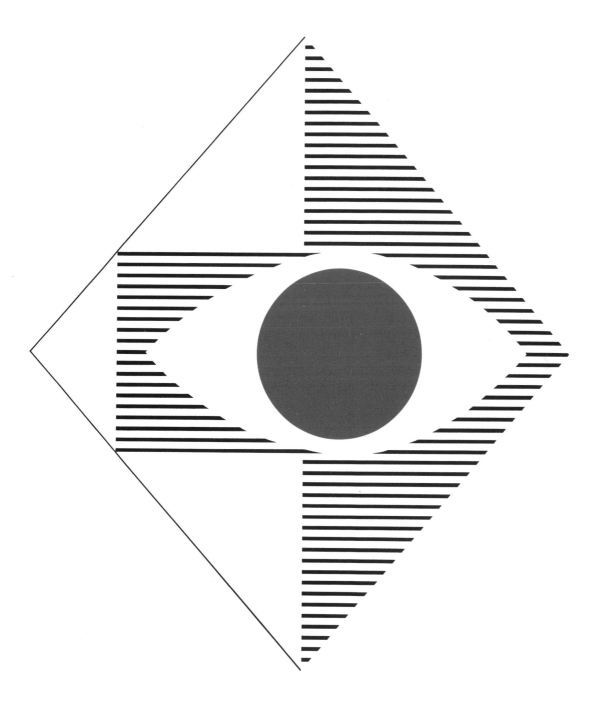

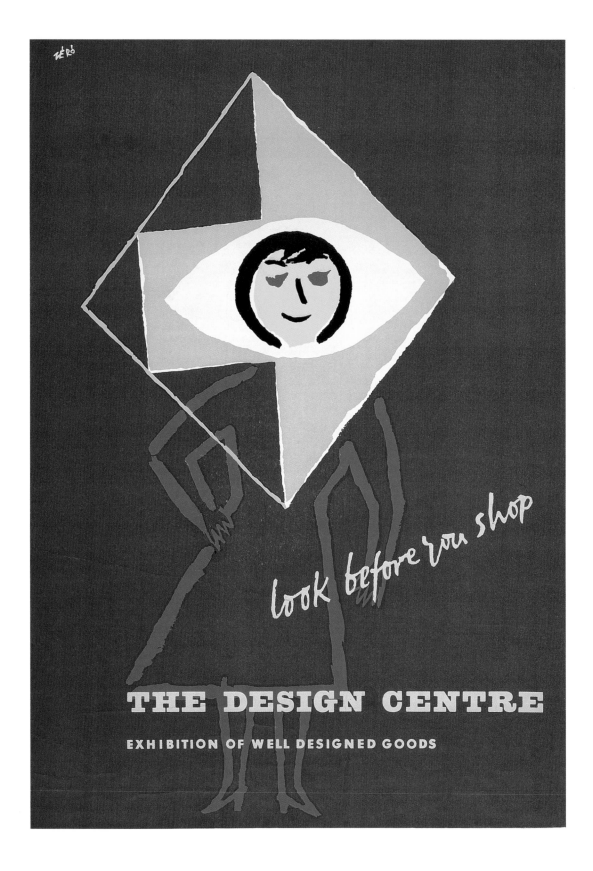

The story of the symbol

from the Partnership Gazette, January 1965

The story behind the symbol is a fascinating one. First, was a symbol possible? Mr Schleger, who will tell you that he has several times refused to design one because he felt that particular company did not need one, took a look at the Partnership. In a scattered organisation, he agreed, the right symbol could indeed have a valuable unifying effect, for both customers and partners. It must be individual enough to be immediately recognisable; it must represent the essence of the Partnership; it must be suitable for use in all kinds of sizes, from letterheads to vans and in any material, including neon lighting and other three dimensional uses. Above all, it must not date. Mr Schleger's designs of bus stops for London Transport still look pleasingly modern after thirty years. He wanted to achieve a Partnership symbol with the same timeless effect.

He said, 'A true design is not the product of fancy; it is based on work to find pictorial expression of a concept ... Visual communication can be a most penetrating form of communication. Signs and symbols can be more important than words – they certainly are easier to retain in the memory.'

A symbol is worth only what it symbolises. A public image will never do more than reflect the realities that lie behind it. The Partnership's goodwill therefore, will still be generated over the counters in its shops. Its public relations will depend on how it *behaves* towards its public and not simply on how it *appears* before them.

One of the first ideas was a bee, standing for industry and co-operation. Hours of work were put in at the Natural History Museum doing detailed drawings of the anatomy of the bee, working from these to produce stylised symbols. But there were snags, the bee's public image is not all good – it stings. More worryingly there is not much copyright in bees. An alternative was to use a stylised letter P for Partnership. This too proved not quite right. Another solution that Mr Schleger had in mind from the beginning was to redesign the existing JLP. But JLP were three letters hard to weld together into a satisfying and yet legible monogram. In a row they looked plain and uninspiring, however well designed. Squeezed together, they merely became harder to read. The problem was how to link them, to make not just a monogram but a symbol that would express something of the special unifying character of the Partnership.

After weeks of making and rejecting sketches, the answer came one morning while Mr Schleger was playing with his young daughter. It was something more than just JLP; it was an extended P linking the other two. He jotted it down on the back of an envelope – a looped scribble that began yet another session of detailed drawings.

continued overleaf

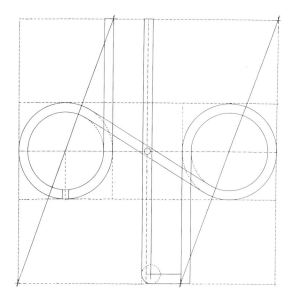

The symbol is bounded by a perfect square. The mathematical centre of the design, in any size, lies exactly at the point where the loop behind the P crosses the L. The slanting line is at an angle of thirty degrees. Then there is the careful rounding off of a single corner on the foot of the L – the accurately proportioned break at the foot of the J – the fact that the two loops are not true circles (if they were, there would be an ugly thickness where they joined the uprights). Complete symmetry is deliberately avoided by leaving a gap between the tops of the J and the L. It would have been easy to echo the bar of the L at the top by joining them – as the original doodle did – 'but', says Mr Schleger, 'too much symmetry makes a design less interesting and this would also have made the letters J and L harder to recognise.'

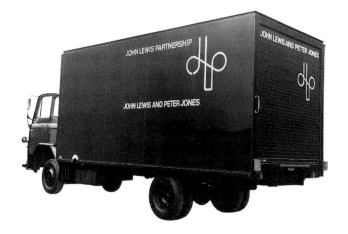

Early versions of JLP, with an alphabetical emphasis rather than that of a symbol.

John Lewis and Peter Jones delivery van showing the application of the symbol.

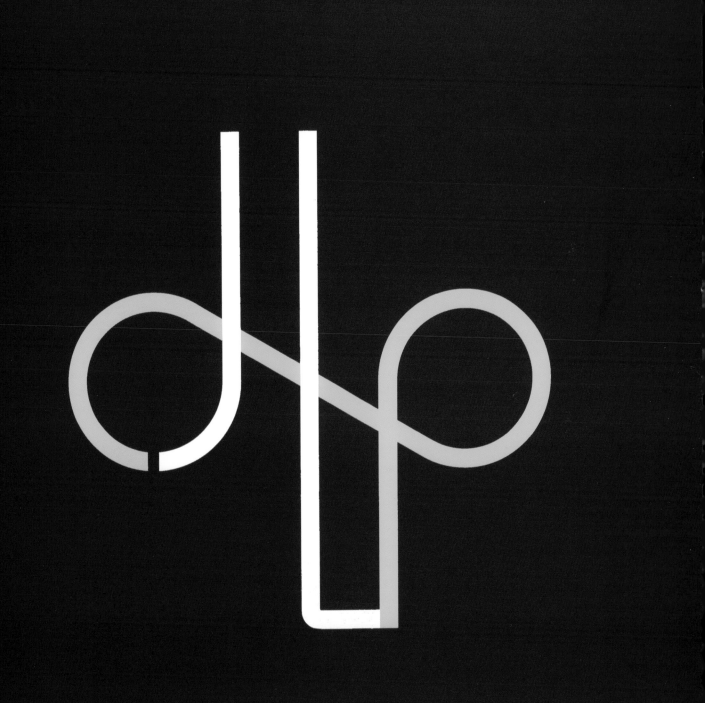

An introduction to ZERO – the adman

David Bernstein

I never met, let alone knew, Hans Schleger. This critique is based on his work, his writings and the comments of his contemporaries. Knowing Schleger only from his output allows me a certain freedom (for example to contribute my answer to the riddle of the name Zero) but also imposes a discipline, the sort I believe Schleger would have relished. Another discipline is that we are concerned here strictly with his work as an adman. We shall examine his philosophy, approach, craft and artistic skill.

Thinker

Hans Schleger was ahead of his time. This is clearly recognised today, for example, in his work in corporate identity. Less obvious, since the result is more ephemeral, is his modern approach to the role of advertising and the values he both professed and practised. If some of his work seems professional but unremarkable that is because we look at it through contemporary eyes. It is only when we rub them and realise that what we are seeing was executed up to sixty years ago that we fully appreciate the achievement.

Every ad was a new challenge. The solution grew out of the problem he was set. He always demanded a brief. This in a milieu where fashion ruled. Advertising is, even now, a notoriously fashion-led business. Style conquers content. A novel answer is soon echoed – to a question that wasn't asked. Fuelled by ad awards, unthinking imitation becomes the norm. 'God protect me from my disciples,' as one famous adman is alleged to have cried. 'Yesterday's idea,' said another, 'becomes today's technique becomes tomorrow's cliché.' But Schleger appreciated this dilemma at the outset of his career.

He was not interested in the past as a guide to the problem in hand. For that reason he refused to display posters on his walls. Gauguin said that art was either revolution or plagiarism. Plagiarism we feel familiar with. We recognise this as an ad because it looks like an ad. The revolutionary ad demands an act of imagination in the client, an act of faith.

The style of each of Schleger's ad campaigns differed. It was unique to the task. Fellow designers, however, and agencies were often chosen for a specific style. Indeed, they promoted themselves, overtly or not, on that premise.

Conversely, Schleger promoted himself on the basis of specific difference. Early in his career as a freelance designer in New York he produced a self-promoting ad which incorporated an ad for the client, Park & Tilford, beneath which he wrote:

For those who do not want to follow the crowd, but want the crowd to follow them advertising art of every type by ZERO *a freelance artist.*

Later, having gained a variety of client experience, he opened a studio and set out his stall. He expressed his philosophy in another ad for himself (p.132).

He listed four beliefs:

In exploring an untried world for those who dare…
This was daring in itself. Many must have been the potential clients deterred by the seeming danger of entrusting their brand to a rash venturer into the unknown. Yet, of course, the ad was a selective device. Only those whom Schleger was interested in working with would be attracted, challenged even, by that phrase. Others don't recognise risk as a concomitant of the new. Some don't even accept the need for invention.

in versatility of style and technique…
The British and (to a lesser extent) the Americans are suspicious of versatility. If a man can do many things he is impossible to classify. Moreover, he is assumed not to possess many talents, just one which he spreads thin. Jack of all trades and master of none. But specialisation diminishes the man. As the Spanish proverb has it, 'a man who is nothing but is not even'. Schleger was versatile not simply because he was naturally curious and creative, but because, as has been said, he believed that each problem was unique and demanded its own, exclusive solution.

in today's tendency towards new rhythms…
A distaste for nostalgia fitted the age. A modern, in-touch style fitted a modern product. Moreover, his ads appeared in topical magazines and newspapers. Brands, Schleger understood, echoed the spirit of the age.

in dramatising simplicity.
His fourth principle is perhaps the most difficult to execute. It gets to the heart of the advertising task. That task is to have an idea about the brand or product which will move the reader or viewer towards purchase. An idea which brings the benefit to life. The benefit which a product offers can always be simply stated. In the brief it inevitably is – so much so that the recipient, the creative team, is tempted to respond with a shrug. That's it? There may be little if anything new in the product or the promise. The task is easier, of course, when there is something new, when the brand represents a breakthrough. But Schleger, like the majority of those involved in creating ads, rarely worked on breakthroughs. Terylene was an exception, one which, as we see later, he fully exploited (p.169). He created his own breakthrough in the Stand Fast bottle. But mostly the task he was faced with was not of saying something new but the more difficult one of finding a new way of saying something.

Differentiation will rely on the manner rather than the matter. Schleger recognised this ahead of most. In a 1963 article, significantly entitled *Advertising – no place for amateurs*, he wrote, 'to help with the projection of a company's raison d'être is an absorbing occupation for, *as more and more products become similar,** this is often a question of good packaging, good service, greater hygiene and the serious thought given to the consumer's needs and to the economy.' Here he places advertising within the broader context of a coherent brand projection. For Schleger company and brand were one. The corporation could not hide behind, but had to stand behind, its brand.

* author's italics

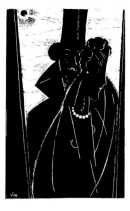

The simplicity, banality even, of the advertising brief was transmuted, imbued with force and vividness, the characteristics of the dramatic. Not that the essential simplicity is in any way complicated or hidden. What Schleger succeeds in doing is making us look at something familiar anew, finding new facets. See, for instance, how he invites us to re-examine the foundation garment, depicting what he calls 'the movable beauty of Charnaux' (p.146). Or how he relates man to nature with a striking Fisons' image (p.158). Yet the thought which inspires that ad is in itself hardly breathtaking. The image, however, is not only dramatic but entirely germane.

There is no dragging in of intriguing but unrelated artifacts, what is known as *borrowed interest*. Schleger in a telling phrase condemns this all too common practice: 'large areas of space showing illustrations of objects which the advertiser does not manufacture, but which he thought so much more interesting than his own product – with which it would seem he has become bored.' Schleger never gives the impression that he is bored by a product. He knows that every good ad surprises and, by the same token, that not all surprising ads are good. Relevant surprise is his watchword. Or, as a promotional piece he contributed to expresses it, 'Astonishment is the essence of advertising'. This was in 1926 for the Gotham Photo-Engraving Company.

Another promotional piece, another statement of philosophy. In the mid-1920s Schleger did some work for the Federal Advertising Agency of New York. The agency's selling point was the 'Federal Interrupting Idea.' An example is the Park & Tilford Candies campaign. One detects Schleger's hand in the copy. 'At no time is *cleverness* permitted to run away with itself.' Surprise, but not for its own sake. The candies advertisement is not an addendum but part of a total brand presentation. The cleverness is harnessed 'to the interrupting features of the merchandise – the chocolate coatings, the *surprise* centres, the package and the price. The campaign is designed to build a favourable impression of Park & Tilford's Candies through the sprightly conversation of ultra-smart people in whose doings *The White Box* invariably figures.'

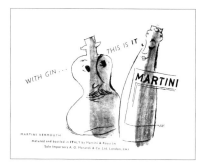

It would be the best part of twenty years before the concept of the 'brand image' popularised by David Ogilvy entered advertising. Ogilvy entreated the advertiser to 'give the brand a first class ticket for life'. This calls for meticulous attention to detail – the smallest infelicity can ruin the effect – and for perseverance. Schleger regarded 'advertising as a long-term investment'. He was a practitioner of 'relationship marketing' half a century before the term was invented. His ads for Fisons and Martini (pp.158 & 68) are examples of this belief. But even in his earlier days, when a struggle to establish himself might have tempted him to create off-the-page, one-off ads, he was determined to lay foundations rather than to erect facades. Nothing illustrates this as well as the work he did for Weber and Heilbroner (pp.118-125) unless it be the Richard Hudnut campaign (pp.137-9).

Just as a campaign is all of a piece, so are his philosophy and *modus operandi*. A one-off ad demands little more than a superficial technique. A campaign calls for homework and a full understanding of the brand. He hated glibness, the 'naiveté

and high polish' he saw elsewhere, technique masquerading as creativity and smart execution blinding the onlooker to the absence of an idea. He believed too in 'negating self-expression'. In a sense of course, all expression reflects self. But we know what he means: self-expression at the expense of the brand as opposed to self-expression on the advertiser's behalf.

Planner

'In advertising,' says Schleger, 'the designer is at last emerging as a planner.' (*Graphis*, 1957). 'A practical advertising man whose campaigns, broad and embracing, fined down in detail, evolve rationally from a balanced analysis of the job to be done' – the view of a colleague who worked with him during and after the war, Mary Gowing, a respected copywriter and advertising thinker. 'Hans related to women as both consumers and co-workers,' says his widow Pat. 'That's because he wasn't English,' she adds, only half jokingly. Gowing and Schleger were a team long before teams were the norm in advertising agencies.

Ashley Havinden, the gifted designer and creative director of the Crawford's agency, might write in 1933 that, 'the most significant thing which happened in advertising' in the years since 1920 'is that the work of the artist has become as important as that of the writer.' However, this did not mean that writers and artists worked together. In the 1950s the exceptional Gowing and Schleger combination wrote and designed an ad on behalf of the agency Mather and Crowther (subsequently Ogilvy and Mather). It is very illuminating. 'A good advertisement often starts at a planning meeting to which both contribute, the copywriter seeing in pictures and the artist hearing in words.' Very often the visual idea would originate with Gowing and the verbal with Schleger.

That was the case with the successful wartime recruiting campaign for the ATS. As Pat Schleger has written, 'the visual image played a secondary role to the planning, content and psychology of the approach.' It was Schleger who suggested the headline 'out of fashion' as a means of disrupting complacency and indifference, touching a nerve by showing that in unusual times the normal could be abnormal.

Schleger was not the usual stereotype of the instinctive, untidy, irrational quasi-genius. He was an artist-designer, his own term for someone responsible for design policy, whose toughest task was to 'sublimate himself' and 'channel all his powers into solving a problem'. He was the thinking man's creative – because for him deep thought preceded action.

The other way can work. Indeed, the role of the agency creative director is often to tell the volatile copywriter/art director team exactly what they've created and why it's good (or not), to detach the rational from the emotional. Schleger needed none of that. He built on a bedrock of belief – in the brief, which, if necessary, he would write himself, and in the nature of the task it demanded. Schleger's cerebral approach, though less rare today, is still uncommon. As Gowing wrote in 1957, 'Schleger's approach to advertising is an influence to be reckoned within our time. So long as it remains one of method, *as a way of thinking**, it will stimulate

the intelligent writer's

guide to advertising

QUESTIONS

1 Is there such a thing as a formula for a good advertisement?

2 Does sincerity matter in advertising? Does one have to believe in a product in order to write good copy about it?

3 Is it necessary for a copywriter to be a man (or a woman) of the world?

4 Is an 'original mind' an advantage in a copywriter?

5 Who is the copywriter's chief competitor?

6 Does copywriting provide a short-cut to a high salary?

7 Are literary qualifications necessary in a copywriter?

8 Where does a good advertisement start? With the copywriter or the art director?

9 Do women make good copywriters?

Mather & Crowther Limited

give you their answers

on page 77 **TURN OVER**

* author's italics

111

and invigorate. But to copy the externals is to miss the point, to understand Hans Schleger, look beneath the surface.'

Lazy thinking was anathema to him. Conversely, he appreciated views contrary to his own if sincerely held. Collision could produce ideas. 'He believes that a good campaign can only be produced through combined operations,' said Gowing. He was a team player. 'Advertising,' he wrote, 'which really includes packaging, exhibitions and other three-dimensional tasks, is a splendid field for the graphic designer, as long as both client and designer are prepared to surrender part of their sovereignty in mutual trust. People who stubbornly oppose one another may produce malformed offspring. Real advertising is based on team work and can give the designer great scope for dynamic visual expression.'

'When you work with him,' said Gowing, 'you find that he carries no "luggage", no private aesthetic preoccupation, no ready-made fireworks... He lets the facts develop the theme. He uses all his gifts to serve the end in view.' But, as the work shows, his preoccupation with facts in no way led to prosaic execution. Designer George Him wrote of his contemporary, 'in the case of Schleger, the rationaliser never managed to gain the upper hand over the creative artist: he merely provided a secure foundation over which the latter was free to soar.' An idea is what happens when imagination ignites the brief. He gets to the essence of the product and captures its poetic truth. 'The symbolic,' Schleger said, 'says more about the brand than the directly representational', just as poetry attempts to make meaning more meaningful.

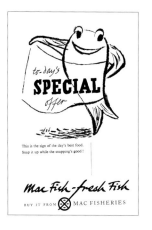

Schleger never merely decorated the text: he illuminated it. In some campaigns the design communicates the brand promise so powerfully that the role of text is to reinforce the visual message. The Mac Fisheries campaign shows his principles in action. The answer is arrived at only after submerging himself almost literally in fish. 'The very air of the studio seemed to smell of fish,' wrote a reporter. Engravings of fish of all sorts were pressed to a screen and sketches occupied tables and chairs. Real kippers too. Schleger described his approach: 'Mac Fisheries have an enormous number of branches, but I want to give each branch a personal note. So I am putting myself in the place of the fishmonger and I'm designing as if the fishmonger himself had quickly chalked up a notice on his blackboard.' And the approach, of course, leads to a distinctive solution, another of his principles. 'Every design problem', he said, 'differs from every other. Force it into a conventional, or favourable framework – or fit it into some convenient or aesthetically tempting shape – and the design will always suffer.' On another occasion he told an interviewer, 'I could not have created the Mac Fish if the character of Mac Fisheries' own shop people had not been personable, friendly and cheerful.'

Craftsman

The materials are words and pictures. For too many art directors and designers advertising copy is but a design element to be positioned conveniently, cropped if too long or untidy, reduced in size if in danger of predominating. Schleger worked differently. Words and pictures entered the stage together, affected each other symbiotically. One would take centre stage where appropriate.

Compare the ads for Hudnut (p.137) and John Tait and Partners, the one picture-led, the other copy-led. The visualisation of the John Tait ad acts as a curtain raiser to the important text. Schleger intrigues the reader by portraying a figure seemingly contradicting the headline. Yet how less impactful would the ad appear with a congruous feminine illustration. Contrast also the way type is treated in these two ads. Fitness for purpose – and to hell with Schleger style! Yes, the same man designed the Super Shell poster (p.72). Again, note the part played by type in the composition, the tension it creates, and the impression of speed. This campaign appeared on hoardings and in the press. For Shell Schleger developed ads announcing race successes which were inserted immediately after the event, with the text often set by the paper itself (p.142). He combines dynamism in the layout – by angles, lines, flat expanses, airbrushing etc – with essential information treated straightforwardly in serif type. These are essentially posters for press.

Schleger understood the media he worked with and the media the ad appeared in. He knew what newsprint would allow, what engraving could achieve. He was an artist because he first learned his craft, carried on learning it and enjoyed constantly experimenting. He would cut up photographs of sportsmen and reassemble them to produce a more dramatic effect. The result was the series of ads for AEI (p.154). The campaign ran in various sizes. Schleger did the layout and typography for all of them, rethinking the design problem each time. As a critic observed in 1952, 'adaptations are often the Cinderellas of press advertising – but not to Hans Schleger'.

In three words, almost as potent as 'less is more', Schleger defined his driving belief. 'Limitation produces form.' The line embraces both the necessity of discipline and its creative force. If the ad designer is denied space then he has to create it. Note the quantity of white space in the AEI ads. The Forsyth ads from the 1930s are a supreme example. The mixture of tones, the shafts of white space, the overlapping of elements combine to achieve breathing space in an otherwise claustrophobic environment. Deny the artist colour and he will conjure it from black and white (Forsyth again or AOA p.152). Deny him movement and he will make the static mobile with lines, angles and distortion (Shell, AEI).

One of the most difficult challenges Schleger faced was Shell's brief for an ad campaign on their re-formed petrol. The molecular structure was changed from long chains into compact groups. Schleger's answer (p.143) is unusual. Molecules of fishy creatures – a man strides one as if on a horse, in another a statuesque mermaid is joined by the hair to a merman carrying a flag – all these are linked in one chain which forms the main picture and it is contrasted with a long line of ordinary chain molecules. A whimsical solution? Certainly – surreal also – but it is relevant: a more involving interpretation of the facts than a mere restatement of chemical formulae, and it is true to the brand. It could not be mistaken for an Esso or any other gasoline ad. The idiosyncracy is not Schleger's but that of the brand. And note how it is branded – the name in the headline and baseline and the shell naturally forming part of the oceanic picture. There are over 250 words of copy but so arranged to facilitate reading (and reading in a desired order) and

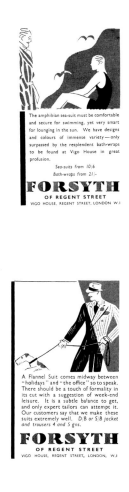

The amphibian sea-suit must be comfortable and secure for swimming, yet very smart for lounging in the sun. We have designs and colours of immense variety — only surpassed by the resplendent bath-wraps to be found at Vigo House in great profusion.

Sea-suits from 10/6
Bath-wraps from 21/-

FORSYTH
OF REGENT STREET
VIGO HOUSE, REGENT STREET, LONDON W.1

A Flannel Suit comes midway between "holidays" and "the office" so to speak. There should be a touch of formality in its cut with a suggestion of week-end leisure. It is a subtle balance to get, and only expert tailors can attempt it. Our customers say that we make these suits extremely well. *D/B or S/B jacket and trousers 4 and 5 gns.*

FORSYTH
OF REGENT STREET
VIGO HOUSE, REGENT STREET, LONDON, W.1

text is highlighted so that the essential message is absorbed simply by reading the captions, headline and baseline. This is craft of a high order.

Schleger relished the challenge of seemingly unfriendly spaces. A single full length newspaper column is surely inappropriate for a man's store to show off its merchandise. The campaign for Brokaw Brothers (p.134) breaks the shackles of this restrictive format. The headline throws down the gauntlet: 'About with Brokaw'. A flowing line of male figures or a sequence of the same one are indeed out of the frame and 'about'! Note too how Schleger echoes the visual in the treatment of the text. The sentences are actually very long but by breaking them up and introducing cap initials, like poetry, he seduces the reader. 'About with Brokaw' became an item in a newspaper, an ad providing information in an entertaining way and contributing to the totality of the paper's offering as opposed to interfering with it.

The shape of another ad for a man's outfitter, Forsyth of Regent Street, is more conventional. The treatment, as we have seen, is not. These are small spaces which Schleger chooses not to fill. Perverse? Not at all. In broadcast media the surest way to make a fifteen second commercial sound like ten is to crowd it with audio copy. To do the equivalent in the press for Forsyth might suggest tight-fitting clothes. The campaign is coherent, recognisably Forsyth. The contrast in the design is a true echo of the message of the text — sea-suit talks to bath-wrap; a flannel suit is both 'holidays' (out with the dog) and 'office'; the vertical change of tone suggests a range of colours for jacket and trousers.

Schleger combined more than just tones. He combined images. If a cockerel says early morning and a skyscraper says New York, then Schleger will combine them for AOA to stunning effect. A brilliant issue from the mating of two clichés. See also the face of Liberty and the sun. Indeed, the whole campaign consists of the familiar afresh. Images collide. Fusion was what the major poster artists of the period achieved. Fusion initially of image and text. See, for example, Schleger's work for the GPO (p.48). Perhaps more arresting is his surreal 1937 poster for the Ministry of Transport exhibition (p.40). What must the brief have been? 'Design a poster that encourages the public to use their eyes and ears when crossing the road and to teach their children to do likewise.' Schleger's design got to the point without being patronising.

Integration is beautifully achieved in the Martini 'with gin this is it' design, which appeared as both a press ad and a poster. This happens to be my personal favourite from among his entire œuvre (p.68). It is deceptively simple. The proposition is that Martini is the genuine Italian vermouth for the drink known as gin and Italian. The copy line reduces the thought to five words. The visual combines bottle and glass angled to form a 'V'. Schleger's knack of getting to the essence of the brand promise in the visual not only enabled some of his ads to become posters (e.g. Charnaux, p.146) but guaranteed that the look of the brand communication throughout all its manifestations had a coherence.

This is evident very early on in the seminal work for Weber and Heilbroner. The

brand is the branding. The original trademark is omnipresent but never tediously so. 'It consists (said a contemporary *Gebrauchsgraphik* article) of three male figures, very much conventionalised, which reappear in each advertisement in ever-varying forms. The fact that the trademark admits of so many versions has proved to be a tremendous advantage as opposed to the rigid trademark which is incapable of any variation.' Again, note how ahead of his time he is. Trademarks in America were conventionally static sign-offs, however, in Europe they were often characters (e.g. Michelin, Lampo, Dubonnet). As such they could live in the ads. Schleger decided to create a logo and then make it a character. Pat Schleger wonders whether the idea of animation owes its origin to his formative years in the film business. 'Zero's work,' the article concludes, 'is the best proof of the fact that absolutely binding laws for the graphic presentation of advertising ideas do not exist. It is always a question of creating them anew with real ability and in a new and original form.'

One might add that a complete understanding of the medium in which they appear – the reading experience and the potential of engraving and newsprint – is also evident. 'His drawings for ads,' says Pat Schleger, 'always made the most of the available shape.' By using fine line, rough litho-graphic crayon or coarse half-tones, he exploited the techniques suited to cheap newsprint and created strong abstract patterns combining movement, mystery or humour.

A character with even more versatility is, of course, the Mac Fish. The total campaign (brochures, packaging, signage, mailings etc) is treated elsewhere. But in the confines of newspaper ads the fertility of invention is staggering. The fish character is sometimes the product, sometimes the fisherman or the cook or the chef or the retailer. But always the brand. The impetus for the campaign, as we saw, is the fishmonger. Hence the lettering style and, of course, the simple, clean, short messages: 'Mac Fish – fresh fish', 'Top Shop for Fish', 'Good Food. Good Value' and 'Such Lobster'. The lettering, incidentally, is clearly from the same pen as the illustrations. One illustration was utilised by the *Punch* cartoonist Norman Mansbridge in 1959 (p.188). When campaigns get into the public domain they generate publicity, which is a form of advertising the advertiser can't control but also doesn't have to pay for.

Artist

One cannot and should not divorce Schleger's artistry from its commercial purpose. As Paul Rand writes, 'He was as versed in the art of selling as he was in the art of Art.' One admires the art and the way he uses it to achieve his commercial ends. Mary Gowing is right, 'look beneath the surface'. Superficially a Schleger ad seems all too simple but when you examine it you realise there is a reason why the elements are exactly where they are. Look at *Hands at your service* (p.62) for London Transport. How expressive those hands are – one, holding a ticket, points a direction whilst the other holds the punch. The lines and the circular motif lead the eye to the copy and the caption and we realise that 'hands' also refers to the LT staff.

Observe the economy in what is merely a sketch for Martini. The message of the

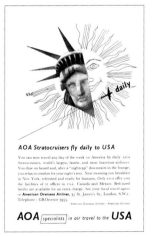

AOA Stratocruisers fly daily to USA

You can now travel any day of the week to America by daily AOA Stratocruisers, world's largest, fastest, and most luxurious airliners. You dine on board and, after a "nightcap" downstairs in the lounge, you relax in comfort for your night's rest. Next morning you breakfast in New York, refreshed and ready for business. Only AOA offer you the facilities of 37 offices in USA, Canada and Mexico. Bed-sized berths are available for an extra charge. See your local travel agent or *American Overseas Airlines*, 35 St. James's St., London, S.W.1. Telephone: GROsvenor 3955.

American Overseas Airlines · American Airlines

AOA specialists *in air travel to the* **USA**

ad is immediate but give it a second glance and you notice the central thrust of the four circles – the sunny face, the glass with the cherry and its base, serving another purpose as the bottom of the bottle, which goes off at an angle and from which the label detaches itself and points to the artist's name. Notice, finally, the way 'IT' is echoed. In another ad in the same series a gin bottle is chatting up a Martini bottle. (Observe the angle again.) They are meant for each other. We use these words. The ad doesn't. We take the message from the design. Schleger is a master of composition. Remove one element or transfer it elsewhere, put the text in a different typeface or place and the effect is diminished. The poetry has turned to prose.

Paul Reilly called him 'the master of the simple statement'. This art of arriving at a simple answer led one critic to declare that 'he seems to have a quite extraordinary capacity for letting problems evolve their own solutions'. Reilly has no time for that. 'Solutions do not evolve on their own. They are arrived at only after a proper process of analysis and synthesis. The fact that these labours are not visible in the final result is the measure of Schleger's mastery of his job and of himself.'

And each job, as all commentators including this one have pointed out, is a new beginning, starting, as a commentator observed, from zero. Schleger's ads are each a direct but unique response to the brief. They are each true to the brand. Each is consonant with the brand personality, which in some cases he himself created. Coherence is all – the ad is not an isolated artifact but part of a campaign, not only of ads but also of a total brand communication.

Schleger was honest – true to his beliefs. His approach had a purity, a single-mindedness. The craft is in effect a fusion of crafts, his own (which were many) and those of others, alongside the ability to combine elements into a salient whole. Wholeness is the word for this art. I suspect that his clients got more than they expected or bargained for. I should imagine the word 'piecemeal' was not in his vocabulary. The piece was part of a bigger whole. And it was the whole picture – the totality of the brand – which attracted and excited Zero the adman. These words – honesty, purity, fusion, wholeness – can be subsumed by another, integrity. If you refer to *Chambers Dictionary*, there is an intriguing entry, 'INTEGER: [a]… whole … any whole number, or zero'.

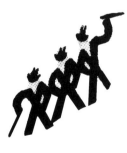

3

ADVERTISING

Weber and Heilbroner
New York 1925-9

Trademark for one of Weber and Heilbroner's brand names

An Hour with Silas Spitzer

Silas Spitzer, the advertising manager of the clothing and haberdashery chain store Weber and Heilbroner, of New York, was the first to replace the usual realistic American advertising by more modern methods. His success brought about the development of an entirely new movement in American advertising. It was he who, with surety of instinct, perceived that Hans Schleger (Zero) was the artist whose intentions were most in accordance with his own.

Schleger started by designing the now famous *Fabric Group,* a trademark composed of three men which in many graphic and photographic variations was used as the fundamental motif for Weber and Heilbroner. Spitzer visited Berlin last autumn, met Schleger and the editor and the following conversation took place:

Editor: As far as I am aware, you were the first to carry out modern advertising in the artistic sense of the term in America and apparently you had great success with it... would you tell us what induced you to resort to such measures, when other American advertising is so very conservative?

Spitzer: Don't talk about modern advertising. Modern means what is modish, something which everybody does and everybody tries to imitate. The result is mostly things that are meaningless imitations.

Editor: You are certainly right. Nevertheless in advertising there are movements which to a certain extent carry everything before them, the influence of which is everywhere perceptible.

Spitzer: It is futile to lay down rigid rules for advertising practice. Advertising is as fluid as life, changes as life changes, is born, flourishes, dies and is renewed again in other forms. The successful theory of today reflects the tempo of today. When the tempo of life changes, good advertising keeps step. The best advertising of today is really good commercial journalism. An advertisement must, first of all, be news. To obtain an audience, it must be lively, spontaneous, dramatic. Today, the advertising sections of American magazines are more interesting than the editorial features. One reads copy that is compact and brilliant, in a style as vivid as Joyce and as muscular as Hemingway. Illustrations are no longer confined by the old-fashioned rule which dogmatically stated 'Show the product'. I have advertised men's clothing by showing an abstract dynamic photograph of the funnels of a steamship, and have helped to sell many thousands of shirts by using wash drawings of peasant folk dances in foreign lands.

It is evident that modern advertising requires more of the genuine creative gift than in the past. In my opinion, the best advertising is usually the work of one mind, or of two or three, working in harmony.

The story of how Spitzer and Schleger came together is an amusing one. Very original drawings by Schleger for a firm of furriers had already appeared. Thereupon Spitzer went to Schleger and said to him, 'Can you draw me an elephant for five dollars?' Schleger replied, 'No, I can't draw anything for five dollars, not even an elephant.' The conversation continued from this point, indeed one might almost say this was the snowball which launched an avalanche of advertising development.

from an article in Gebrauchsgraphik, 1930,
translated by E.T.Scheffauer

Trademark
Weber and Heilbroner
c1925

"Can I give you an aspirin, or something?"

"No, but you might give me a hint or two about what you'd like for Christmas."

"Well, I can tell you what I *wouldn't* like."

"Shoot."

"I wouldn't care for genuine Havana cigars smuggled in by mysterious Latins."

"Check!"

"I never use scent or seal rings, and I break every wrist watch thirteen days after installation. My old golf clubs are in perfectly good shape and I loathe self-coloring meerschaum pipes."

"Well, for goodness sake—what *do* you like?"

"If you really want to know, go to the nearest Weber and Heilbroner store, put yourself in the hands of an intelligent clerk, and let him do the rest."

For example . . . Manhattan Shirts (protected by the 9 Little Watchmen) . . . imported wool half-hose . . . sweaters and golf hose in matching designs . . . lustrous silk pajamas at the special price of $8.95 . . . and many, many other things which he'll wear and treasure.

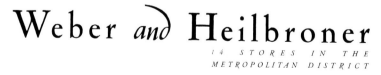

Weber *and* Heilbroner

14 STORES IN THE METROPOLITAN DISTRICT

*Illustrations from
advertisements
'Plain or Fancy' was a range
of silk socks for men
Weber and Heilbroner
New York 1925-9*

PLAIN OR FANCY

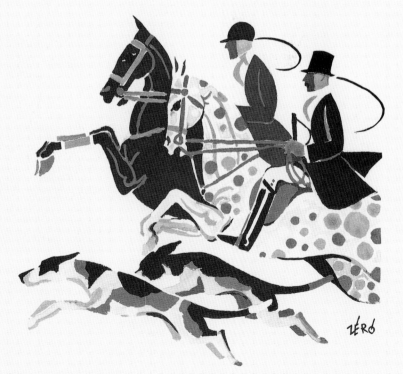

Hans Schleger chats about New York

Almost every man sees New York from his own special viewpoint and at first one might think it was a city without character, a mere conglomerate of folks of all nations, each keeping to itself and making itself painfully understood to the others in Italianised English, Yiddish, Pennsylvania Dutch, 'pidgin English' or some other concoction.

However, this is not the case. New York has a definite character of its own. It is magnificently unique. Let us imagine an early morning in summer – endless crowds of humanity pour into the centre of town from Long Island, Brooklyn, Westchester and all the other suburbs – all headed for the Isle of Manhattan.

Won't you sit down for a moment among the crowd crossing from Staten Island with the ferry? You will like it, and you, as a German, will be apt to meet a good many of your countrymen. The crossing takes about twenty-five minutes and costs five cents. Inspired by such prices, the ferry glides like a flat rye bread loaf run wild over the waves. Amidships stand two rows of motor cars. Along the sides and up above sit the passengers. Their hands hold newspapers, their legs are in the possession of energetic Italians who are hastily shining their boots.

Only a few people stand up and watch for the city to *loom up* on the horizon. Suddenly, artificial, and always improbable the town appears floating on the waters. The sun plays on the topmost towers of the skyscrapers and endless rows of windows blaze like fire. The mighty canyon of Broadway divides the shining Colossus with a blue stripe of air, as the ferry turns its broad, oval nose. New York turns and preens itself before us like a vain woman.

It seems to me as if all the passengers, on the way to their work, have a rendez-vous with the city. New York is like a woman: forgetful, complicated and hard to please for the one – simple motherly and child-like with another. She makes one famous or poor, sad or merry – according to her mood. She gives herself or denies herself – a creature of urges, care-free – many-sided but always herself. Today she celebrates and loves someone whom tomorrow she will have forgotten, even his name. The men on the ferry would ruin themselves to gain her recognition, to earn her smile. She is sovereign and exclusive – divided as she is by water from the whole gigantic continent behind her, she lets herself be courted anew every day. Her suitors are the men from Brooklyn, Staten Island and Westchester. Some are stormy lovers, some patient, masterful or half-resigned. Sometimes it is only habit that makes them carry on. But they are all of them always in the pink, never confessing to being tired or sick. Punctual, well dressed, they travel towards the city. Willing to purchase all the things that keep one young, good looking – and in the running.

Here is our field of work, this very town, these very passengers, newspaper in hand. Perhaps it is the 'Times', perhaps it contains an advertisement of Weber and Heilbroner's. Perhaps one of mine. People see it (let us hope) and read it. They are already in the streets, which look quite different now that one has

The three men trademark was a recurring theme throughout much of the company's advertising.

Weber *and* Heilbroner

landed. Mr Miller, iron agent from Richmond, hurries to his allotted station in the great ant hill, the office on the 24th floor of the French Building. It is nine o'clock and work is beginning. Not for me, for I am just getting up. Mostly, anyhow. And at one o'clock I sometimes have an appointment to lunch with the advertising manager of the firm in question. Later on in my studio we discuss the advertisements to come, perhaps I do a couple of sketches on the spot. And the best of it is that — when the heads of the firm get a look at the originals — they often call up and say they like them.

It seems to be a secret faculty of the American that he recognises and encourages the best possibilities of the various artists. He possesses enough psychology to encourage and develop them by every means in his power. He does it with friendly words — sometimes he scolds — but above all with honest acknowledgement of what has been accomplished — if anything. This finds expression in the care with which he looks after the printing. There is no haggling over the cost of clichés*, typography and so on, for most of the firms have their printing done privately. The advertising manager writes the text of the advertisements, sometimes we work out the ideas together (as in the Fabric Group, for instance) sometimes he orders a drawing and writes the text subsequently. The inner nature of this kind or advertising — as indeed of every American advertising campaign which can be taken seriously — is the long-sightedness, the despising of momentary success which could easily be achieved by means of attacks upon competitors, sensational drops in prices or other catch-penny tricks.

This same principle is also very noticeable in the advertising agencies. They do not seek to grab a lot of money from a client in order to earn their percentages, but want to see the business maintain a steady growth. I like this idea for I believe it works better all around.

from an article in Gebrauchsgraphik, 1930, translated by E.T. Scheffauer

* A cliché is a metal cast used for printing.

*Full page newspaper advertisements
and a symbol for Weber and Heilbroner's
'Town Series' suits
New York 1925-9*

*Photo of a New York street where
a new store for Weber and Heilbroner
was about to open 1925*

WE REMEMBER THE TIME ✦ ✦ AND IT'S NOT SO
FAR BACK EITHER ✦ ✦ WHEN BEING WELL-DRESSED WAS JUST A LITTLE
BIT painful. The smartly turned out New Yorker of the five-o'clock cocktail era was as stiff as

starch and rigid as a ramrod. Nowadays, things have changed. Today the well-dressed man can sit five hours in the rumble seat of a roadster and climb out looking just as fit as when he started. Pliant worsteds, clever hand-tailoring and a healthy modern viewpoint are responsible. And yet, while good clothes have become easier to wear, the New Yorker's standard of correctness is just as stern as ever. TOWN SERIES suits are modelled after his tastes ✦ ✦ they accurately reflect, in every detail of color, modelling and cut, the townsman's intimate and characteristic preferences. TOWN SERIES suits may be compared with the finest custom productions ✦ ✦ they are expertly tailored, lined with silk throughout. $53, $65, $75.

Weber *and* Heilbroner

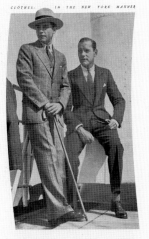

CLOTHES · · IN THE NEW YORK MANNER

«TOWN SERIES SUITS»
ARE NOT SELF-CONSCIOUSLY "SMART".
THEY have the quiet assurance of good taste. The correct notion of styling in New York is essentially conservative and Town Series suits speak in the moderate and cultivated tone which typifies the representative New York man. The selection of colorings and patterns is extremely broad. Brown and grey shades in selected British and American woolens are prominent. Tailoring is the finest type of hand-craft-manship and each suit is luxuriously lined with silk. The "Broad Street" is a two-button model with the modified rope shoulder usually found only in the best custom-tailored suits. $55, $65, $75.

Weber *and* Heilbroner
14 STORES IN METROPOLITAN AREA

slip into a BRADLEY

....and prove your kinship to the hawk that swoops through the air and the seal that glides through the sea! Bradley-Knit Bathing Suits are made for *swimmers*...they fit every contour of the body...their patterns are bright but not circus-bright...they're here in our fourteen stores..."in the New York manner". *Bradley-Knit Bathing Suits, $5 to $7.50.*

Weber *and* Heilbroner

Advertisements
'Advertising and Selling Fortnightly'
New York 1924

Illustration for an advertisment
Gunter Furriers
New York 1925

— in other words,
the Fortnightly has moved
its New York offices to
9 East 38ᵗʰ Street

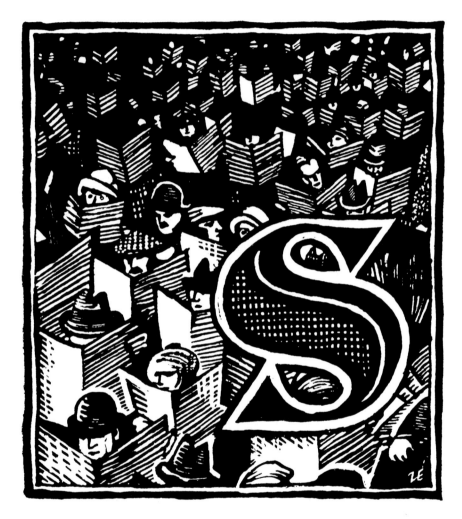

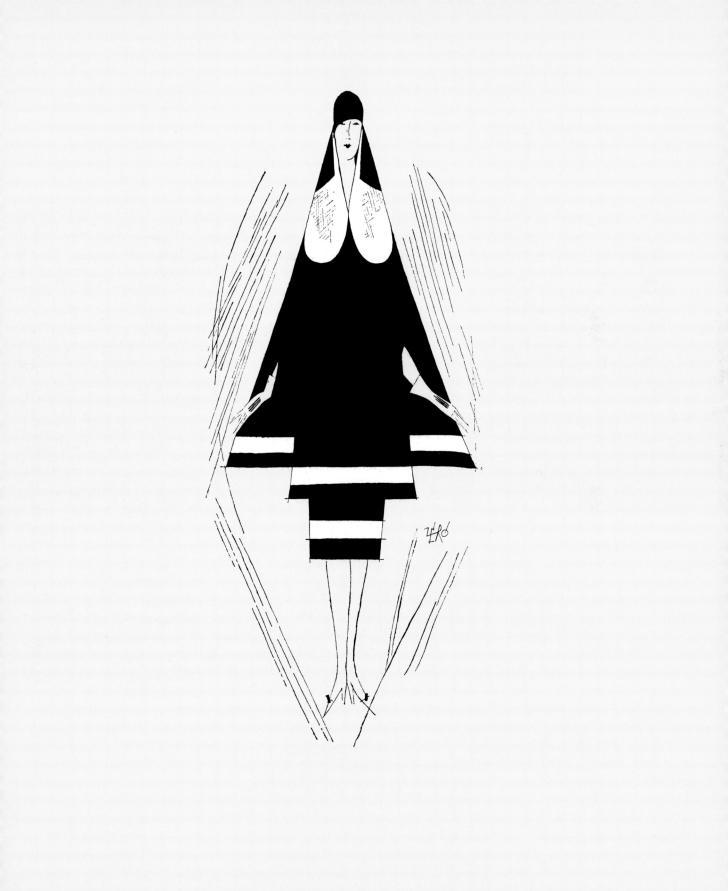

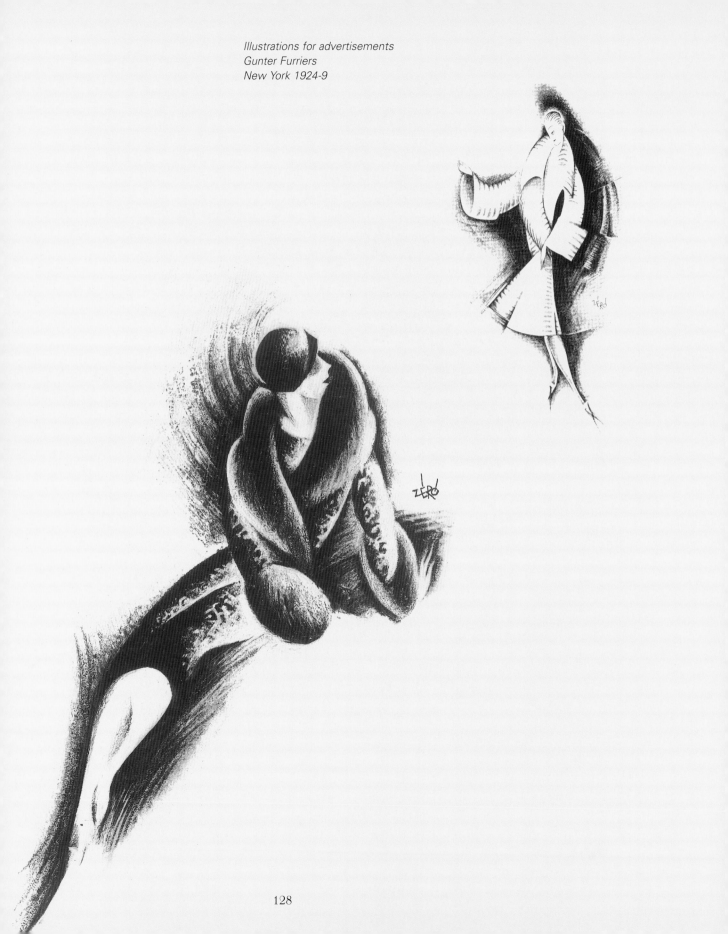

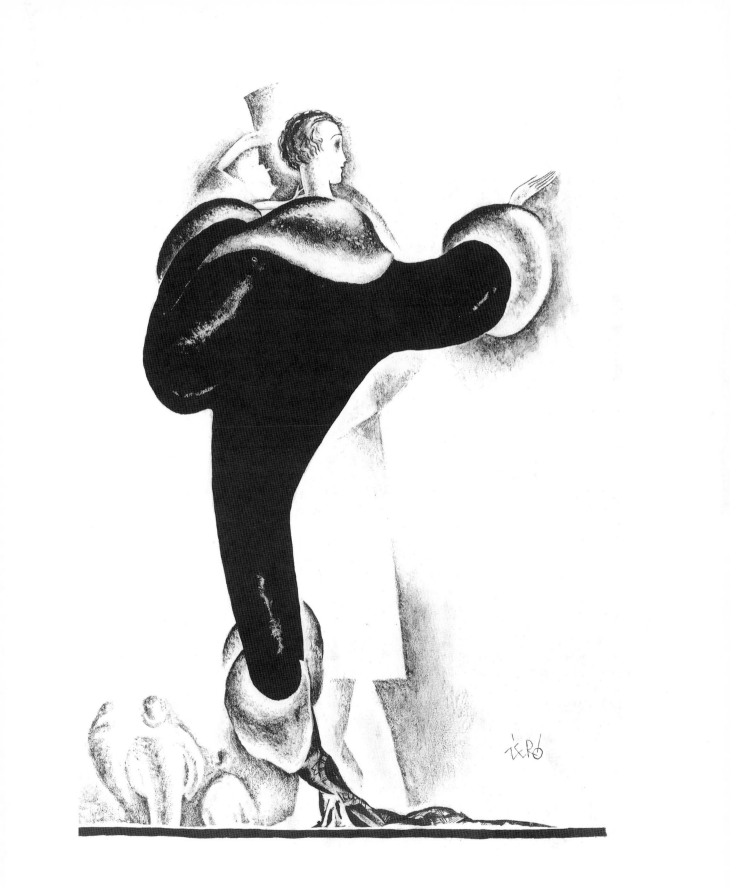

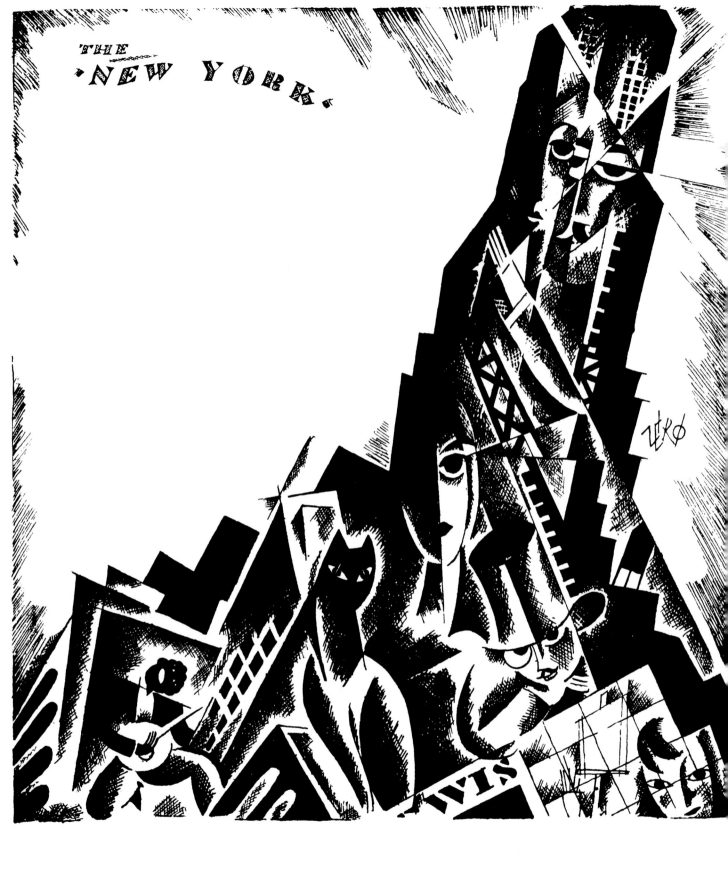

Illustration for an advertisement
for a woman's shoe called 'The New York'
Ben Lewis
New York c1927
The 'hole' in the middle of this ad housed
a very boring rendering of the shoes which
Schleger blotted out.

Illustration for an advertisement
Empire State Engraving Company
New York 1924-9

"Paris" by ZÉRO

Advertisements by Zero for Zero
New York c1925
Schleger reused drawings he had done for clients. The one below was originally for Park & Tilford, now advertising Strathmore papers and himself simultaneously. The other had been used for Gunter Furriers.

Illustrations for advertisements
'The Talk of the Town' – White Box candy
Park & Tilford
New York c1926

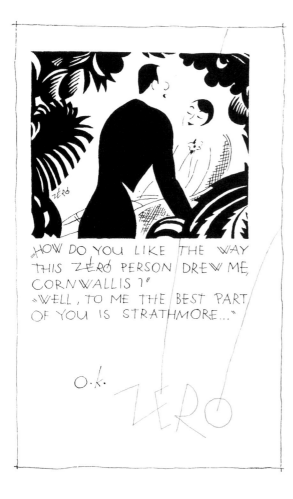

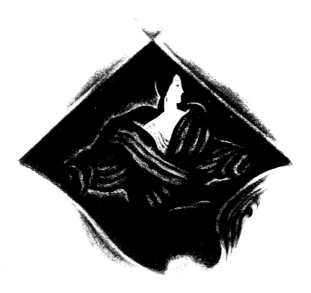

I B E L I E V E

In exploring an untried world *for those who dare*

In versatility of style and technique

In today's tendency towards new rhythms

In dramatizing simplicity

After working for a limited group:

Belding's	Brokaw Brothers	Park & Tilford
Dunhill's	Gunther's	Continental Tobacco Co.

and others here and abroad

I have opened a studio at 270 Madison Avenue

Caledonia 7315

DRAWINGS PICTORIAL CAMPAIGN KEYNOTES VISUALIZATION

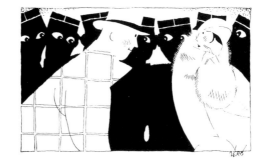

HE The train was a bit late. How long
have you been waiting, dear?

SHE Almost the top layer of *The White
Box,* I should say!

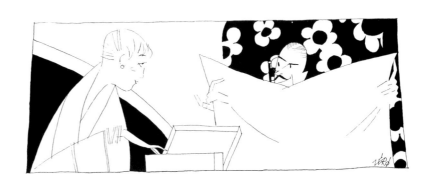

HE Actually, you know, *The White Box*
is the talk of the town!

SHE (delving into the bottom layer)
Well ... it keeps me too *busy* to talk!

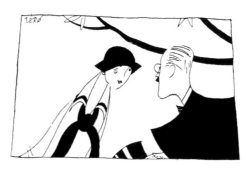

HE (hopefully) How often am I to be
permitted to see you?

SHE Just as often as you bring me
The White Box!

HE What did you consider
the best part of the show?

SHE The intermission, when you brought in
that wonderful candy – *The White Box!*

about
with
BROKAW

*Advertisements and illustrations
single column, broadsheet newspaper
Brokaw Brothers
New York 1924-9*

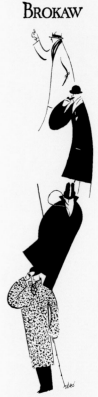

about
with
BROKAW

I F you like walking—

You can get plenty of it in your Christmas shopping tours.

* * *

But if you are really interested in finding a gift

That will rouse the most phlegmatic, finicky male to a hitherto unattained display of enthusiasm—

Then you don't need to do any shopping—

Just go straight to Brokaw.

* * *

We've gone shopping all over the world

So that you wouldn't have to do any.

* * *

And we've collected the most distinguished assortment of handsome gifts

That ever tempted this advertising department to hurl tradition out of the window

And burst forth into purple superlatives.

THE young man about town

Seeking a double-breasted, wide-shouldered suit

Like the one he noticed at Princeton last week

Will do well to head for Recent Row

Where well dressed young college men always find the styles they prefer.

Also * * *

The elderly banker

Whose wife

Has often remarked of late

That he really should go on a reducing diet

Will find it much simpler to drop in at Recent Row

And select a suit from the many becoming models

Which have been particularly designed

For a portly figure.

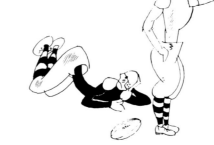

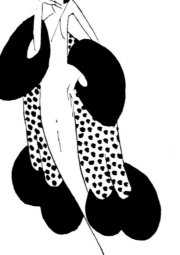

BROKAW
BROTHERS

BROKAW
BROTHERS

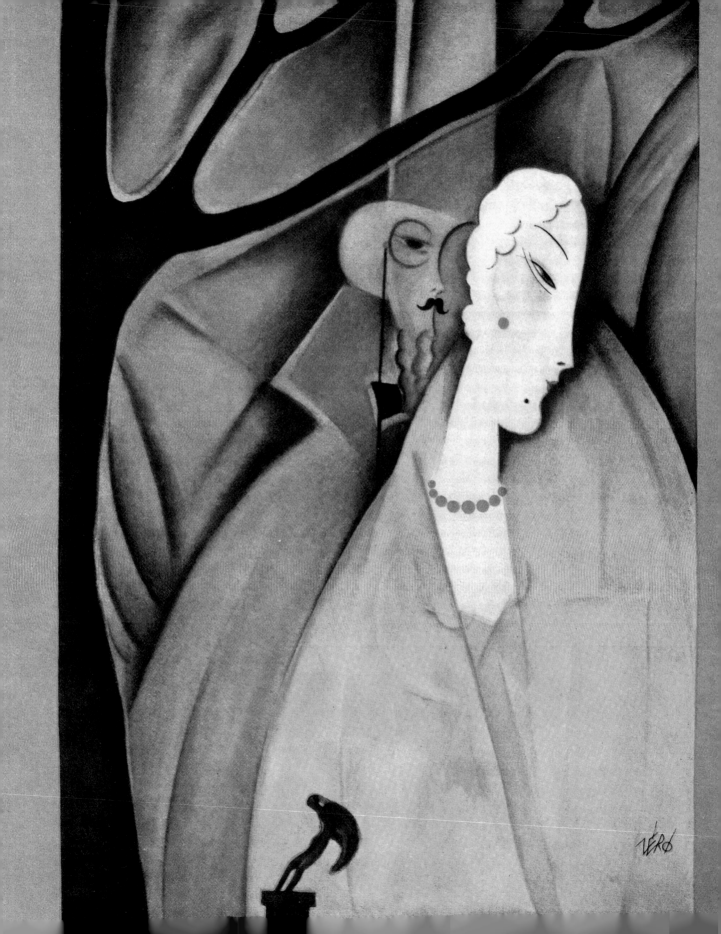

**Richard Hudnut AG
Berlin 1929-33**

Schleger created these advertisements for the American cosmetic company Hudnut, while working in Berlin for the English advertising agency Crawford's. There were grave doubts whether any printer would be able to reproduce the illustrations sufficiently well for mass reproduction in magazines. Schleger was also doubtful they would retain the subtlety of tone which was a vital part of their appeal.

The publicity material accompanying the launch of the campaign made much of the challenge which these illustrations had posed for the platemaker. Crawford's offered the printing firm Walter Greutzmacher the task of production... Several tests were done...the intensity of the planned advertisement depended on great patience to achieve no loss of detail...the atmosphere, created by Zero, emanates out of the print with undiminished subtlety...millimetre on millimetre without disharmony, thus were plates made that are unique...the printing achieved the unachievable.

Professor Frenzel, the founding editor of *Gebrauchsgraphik*, wrote of the Hudnut campaign, 'Youth is something we would all like to possess, beauty is something which we all covet. Youth can at best be conserved, but beauty is something which can always be created at any age. The strong appeal of these advertisements is the desire for beauty, not the unconscious beauty of youth, but the beauty of the ripe and perfect woman. In the Schleger advertisements we have two ideals of beauty – the experienced woman who is in love because she is experienced, and the other woman who has become experienced because she is in love.

The atmospheric quality of the pictures have an immediate appeal and cut out the mental effort needed for reading text. Rarely indeed does any text succeed in creating the atmosphere of delicate erotic tension that emanates from these designs. The sensation of a delicious perfume is much more readily conveyed by the flower in the lady's hand than by the aspect of a bottle of perfume. These designs convey (by their originality) the best advertisements for perfume which have been seen for many years.'

from an article in Gebrauchsgraphik, 1930,
translated by E.T. Scheffauer

Cover for a folder about the campaign

◁
Illustration
Client unknown
New York 1924-9

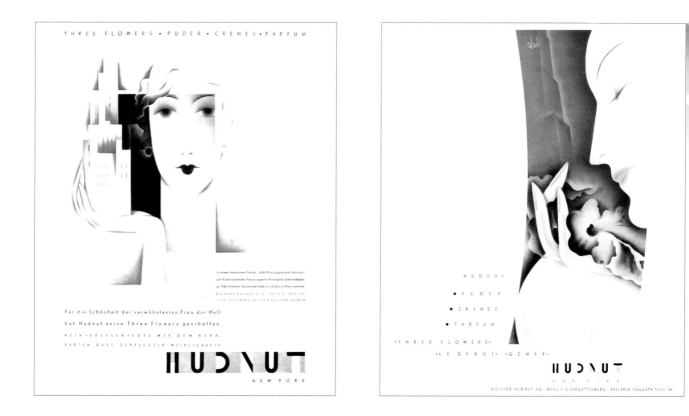

HUDNUT

● PUDER

● CREMES

● PARFUM

THREE FLOWERS · LE DÉBU°T · GEMEY

NICHT NUR BEWUNDERN sollten Sie die Meisterschaft, mit der die Amerikanerin die Schönheit ihres Teints pflegt und betont! HUDNUT präparate – seit 50 Jahren bevorzugt von der anspruchsvollsten Frau der Welt – stehen auch zu Ihrer Verfügung: Ihr Friseur und jede gute Parfümerie führt HUDNUT. Rein, erlesen, edel, mit dem herb-zarten Duft gepflegter Weiblichkeit.

HUDNUT

NEW YORK

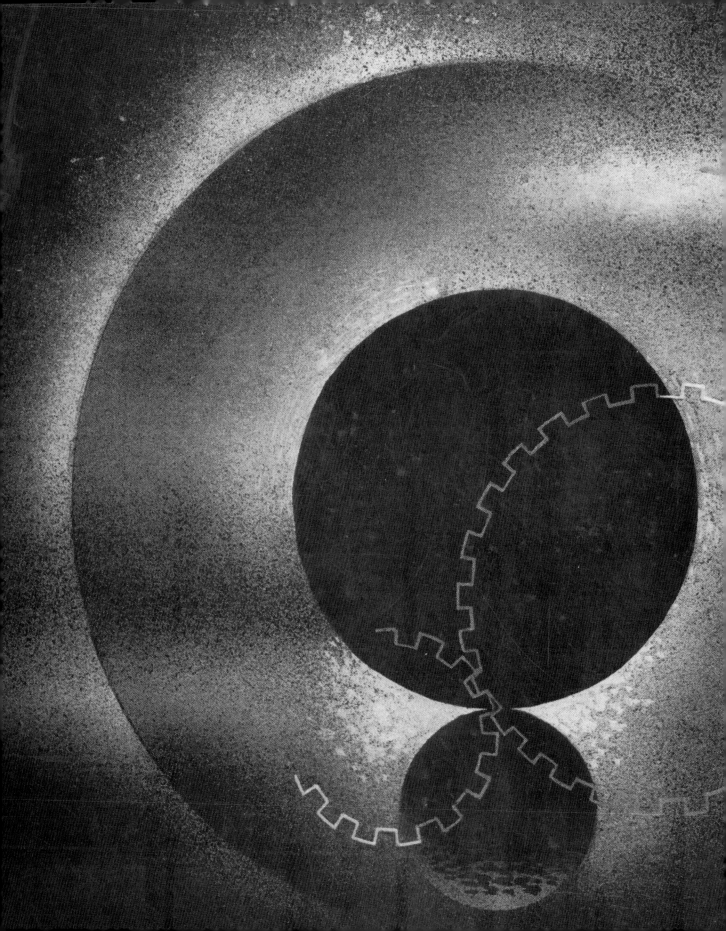

London from 1933

Spiral-bound booklet explaining
the lubrication of the self-changing gear.
Detail from cover and two inside spreads
Shell-Mex & BP Limited
1934

ALES, HURRICANES, TYPHOONS, WATERFALLS, tides, Atlantic rollers, geysers and volcanoes. Forest trees are flung down. Cliffs are undercut and fall into the sea. Volcanic explosions spout dust and stones miles into the air. These forces run to waste. Engineers have contrived methods of disciplining such forces and using them to drive machines. The link between these forces and the machine is the lever. The sails of a windmill and the paddles of a water-wheel and the crank of a steam engine are levers. Only by levers can natural forces—like the power of expanding steam or exploding petrol vapour—be made to drive machines. The simplest kind of lever is a crow-bar. It is a bar pivoted nearer one end than the other. By pressing down the end of the long arm you can raise a weight on the end of the short arm, which you could not lift by yourself. And the longer the part of the lever you are pressing on, and

7

held fast. Otherwise it runs quite free. On the next page are six photographs of the partly assembled gear. The first (1) shows the brake band with its lining. It is tightened by drawing together the two claws on the right. Next (2) you see it assembled in position. The complicated arrangement on the right is the tightening mechanism which we shall come to presently. Next (3) another view of the same thing to show how the brake bands are fitted side by side. Next (4) one of the gear groups to be encircled. The ring joining the three planets takes the place of the forked bar we considered in the diagram and is connected to the annulus of the group next to it. A set like this—one for each gear—is contained in each brake band. And finally, two views (5 and 6) of the gear box with the sets of cogs in place, one behind the other. The change is worked by a pointer on a quadrant. The

32

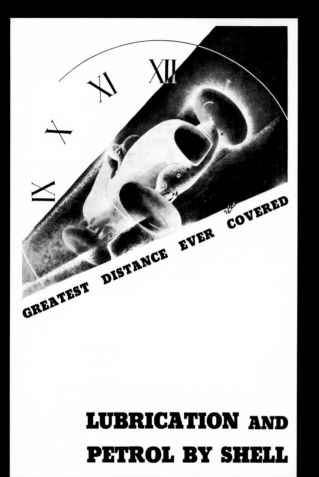

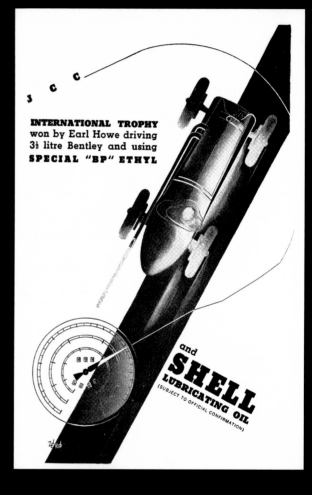

Advertisements
Shell-Mex & BP Limited
1937-8
With great imagination and ingenuity,
Zero used surrealism as his point of
departure to express the complexities
of chemical reaction in a dramatic
pictorial way. Ashley Havinden

IN LONG CHAINS ORDINARY PETROL MOLECULES *burn too quickly*

Why Shell has been RE-FORMED

In the old days the thing was to get a petrol which would burn *or explode* as quickly as possible. This was all right until engineers found that the way to get more power from a given engine was to increase its compression ratio. They then found that this increased cylinder pressure caused ordinary petrol to explode too quickly. This detonation or *pinking* resulted in loss of power and an over-heated engine.

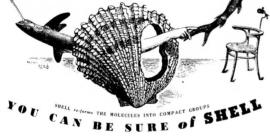

The problem, then, was to produce a petrol which had a rate of burning suited to the modern engine. SHELL has solved the problem *by changing its molecular structure*. This is done by a process called *re-forming*. *Re-forming* takes the atoms of carbon and hydrogen, which are present in all motor spirit, and puts them together in compact groupings instead of in long chains as they are in ordinary petrol ✶ In this condensed formation they combine regularly and evenly *instead of spasmodically* with the oxygen supplied by the air from the carburettor; thus combustion is controlled and *pinking* prevented ✶ In this way SHELL offers you the advantages of a pure petrol in a form suited to the modern engine.

SHELL *re-forms* THE MOLECULES INTO COMPACT GROUPS

YOU CAN BE SURE of SHELL

IN LONG CHAINS ORDINARY PETROL MOLECULES BURN TOO QUICKLY

Why Shell has been RE-FORMED

In the old days the thing was to get a petrol which would burn *or explode* as quickly as possible. This was all right until engineers found that the way to get more power from a given engine was to increase the compression ratio. This increased cylinder pressure caused ordinary petrol to explode too soon. This detonation or *pinking* caused loss of power and over-heating.

SHELL *looking ahead* RE-FORMS THE MOLECULES INTO COMPACT GROUPS

By a process called re-forming, Shell changed the molecular structure of petrol. RE-FORMING puts together the atoms of carbon and hydrogen present in all motor spirit in compact groupings instead of long chains. Thus condensed they combine evenly instead of spasmodically with the oxygen supplied by the air from the carburettor. Combustion is controlled and pinking prevented. In this way Shell offers you a pure petrol best suited to the modern engine.

YOU CAN BE SURE of SHELL

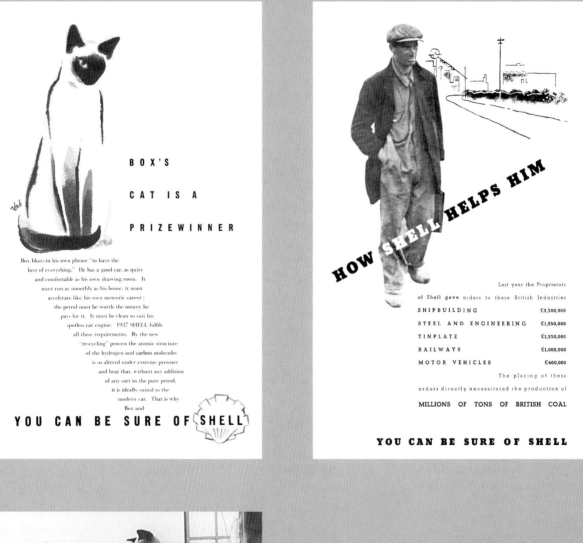

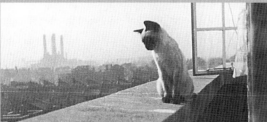

Marjorie Castle
Advertisements
1934-8
Marjorie Castle was an American who
had a fashion shop in a smart area of
London, Berkeley Square, specialising in
clothes, shoes and fabric from America.

Charnaux 1935-48

Small poster
Illustrations for advertisements
which appeared in Vogue
and a showcard

Charnaux was a company who manufactured and sold corsets and bras. They were made from latex and perforated with thousands of holes so that the body could move freely, an advance on boned corsets. The advertising scheme was based on the grace and elegance which Greek sculpture evokes.

I found an old reel of black-and-white film with shots of this model on it. Taken by Hans, probably in his first bed-sit in London.

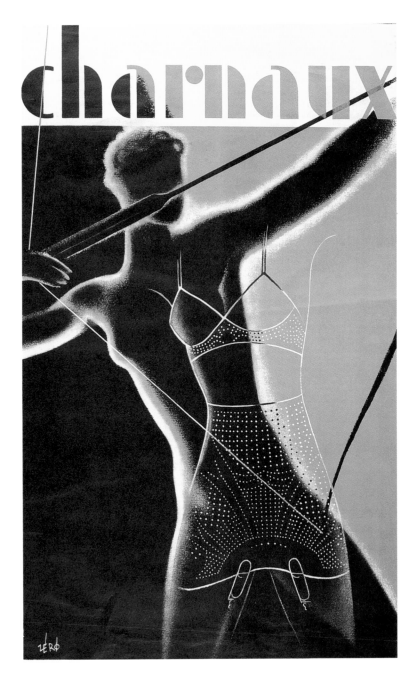

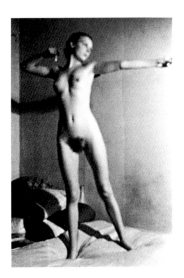

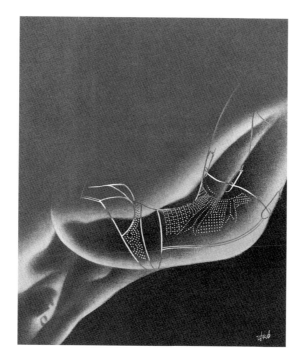

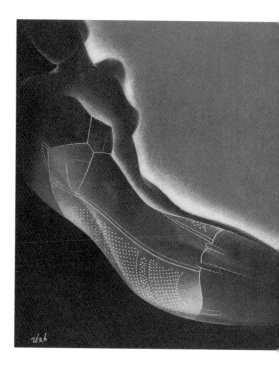

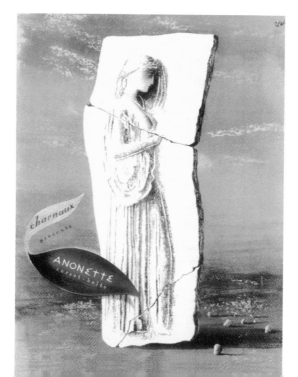

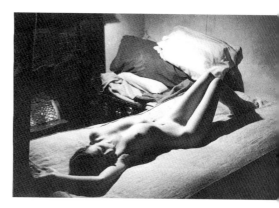

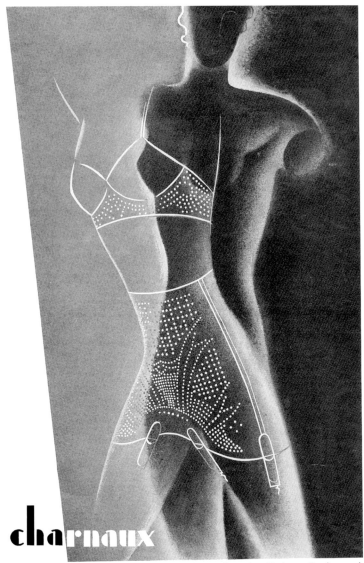

charnaux

To-day Health and Fashion dictate Strength — Vitality — Freedom and Suppleness. Only the movable beauty of Charnaux will give you these. Made from latex by electricity with thousands of scientifically designed perforations, Charnaux is the newest, cleverest support ever invented. To-day the ten guinea corset has been supplanted by Charnaux at 2½ & 3 guineas. Write for booklet to Charnaux, 179 Tottenham Court Road, W 1.

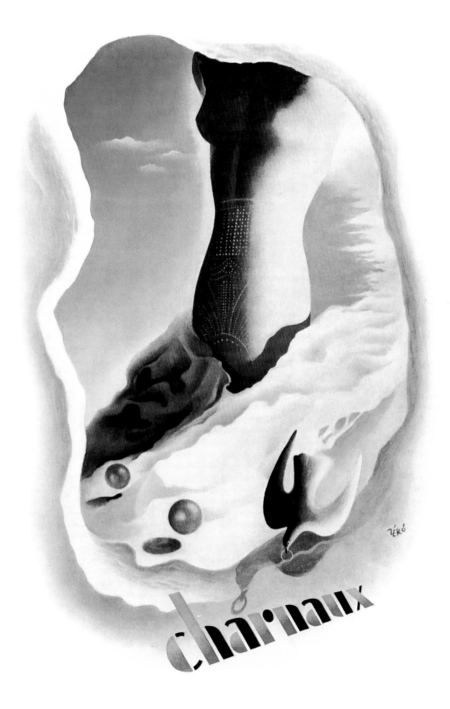

American Overseas Airlines 1946-50

'The better you get to know your audience the simpler it is to reach them.' – Schleger somewhat understating the problem of a comparatively small airline competing with the giants. His idea was to pinpoint the fact that AOA flew more direct flights to America than any other airline. The Statue of Liberty and skyscraper images, used in a dramatic way, lift them above the boring and mundane. The white space helps to separate the advertisements from their competitors and emphasises the feeling of airplanes moving through the sky in space. The type floats like a cloud or has a sharp diagonal edge to stress a *cut* in price.

In January 1951 *Advertising & Marketing Review* ran an article on advertising campaigns of the past year. It was divided into lively headings: Most Striking, Most Obscure, Craziest, Rudest, and Saddest etc. It went on, 'in every class except the last there were lots of candidates to chose from, but here is one man's final choice.'

The Year's Saddest
We created this class solely to bid a suitable farewell to an old friend, and there is only one candidate. After years of argument, Pan American Airways finally absorbed American Overseas Airlines in the autumn of 1950. We have no views on the merger itself. But from the advertising point of view we can only regard it as Red Riding Hood swallowed by the wolf.

In its four years of life, AOA advertising had established an individuality all of its own. Whether it sold seats* we do not know, but it had a distinction which made it always a joy to look at and we shall miss it. Judging from Pan American past advertising we do not think they will have the taste to adopt AOA's individual style. We imagine it has gone for good, which leaves us very sad. Nor can we award a prize to a corpse. We had intended a case of champagne for AOA but now we will drink it ourselves — wishing all our readers a festive 1951.

* Schleger wrote in the margin of this article,'more than any other line'.

Greetings card for Bill Bernhardt, advertising manager of the AOA campaign, c1946.

Bernhardt (left) with ex-Crown Prince Wilhelm Hohenzollern (right), who opened the AOA exhibition, designed by Schleger, in war damaged Frankfurt, 1946.

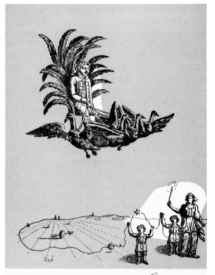

WILLIAM BERNHARDT *sends Greetings*

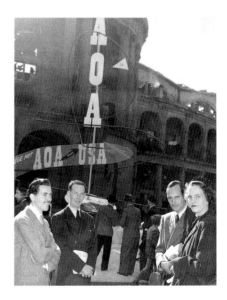

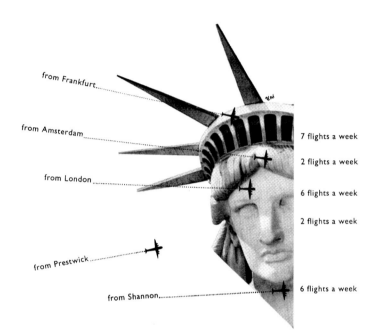

from Frankfurt.. 7 flights a week

from Amsterdam.. 2 flights a week

from London.. 6 flights a week

2 flights a week

from Prestwick..

from Shannon.. 6 flights a week

only AOA Stratocruisers serve all these cities !

Wherever you are, you can easily arrange your booking
by AOA Stratocruiser to USA. These double-deck airliners are the
world's largest, fastest and most luxurious. Full-size sleepers are available
at a small extra cost. Meals and drinks are served without charge.
From Scandinavia AOA Constellations with sleeper lounges
are at your service three times a week. Remember, **you can save 25%** on
round-trip tickets for trips if you leave before April 1st.
Of special importance to business men : AOA Stratocruisers have a cargo capacity
of 7,000 kg. Only AOA offer the services of 77 offices in USA, Canada and Mexico.
See your local travel agent, freight forwarder, or **American Overseas Airlines**
General Agents for the Mediterranean : American Export Lines.

American Overseas Airlines · American Airlines

AOA | specialists | **in air travel to the USA**

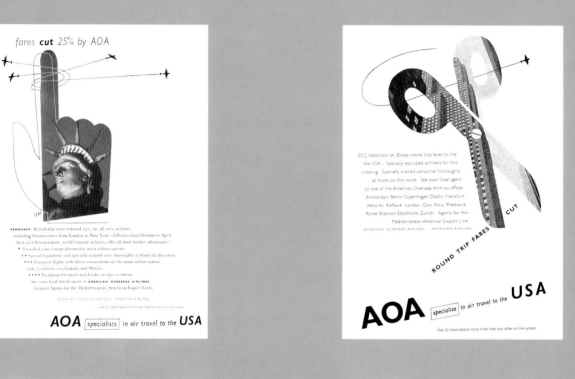

largest fleet of 300 mph airliners . . .

Wake up and you're there! AOA offer you the most
in comfort and dependability with their ★ special equipment for
this crossing ★★ specially trained personnel thoroughly at home on this route.
And they have a larger fleet of 300 mph airliners than any other airline system.
No wonder so many experienced travellers choose AOA. See your local travel agent
or American Overseas Airlines offices: Amsterdam, Berlin, Copenhagen, Dublin, Frankfurt,
Helsinki, Keflavik, London, Oslo, Paris, Prestwick, Rome, Shannon, Stockholm, Zurich.
Agents for the Mediterranean, the American Export Line.

AMERICAN OVERSEAS AIRLINES · AMERICAN AIRLINES
. . . they fly more people more miles than any other airline system

AOA specialise *in air travel to the* **USA**

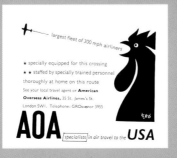



...e number of Opposition members in
...t Parliament had signed a resolution
...vour of the change.

...plying to MR. WOODBURN (Clack-
...an and East Stirling, Lab.), he said
...an inquiry had suggested that only
... per cent. of the vehicles observed the
...iles an hour limit.

VALUE OF AN M.P.'s SALARY

R. LEWIS (West Ham, North, Lab.)
...f the Chancellor of the Exchequer what
... of salary would be necessary to-day
...an M.P. to receive the equivalent in
...asing value of the salary of £400 a
...in 1911, £600 in 1937, and £1,000 in
...ely.

R. BOYD - CARPENTER, Financial
...tary to the Treasury, states in a written
...: The equivalent rates to-day would be
...oximately £1,480, £1,400 and £1,660 re-
...ively.

INTS FROM OTHER REPLIES

...otplate Pensions.—I recently informed
...Transport Commission that I could agree
...rinciple to the proposal to establish
...sion scheme for wages grades. The out-
...of a proposed scheme has been agreed
...een the commission and the unions and
...mitted to me by them, but I have not
...been able to give them my observations
...t in detail. (Minister of Transport.)
...adlamp Dazzle.—According to police re-
... headlamp dazzle was responsible for
... road accidents involving personal in-
...in 1952. The total number of personal
...y accidents was 171,757. (Parliamentary
...tary, Ministry of Transport.)
...uit Content of Jam.—On the recom-
...lation of the Food Standards Com-
...e I shall shortly make an order in-
...ing the minimum fruit content of both
...berry and loganberry jam from 25 per
... to 30 per cent., and of blackcurrant
...from 22 per cent., and of blackcurrant
...inister of Food.)

ASKS OF THE NAVY

STRATEGIC ROLE
UNCHANGED

...n the motion that the House should go
... Committee of Supply on the Navy
...mates,

...R. J. P. L. THOMAS, First Lord of the
...iralty (Hereford, C.), said that the net
...for which he was asking was £5,750,000
...than for the current financial year. This
...e allowed for American counterpart aid,
...for a further grant of £3m. relating
...he current financial year to meet excess
...diture arising from increased prices,
...han war expenses, an unexpectedly sharp
... prolonged increase in the proportion of
...ied ratings.
...e strategic role of the Royal Navy if
...with all its modern beastliness, should
...had not been altered, and its supreme
...if such a disaster occurred would still
...keep the sea communications open
...ng the first intensive phase and after it.
...e Navy was unable to succeed in this
...the most up-to-date air force and the
...equipped army would be of no avail.
...was why they had concentrated their
...arations on defending the mine, the sub-
...ne and the threat from the air.
...uch as we pray the went on) that the
...ing years may bring a peaceful solution
...ur difficulties with any potential enemy,
...el I should tell the House and the
...try frankly the strength of the Russian
...y to-day. It is, of course, true that
...e naval losses and that, except in the
...ic, warship building came to an end.
...as soon as the Germans were driven out
...the shipbuilding yards repaired, the Soviet
...l construction programme was resumed.
...rese was slow at first, but the increase
...eed of this programme has been very
...rkable of late. At present it includes
...y destroyers and submarines, while more
...ers are now being built annually than
...ll of the N.A.T.O. forces combined.

RUSSIAN STRENGTH

...day the Soviet Navy has about 20
... powerful cruisers, over 100 destroyers
...more than 350 submarines of all classes.
...ships are kept manned, with the result
...Russia has to-day the second largest
...in commission in the world. The first
... course, the Navy of our ally the United
...es, but I would remind the House that
...e the Soviet naval forces are dispersed
...our main fleet areas, by far the greatest
...of their strength, and this is of particular
...rt to Britain, is concentrated in the
...ic and in northern areas. There is every
...ation that Soviet ships are well built
...well armed, and that a high proportion
...oth their surface and underwater craft
...capable of laying mines. Russia also
...earned a great deal of valuable technical
...mation both from allied warships which
...lent to her during the war, and from
...an experts after the war so that the
...up-to-date technical equipment has been
...oped in their latest ships.
...addition, Russia also has a powerful
...il air force, including an increasing pro-
...on of jet machines which could be used
... for bombing or torpedo attacks, or
...minelaying. Although all aircraft are
...based, the Soviet naval air force is
...tegral part of the Russian Navy.
...d so the Soviet Navy will allow Russia,
...should come, not only to meet her
...sive commitments but also to lend
... powerful support to any land and
...hibious operations, and also to wage
...fensive war against our sea communica-
...and our ports with every kind of
...aft, with the very latest mines and tor-
...es, atom bombs and, in due course,
...guided missile. It is no use blinding
...elves to the fact that there is a very
...gly armed and efficient Soviet Navy with
...to reckon.

NEW CONSTRUCTION

...cause of the review of defence policy
...ontinued) and its effect on rearmament
...reductions in naval production had so
...s possible been obtained by rephasing
...rogramme so that the one for 1953-54
...succeeded in avoiding cancellation of
...s on any considerable scale. Although
...difficulties had obviously been caused
...e shipbuilding, marine engineering, and

Column 2:

...landing it could fly straight off over the
ship's side without altering course and come
round again for a further attempt. It would
be possible both to land heavier aircraft
and to avoid the risk of machines crashing
into parked aircraft or into men handling
them, which had happened on one or two
occasions. The total effect of the layout
of this angled deck was equivalent to in-
creasing the length of a carrier's flight deck
landing area by just over one-third, which
meant a great advantage in operating high-
speed aircraft.

During the current financial year two more
of the Daring class destroyers had been,
and a third was about to be, completed. The
remaining three ships of the eight of this
class—Decoy, Diana, and Delight—were ex-
pected to complete during the coming finan-
cial year. These ships, which were nearly
400ft. long with a main armament of
six 4.5in. guns, were to all intents and
purposes light cruisers, but they had a power
and an ability to manoeuvre which
no larger cruiser could attain.

FRIGATES AND MINESWEEPERS

The frigate programme had been delayed,
but 13 ships of the four different types
were well in hand and several more would
be laid down during the coming year. They
were also getting on well with the modern-
ization of existing frigates and with the con-
version of destroyers to anti-submarine
frigates. The minesweeper programme was
really making steady progress in spite of the
delays over special materials and, in some
cases, an inadequate labour force in the
small yards. This minesweeper programme
had been carried out in no less than 33
separate shipyards, was costing two-fifths of
the total expenditure on naval new con-
struction during 1953-54, and during the
coming year they would see the beginning
of a very substantial flow of these ships.

The first of the new coastal minesweepers
had been completed, and by the end of this
year the framing and the structural casing
and the outer bottoms were wood planked
so the hulls would be largely non-magnetic.
They were driven by diesel engines, they
had the latest minesweeping equipment and
would be able to operate sweeps against
contact and against influence mines. Of the
smaller inshore minesweepers for operating
in rivers and estuaries, 48 would have been
laid down by 1952-53, of which 20 would
have been launched.

FLEET AIR ARM

OVERCOMING DELAYS IN
PRODUCTION

Naval aviation was not being re-equipped
with modern types of aircraft as quickly
as could be wished, but the Admiralty and
the Ministry of Supply were facing the
coming year with a good deal more confi-
dence.

Over a year ago super-priority had been
given to the Gannet, our anti-submarine air-
craft. As a result he hoped that deliveries
of these aircraft would not lag in future.
Although there had been a hold-up over
the earlier deliveries of the Navy's first jet
fighter, the Attacker, this aircraft had been
in squadron service in H.M.S. Eagle since
1952. There had been certain reports that
it might not be safe to fire its guns under
all conditions, but that was not the case,
and technical troubles with the fuel supply
had been righted. Attackers were now per-
forming well in service and were good air-
craft to operate from the deck of a carrier.
Pilots were getting extremely useful experi-
ence through them in landing jet aircraft
on carriers.

SPECIAL MEASURES

There had also been a disappointment
over the Sea Hawk, mainly due to shortage
of labour in the early stages of production,
but the Minister of Supply had taken special
measures for handling the production line
and it should now go ahead satisfactorily.
No. 806 Squadron formed at the Royal
Naval Air Station, Brawdy, on March 2
would have Sea Hawks during this month.
Other Sea Hawk squadrons would follow later
in the year.

The Sea Venom, an all-weather fighter,
was in two marks. The production of the
first mark was only just behind schedule.
The second mark was delayed both by the
need to make certain modifications for carry-
ing special radar which it was hoped to obtain
from America, and by certain difficulties in
design which he hoped now were being
rapidly solved. There had been difficulties
too with the Wyvern strike aircraft, but this
aircraft was now cleared for operation from
airfields.

The United States had generously agreed
to supply us with a number of aircraft
which would be delivered under the Mutual
Defence Assistance programme. We had Sky-
raiders for an operational role, and a number
of these aircraft were already in H.M.S.
Eagle, and other supplies were coming along.
These were powerful 10-seaters,
allocated 10 Sikorsky S 55 helicopters by
America. These were powerful 10-seaters,
which first flew in England in the summer
of 1951, and it was hoped that there would
be future supplies of helicopters of heavy and
light types.

We were also receiving under the Mutual
Defence Assistance programme a substantial
number of Avengers which would be par-
ticularly welcome to strengthen our anti-
submarine forces until the Gannet was avail-
able in sufficient numbers. H.M.S. Perseus
had left to fetch these first Avengers last
week and arrived in America to-day.

NEW JET FIGHTER

In addition to the aircraft which were
expected to be in service during the next
year or two, they had placed a substantial
order for a new naval jet fighter of the
swept-wing type. It would be twin-engined
and would be capable of a very high rate of
climb. Super-priority was to be given to that
aircraft as well.

He had not attempted to hide the dis-
appointments which both the last Government
and this one had suffered over naval air-
craft but he could at least say that the
aircraft about to come into service in the
Royal Navy would be comparable to their
counterparts in other countries and that it
would be possible for us to match, and he
hoped to lead, the best that any of our
potential enemies might have in mind.

Changes in the propulsion machinery of
new warships would result in greater eco-
nomy in the consumption of fuel. There
were both lightweight high-efficiency diesel
engines and gas turbines. The Navy believed
that the development of the gas turbine
would prove to be as revolutionary in the
marine engineering world as had the change-
over from fire-tube to water-tube boilers at
the beginning of the century. In the near
future gas turbines would probably be found
in some form or other in all classes of
vessels.

It had been comforting to show to the
world this year the latest British technical
advances, such as the angled deck, the steam
catapult, the anti-submarine mortar and the
use of gas turbines for marine propulsion.
If we had no longer the biggest Navy in the
world, we had no intention whatever of
having anything but the best. All that could
not have been done without a great deal of
work by the civil staffs of the Admiralty.
That staff had been cut down over many
years but had not been fully
absorbed by an increase in the research and
development staffs.

The work was costly and it had been paid
for by sacrifices elsewhere. Provision of
ammunition, oil fuel and stores for 1953-54
was on a reduced scale and it would be
necessary to draw on stocks to a certain
extent. That was a situation which could not
be allowed to continue in future. There were
also great accumulated arrears of work in
certain of the shore services. Dockyards were
often congested and old-fashioned, and
modernization had to take place. Even the
£18m. to be spent for 1953-54 would do no
more than nibble at the problem. The Navy
Estimates could not be expected to go down
in the next few years.

THE COLD WAR
SPIRIT OF RESERVISTS

To achieve the strengthening of the Navy
...pired and a further 600 officers and 8,000
Royal Fleet Reservists had been recalled to
active service up to the end of 1952. They
had enabled the Fleet directly or indirectly
to play its part not only in the Korean
operations but also in meeting the many
tasks that had fallen to the Navy in ful-
filling its commitments in the cold war. He
had been heartened by the relative absence of
complaint. The other day some 14 reservists,
whose ship was being ordered unexpectedly to
Korea, where they would not normally have
been sent, all made requests to be allowed
to remain in the ship for its service. This
spoke volumes for the spirit in which these
difficulties had been faced. As a result of
the growing strength of the free world, the
Admiralty were now able to begin to arrange
for the return to civil life of the 12,000 of
them who were still serving. It was intended
that all of the retained and recalled men
should be released by the end of March,
1954, unless there was any deterioration in
the international situation.

RECRUITING POLICY

There would be two great difficulties as a
result of this large out-flow, because it in-
cluded many of the Navy's most experienced
men. The Admiralty had high hopes,
that, in view of their efforts to make
a naval career attractive, many of the short-
service men would decide to turn over to
the long engagements. That would do much
to redress the balance in naval man-power.
The award of married unaccompanied over-
sea allowance to the Army and Air Force
would also apply to the Navy ashore abroad.
The recruiting policy during the current
financial year had been to enter a far higher
proportion of ratings on continuous service
engagements than on seven-year engagements.
Between April 1 and December 31, 1952,
11 recruits entered the Royal Navy on a
continuous service engagement for every one
entered on a seven-year engagement.
The Admiralty were experiencing shortages
of officers before the Korean emergency
and obtained temporary relief by retaining
and recalling officers. That form of
relief would end in April, 1954, and
the shortage would then be of junior officers
and would be especially serious in the engin-
eering and electrical branches and in the
medical and dental branches, which carried
a substantial proportion of national service
officers. To carry over this period the
Admiralty would rely meanwhile on those
retained and recalled officers who volunteered
to serve for a further period. To date some
500 such officers had volunteered and, in
addition, some 80 had been given permanent
commissions. That represented a satisfactory
response of about 45 per cent.

CADET ENTRY
STATEMENT EXPECTED
SOON

The committee on cadet entry, which was
set up last year, was still sitting, but he hoped
to have its report and recommendations be-
fore long. As soon as it was possible to
consider the report and to take decisions he
would make a further statement. He was con-
cerned to reach decisions in this difficult
matter which would be helpful to the future
of the Royal Navy and fair to every section
of the community.
Recruitment for naval aircrew had gone
up by roughly 50 per cent, and a higher
proportion of permanent executive officers,
entered through Dartmouth and the special
entry, had said that they wished to specialize
in naval aviation. More young men from
civilian life were still needed to come for-
ward and apply for short service commissions.
The W.R.N.S. were doing excellent work
ashore both at home and in Norway, Ger-
many, Malta, and Fayid. As they were
decorative as well as efficient there was
some marriage wastage at the moment.
(Laughter.)

KOREA AND MALAYA

There had been little change in the pattern
of naval operations in Korea during the
year, where all ranks had done magnificent
work alongside the navies of the Common-
wealth and our allies. The performance of
our aircraft carriers had been outstanding
and on several occasions there had been
sequences of over 1,000 accident-free landings.
In Malaya there had been constant patrols
by the Royal Navy to prevent gun-running
and the entry of bandits, and the Navy
had also sent and manned a squadron of
operational helicopters for the support of the
Army. The manning of helicopters was a
fairly new and unusual job for the Navy and

... million people in this country
threatened with starvation by enemy sub-
marines. The great centres of Russian war
potential in Siberia were much nearer to the
waters north of Norway than to this coun-
try, and if it was possible to fly heavy
bombers from our aircraft carriers the car-
riers could be more important to us than
airfields in this country.

Taking the defence Estimates as a whole
the Navy had had a raw deal. Obsessed
with visions of vast Russian armies, the
Government had allowed too much of the
expenditure on defence to go on the Army
at the expense of the Navy. He hoped that
next year's Estimates would show that there
had been a reversal of this policy and that
the Royal Navy would no longer be sub-
ordinated to the other forces.

INSPECTION OF STORES

LIEUT.- CMDR. HUTCHISON (Edin-
burgh, West, C.) said that it was imperative
that the inspection of filled ammunition stores
should continue to be the responsibility of
the Chief Inspector of Naval Ordnance. Any
relaxation in the standards of inspection of
explosive stores carried in warships would
endanger both ships and men. The Naval
Ordnance Inspection Department should be
made a uniformed, active-service branch of
the Royal Navy.

MR. K. ROBINSON (St. Pancras, North,
Lab.) said it was time the Admiralty came
to a decision on the future of the battleship,
which, to-day, was nothing more than a
floating white elephant. There could be no
argument for retaining in the reserve the
four King George class battleships. It might
cost little to keep them in reserve, but it
cost something, and their existence probably
affected the strategic thinking of the
Admiralty.

MR. R. A. ALLAN (Paddington, South,
C.) said sea power would cease to be essen-
tial to our survival when the majority of the
world's commerce was carried by air, and
sea lanes had no longer to be kept open.

MR. BOTTOMLEY (Rochester and Chat-
ham, Lab.) said that more work should be

Column 5:

...of our possible enemies to have a monopoly
of Arctic research. The Government should
consider allocating a sum for vessels able
to enter the important Arctic waters and so
maintain this country's prestige in that part
of the world.

MANAGEMENT OF DOCKYARDS

MR. R. W. WILLIAMS (Wigan, Lab.)
moved the following amendment:—
That this House welcomes the acceptance
by her Majesty's Government of certain
criticisms concerning her Majesty's dock-
yards referred to in the Eighth Report of
the Select Committee on Estimates (session
1950-51), but regrets that certain recom-
mendations set out in that report relating
to personnel management policy and the
improvement and strengthening of the struc-
ture of management have not been adopted.

MR. FOOT (Plymouth, Devonport, Lab.)
said there was need for more repair and
maintenance work in the dockyards. Much
of the plant and machinery in them was
disgraceful. The Admiralty had turned down
many of the recommendations of the select
committee.

MR. DIGBY, Civil Lord of the Admiralty
(Dorset, West, C.), said that the Royal Dock-
yards were totally unlike anything in outside
industry. They were not analogous to ordinary
and in-line production. The Admiralty would
endeavour to carry out improvements on the
personnel side of the dockyards. An experi-
ment was to be made in the appointment of
a deputy superintendent.

MR. KING (Southampton, Test. Lab.) said
that an effort should be made to ensure that
the social structure of the interviewing board

Column 6:

thought he was not going on leave at the
right moment or for some such reason.
The royal yacht would be used as a hospi-
tal ship in time of war and she was being
built so that she could sail the oceans in
rough weather. She would not be ready in
time for the royal visit to Australia and
New Zealand.

It was not the Government's present inten-
tion to build more battleships. The four of
the King George V class were in a low state
of reserve and little money was being spent
on them, although the Government did not
think that their useful life was at an end.

The motion was agreed to and the House
went into committee, Sir CHARLES MAC-
ANDREW, Chairman of Committees (Bute and
North Ayrshire, C.), in the Chair.

The Vote for men was agreed to and
consideration of the remaining Votes was
adjourned.

The House resumed.

The House adjourned at 18 minutes after
2 o'clock.

PARLIAMENTARY NOTICES

HOUSE OF LORDS
To-DAY, AT 2.30
Motion by the Marquess of Exeter relating to peers
and voting in divisions.

HOUSE OF COMMONS
To-DAY, AT 2.30
Iron and Steel Bill, third reading.

SUNKEN CARGO SALVED
AFTER 35 YEARS

FROM OUR CORRESPONDENT
SYDNEY, MARCH 16

The British salvage ship Foremost 17 has
reached Sydney after salving most of the
copper and lead cargo of the steamer Cumber-
land, which was sunk by a mine off the coast
brought up eight and a half tons of gold from
the Niagara, but the work was then stopped
by a change in ocean conditions.

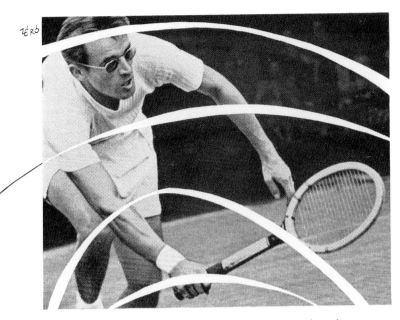

The legs rush him up from the base-line. The shoulders stoop into the stroke. The right forearm tenses. The left arm balances the body. The racket is held square for the classical low backhand volley. The eyes can all but read the maker's name on the ball. **It all adds up to** Game, Set and Match to Frank Parker.

GREAT INTEGRATION

The member companies of A E I work by themselves, and as a group.

That is the policy. As a group, Associated Electrical Industries

spend a million pounds each year on research and run the only industrial School

of Physics in the country. Integration of the different companies means

real rationalisation of production, the pooling of knowledge,

of experience, of resources. It means *co-ordinated effort* for the public good.

it all adds up to

Associated Electrical Industries

These are the companies of A E I
Metropolitan-Vickers Electrical Co Ltd
The British Thomson-Houston Co Ltd
The Edison Swan Electric Co Ltd
Ferguson Pailin Ltd

The Hotpoint Electric Appliance Co Ltd
International Refrigerator Co Ltd
Newton Victor Ltd
Premier Electric Heaters Ltd
Sunvic Controls Ltd

*Advertisement
Teddy Tingling, fashion designer
specialising in tennis clothes
1937-8*

*Advertisement
Mather and Crowther
1956-8*

Images of hands were a recurring feature in Schleger's work and he used them in amazingly varied ways, which was typical of his whole approach to design. The illustration for the recruitment ad for Mather and Crowther is a photogram using his own wooden lay figure from Berlin days. He also collected antique hands and feet.

As well as the two advertisements on this page other examples occur throughout the book. The pointing hand for the GPO wartime poster (p.49), and the graceful hand for a wartime cover for *Vogue* (p.60).

In the late 1940s a campaign was launched by London Transport entitled *Hands at your service* for which Schleger designed posters and advertisements (p.62), and at the same period an advertisement for AOA features a dramatically simplified hand with part of a photo of the Statue of Liberty in it, stressing the number of flights available to the USA (p.152).

A huge semi-skeleton hand dramatises the danger of cyclists tailing motor cars in a poster for the Royal Society for the Prevention of Accidents (p.67). In contrast, the Terylene hand, filled with a flowing Gysi pattern, emphasises the softness and versatility of this new artificial fabric (p.171).

Two thirds of a double spread in a *Farmer's Weekly* advertisement for Fisons Pest Control is covered by a life-size photo of a hand holding the wild oats, which will no longer be a problem for the farmer and his crop (p.164).

awards and rewards at Mathers

Should you be a designer at Mathers? Could you be? This depends, not entirely on experience, but also upon your point of view. Mather's advertising is good looking. (It won the highest Layton awards this year.) It is planned to sell. (You could have a share in the planning.) It sells causes as well as goods. (A national responsibility.) Are you this sort of designer? If you'd like to work for us write to :

S. E. SHELTON, Creative Director, Brettenham House, Lancaster Place, London, W.C.2

**Fisons Limited 1952-62
Fisons Pest Control
1956-64**

After the Second World War, farmers were encouraged by the Government to increase food production by every means possible. The then new chemical fertilisers and pest controls were hailed as saviours of a serious food shortage problem – worldwide.

Schleger explains his thoughts and the approach he wanted to take in developing the corporate image for Fisons.

Armour is not really a sign of strength, but a concealment of weakness. Many firms feel the need of armour; they prefer to hide behind the kind of House Style that is protective and imposing, instead of showing themselves as they are. Think of the suits of armour in museums. What is inside them? Stuffy air.

The answer is not found in borrowing from our forefathers, nor in originality at all costs. Each firm has its own particular raison d'être and the designers true purpose is the revelation of this. For example, Fisons Pest Control undertake their own scientific research, and their investigations of agricultural problems result in products that help to increase the world's food supply and affect one of the most vital questions of this century. Once the problem becomes specific in this way, everything else should follow naturally; each problem contains the seeds of its own solution.

Having made himself aware of his message, the designer must decide how best to interpret it. By now, both he and his client are usually well aware of the virtues of restraint. Copious details, forceful persuasion, high-pressure salesmanship have been seen for what they are. Never has there been a time in

which so much has been so widely communicated and it is impossible for people to see and remember even a small fraction of it. Hence the growing recognition of the importance of the simple statement.

Nevertheless, just as originality for its own sake should be avoided, so should simplicity as an end in itself. It should be the natural result of dealing directly with the problem in hand: the selection of the relevant and the discarding of the irrelevant: the organisation of the elements (like the parts of a machine) into a relationship in which the whole will function properly. Change the relationship wilfully and you change more than you think you have.

Simplicity also results naturally from not attempting to reach too wide an audience. A house intended for a family with four children will not be of interest to a bachelor, neither will a sports car attract the family father. The designer who limits himself not only to a specific message but also to a specific audience is wise in not attempting to reach all the people all the time.

In the campaign for Fisons Pest Control the task is to interpret an individual message each time; no one task is the same as what has gone before. I have concentrated on the importance of limitation of the problem in hand, of the elements and organisation of the design, limitation of the audience – all the essentials. Working within such limits can produce an image which for the client and for the designer is both educational and effective.

*Exhibition stand of work for Fisons
at an AGI expo in the Louvre
Paris 1955*

*Newspaper advertisements
1952-62*

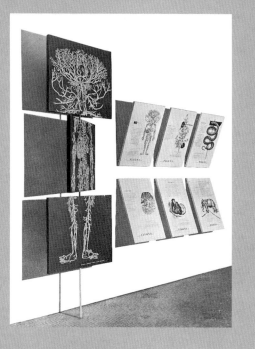

a picture of health

A doctor would recognise this as a picture of a
healthy human liver. Any similarity it may have
to the root system of a plant is intentional.
It illustrates a point basic in the grammar of biology ..
that animal and vegetable share many
of their principles of life.
The taproot of Fisons business has been,
for more than a hundred years,
chemical fertilizers for the soil
of farm and garden.
Today Fisons have roots in the field
of chemicals, for medicine and industry.
Fisons contribute to the harvest,
health and wealth of Britain.

FISONS LIMITED · HARVEST HOUSE
FELIXSTOWE · SUFFOLK
Fertilizers · Heavy Chemicals

Fisons are also among the largest manufacturers in Great Britain
of pharmaceuticals, medicinal food preparations and fine chemicals
for Industry. Many of Fisons products in these fields are household names.

it's all in **FISONS** field

harvests and health

The snake was an ancient symbol of Time and the turning year,
with its earth seasons of spring planting, summer growth,
autumn harvest and winter sleep. And the snake of Aesculapius has,
since classical times, been a symbol of healing.

Agriculture to produce man's food, and medicine to save for his health ...

The improvement of crops has been the main business of Fisons
for a hundred years and more, almost since the science
and production of chemical fertilizers began. And, in recent years,
Fisons have struck roots in the field of chemicals for medicine.
Fisons today contribute to the harvests and health of the world.

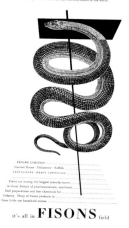

FISONS LIMITED
Harvest House · Felixstowe · Suffolk
FERTILIZERS · HEAVY CHEMICALS

Fisons are among the largest manufacturers
in Great Britain of pharmaceuticals, medicinal
food preparations and fine chemicals for
Industry. Many of Fisons products in
these fields are household names

it's all in **FISONS** field

future imperfect

Wild animals depend for their food on what they can find.

It is a hand-to-mouth existence. Man, having evolved the idea of

agriculture, sows to reap. He cozens nature, making her amenable,

to produce his food when and where he wants it.

He asks only health and strength to work his fields,

peace to enjoy the fruits of his labour and a stable economy

to ensure that he can sell and buy and exchange.

The main product of the Fisons business has for a hundred years

been chemical fertilizers, to enrich the soils of farms and gardens.

But they make chemicals for medicine and industry too.

Fisons contribute to Britain's harvests, health and wealth.

FISONS LIMITED · HARVEST HOUSE,
FELIXSTOWE · SUFFOLK..........................
................................Fertilizers · Heavy Chemicals
...

Fisons are also among the largest manufacturers in Great Britain
of pharmaceuticals, medicinal food preparations and fine chemicals
for Industry. Many of Fisons products in these fields are household names.
...
...

it's all in **FISONS** field

ZERO

man and tree

If nature is kind, a man may live in health

to a hundred years, a tree to a thousand. Man's knowledge

of the chemistry of health is increasing.

Through science man is gradually making

nature kinder and more *predictable*.

Fisons are in the business of chemicals. Their main

manufacture over the last hundred years has been

chemical fertilizers to enrich the soil. But they make

chemicals for medicine and industry, too.

Fisons contribute to Britain's harvests, health and wealth.

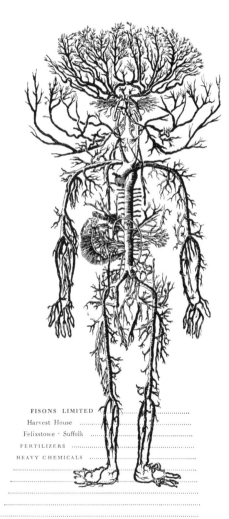

FISONS LIMITED
Harvest House
Felixstowe · Suffolk
FERTILIZERS
HEAVY CHEMICALS

Fisons are also among the largest manufacturers in Great Britain
of pharmaceuticals, medicinal food preparations and fine chemicals
for Industry. Many of Fisons products in these fields are household names.

it's all in **FISONS** field

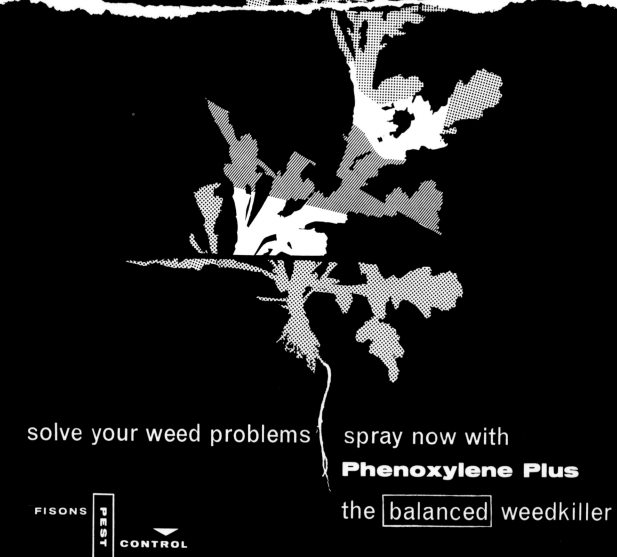

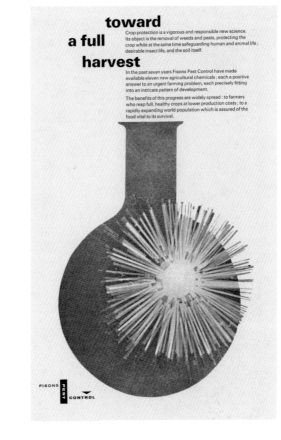

toward a full harvest

Crop protection is a vigorous and responsible new science. Its object is the removal of weeds and pests, protecting the crop while at the same time safeguarding human and animal life; desirable insect life, and the soil itself.

In the past seven years Fisons Pest Control have made available eleven new agricultural chemicals; each a positive answer to an urgent farming problem, each precisely fitting into an intricate pattern of development.

The benefits of this progress are widely spread: to farmers who reap full, healthy crops at lower production costs; to a rapidly expanding world population which is assured of the food vital to its survival.

FISONS PEST CONTROL

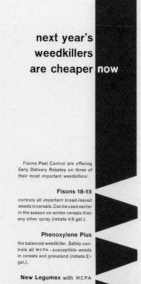

next year's weedkillers are cheaper now

Fisons Pest Control are offering Early Delivery Rebates on three of their most important weedkillers:

Fisons 18-15
controls all important broad-leaved weeds in cereals. Can be used earlier in the season on winter cereals than any other spray (rebate 4/6 gal.).

Phenoxylene Plus
the balanced weedkiller. Safely controls all MCPA - susceptible weeds in cereals and grassland (rebate 2/- gal.).

New Legumex with MCPA controls weeds without damaging clovers. Strikes the exact balance between weedkilling and safety (rebate 2/6 gal.).

plan early for economy
You'll certainly need a basic quantity of these weedkillers for next spring. Buy before December 31st and save money.

FISONS PEST CONTROL

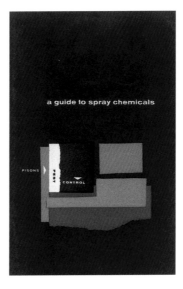

a guide to spray chemicals

FISONS PEST CONTROL

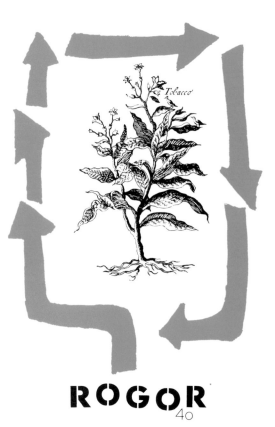

ROGOR 40

yet another field for systemic insect control:

in TOBACCO

research has now proved Rogor 40 effective for the control of white fly and aphids in tobacco. Safe in use, because of its low toxicity and freedom from residue and flavour problems, Rogor 40 is the first systemic insecticide recommended for tobacco. Rogor 40 is safe. Supplies and information from Fisons Chemicals (Export) Ltd., Fison House, 95 Wigmore Street, W.1.

FISONS PEST CONTROL

kill insect pests

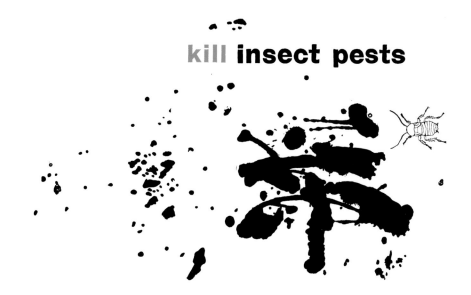

safely with

diazinon

Diazinon kills insect pests in hospitals, schools, hotels, warehouses, markets, stores and private houses – around drains, sewers and refuse dumps – wherever insects annoy, destroy and carry disease. Use Diazinon to kill cockroaches, flies, mosquitoes, bedbugs and ticks. A persistent insecticide, it prevents rapid reinfestation, is economic in use. Diazinon has proved itself where insects have built up resistance to other chemicals. When the older insecticides become ineffective, Diazinon restores control. Extensively used in the tropics, Diazinon is a safe insecticide – virtually harmless to man, livestock and pets. Information and supplies of Diazinon formulations from Fisons Chemicals Overseas Limited Fison House 95 Wigmore Street London W1

FISONS **PEST** ▼ **CONTROL**

carbyne prevents yield losses

carbyne
masters
wild oats

average yield losses prevented with carbyne have been between 10 and 20% of the crop.

Carbyne is most successful in its control of wild oats when the crop is a good one, so that the techniques of good husbandry – drilling at the correct time with the full recommended seed rate and adequate use of fertilizer – actually assist Carbyne. In these good growing conditions, the use of Carbyne has resulted in yield increases as high as 25 cwt. an acre and in one instance the yield from a wheat crop rose from 8 to 40 cwt.

the economics of carbyne

The use of Carbyne to control wild oats in cereals is easily justified economically. On a crop yield of 30 cwt. a 20% increase would represent 5 cwt. an acre or at 1962 guaranteed prices over £6 an acre. Also, since Carbyne is a post-emergent spray, late drilling is avoided. Taking spring barley as an example, late drilling can cut yields by between 4 and 9 cwt. an acre, and this alone is more than enough to pay for the Carbyne.

more profitable rotation

Wild oats can build up to such an extent that it is impossible to grow cereals successfully. The use of Carbyne can prevent this build up in cereal crops. There is no need to fallow, to grow less-profitable break crops, or to put the field down to grass. Profitable white straw crops can be grown more frequently in the rotation.

A typical rotation would be winter wheat*, roots, spring wheat*, barley*, barley*, seeds, mustard or roots.
*may be sprayed if required.

some typical examples of yield increases reported by farmers

Gloucestershire	yield from unsprayed area	19 cwt per acre
	yield from sprayed area	31 cwt per acre
Pioneer barley		increase 12 cwt per acre
Northamptonshire	yield from unsprayed area	32 cwt per acre
	yield from sprayed area	40 cwt per acre
Pallas barley		increase 8 cwt per acre
Huntingdonshire	yield from unsprayed area	21 cwt per acre
	yield from sprayed area	32 cwt per acre
Hybrid 46 wheat		increase 11 cwt per acre

spray timing service

Starting this spring, the Fisons Pest Control Spray Timing Service on television will keep farmers in the Eastern counties informed on rate and state of weed growth over the main arable areas.

Television If your set is tuned to Anglia (Channel 11), watch between 6.35 and 6.45 p.m. every Friday starting March 22. If you receive Yorks TV (Channel 10), then watch between 2.20 and 2.45 p.m. every Sunday starting April 7.

carbyne | another proved product of development by Fisons Pest Control

FISONS **PEST** CONTROL ►

Fisons for good farming

Fisons Pest Control
Double spread advertisements
in farming magazines

Spread from a leaflet
for Basudin
1956-64

basudin

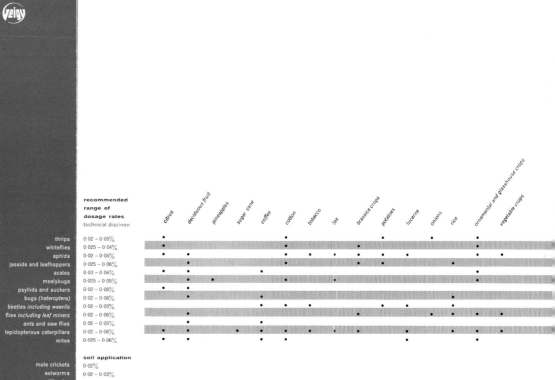

	recommended range of dosage rates technical diazinon	citrus	deciduous fruit	pineapples	sugar cane	coffee	cotton	tobacco	tea	brassica crops	potatoes	lucerne	onions	rice	ornamental and glasshouse crops	vegetable crops
thrips	0·02 – 0·05%	•														
whiteflies	0·025 – 0·04%	•					•			•		•			•	
aphids	0·02 – 0·06%	•	•			•	•	•	•	•	•	•	•		•	
jassids and leafhoppers	0·025 – 0·06%	•	•								•				•	
scales	0·03 – 0·06%	•	•		•										•	
mealybugs	0·025 – 0·06%	•	•													
psyllids and suckers	0·02 – 0·06%	•	•													
bugs *(heteroptera)*	0·02 – 0·06%	•										•			•	
beetles *including weevils*	0·02 – 0·06%		•			•	•			•	•	•	•		•	
flies *including leaf miners*	0·02 – 0·06%		•							•	•	•	•	•	•	
ants and saw flies	0·02 – 0·05%		•			•										
lepidopterous caterpillars	0·02 – 0·06%	•	•			•	•	•		•		•	•	•	•	
mites	0·025 – 0·06%	•	•			•	•				•			•		

	soil application															
mole crickets	0·02%															
eelworms	0·02 – 0·03%															
millipedes	0·02%															
symphylids	0·02%															

Fisons Pest Control
Covers for manuals explaining the use
of pesticides for specific crops
1956-64

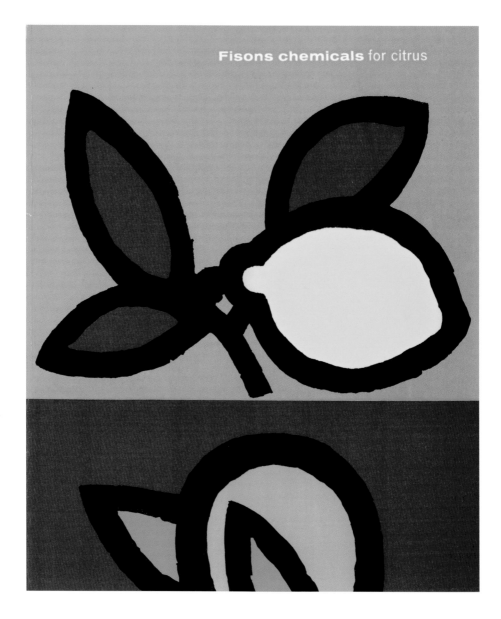

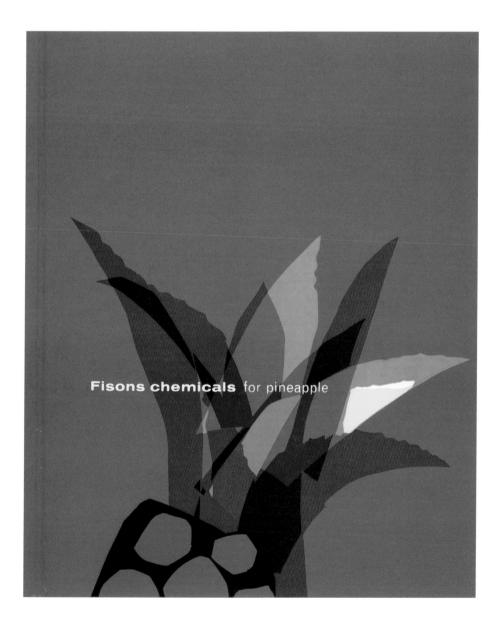

Fisons chemicals for pineapple

Extracts from an article about the introductory campaign for Terylene

Schleger's problem was to discover a form of expression which would, in the simplest manner and by the most effective impact possible, create an immediate appreciation that the discovery of Terylene has been an event of profound significance and to contrive a series of designs that would bring out the beautiful qualities of the material and its origin as a man-made fibre. These are things which cannot be represented literally. They demand abstract treatment, yet abstract in a way which will establish the closest link between physical properties and a dream of untold possibility…

Hans Schleger's outstanding ability as a graphic artist is matched by his breadth of outlook and his appreciation of the value and beauty of graphic forms, not necessarily of man's creation. His designs for the Terylene series have been based upon the photo-physical harmonic traces of Professor Gysi, the well-known Swiss scientist, whose photographs he has used. These traces are the expression of the earth's gravitational influence – a message dictated by universal physical laws … Schleger's designs … created as they are around a physical manifestation of design, use the almost cosmic qualities of these very advanced harmonic patterns to announce the advent of a new material and to express its properties.

A particularly subtle feature of Schleger's methods of composing these harmonic traces is his interpretation of their completeness as figures. This he has carefully contrived so that the eye is stimulated towards an awareness of the importance of the message in exciting pictorial terms and is prevented from merely meandering aimlessly in its contemplation of abstract beauty.

The whole campaign, although based primarily upon physical laws as old as the universe itself, has nevertheless given us something entirely new in advertising design; suggestively experimental and therefore utterly appropriate to the task for which it was conceived.

Art & Industry, 1954

*Advertisement
ICI (Imperial Chemical Industries Limited)
1953-6*

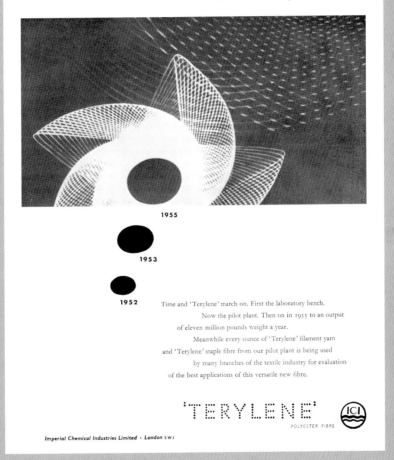

from the laboratory

1955

1953

1952

Time and 'Terylene' march on. First the laboratory bench.
Now the pilot plant. Then on in 1955 to an output
of eleven million pounds weight a year.
Meanwhile every ounce of 'Terylene' filament yarn
and 'Terylene' staple fibre from our pilot plant is being used
by many branches of the textile industry for evaluation
of the best applications of this versatile new fibre.

'TERYLENE'
POLYESTER FIBRE

Imperial Chemical Industries Limited · London SW1

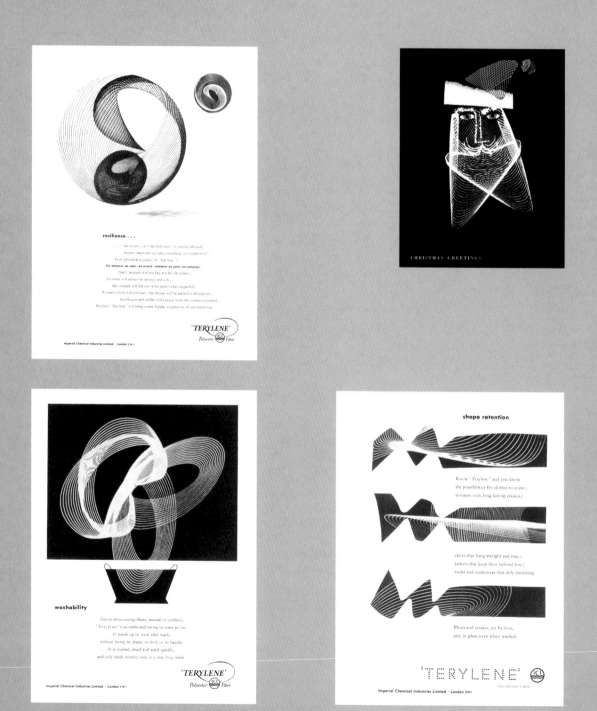

Our womenfolk will fall in love at first sight

with the classical drape of 'Terylene' fabrics.

And head over heels in love

the first moment they feel 'Terylene' 's softness and warmth.

For alone among synthetics

'Terylene' marries those qualities

of a natural fibre to

its own particular virtues.

handle and drape

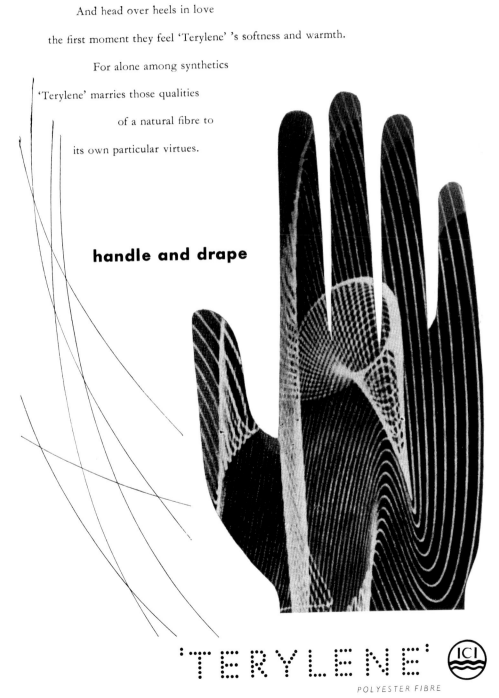

'TERYLENE' ICI

POLYESTER FIBRE

Imperial Chemical Industries Limited · London S W I

TE5

Hans Schleger discusses the situation of the graphic designer in the modern world
extracts from the Introduction in Graphis Annual 1964/5

Events can now be seen, while they happen, by millions of spectators who watch them without actual participation. News of vital discoveries, of inventions and of technological developments is communicated with speed and urgency. Abundance is connected with obsolescence – as we buy the new model we have the uncanny feeling that it is possibly already out-of-date...

Mass media have created a new situation. While formerly a person – to be of major importance – was required to have made a valuable contribution to knowledge or achievement, it is now sufficient to have been seen and heard on millions of screens, to become a TV 'personality' whose thoughts and opinions matter.

What price does the individual pay, what price is he willing to pay for convenience, for standardisations and uniformity – his newspaper delivered every morning, his bread packed and sliced, his milk sterilised, his drinking water fluoridised, his family immunised and insured against most natural disasters. Have we perhaps hopefully or automatically sacrificed a large measure of freedom in exchange for greatly magnified power and vision in order to react to these riches with helplessness, withdrawal or cynicism? Do we concentrate too much on the new material abundance and less on the widening horizon? Spiritual involvement is necessary as well as inevitable...

Advertising as communication performs vital functions, it influences our private lives and our economy even more widely than we assume. It can lower prices by helping mass-production and distribution. It guarantees continuity of performance. It explains new products, new uses and services. It informs doctors and farmers about new drugs and chemicals. It helps young people to choose their careers. It introduces books, plays, moving pictures and the other visual arts, makes newspapers and magazines cheaper to buy and it is proud of its inability to sell useless things for any length of time. Advertising is concerned, vitally concerned, with people...

The processes of international marketing and finance are now so complex that the old methods are under increasing scrutiny. Never has the need to communicate facts and news been greater. Never was there a greater opportunity for co-operation between research and creative men. Research cannot be a substitute for individual or group responsibility. Research finds facts and can record them. If objectively interpreted, it can help to eliminate loose thinking and it can do away with a surprising amount of waste in the employment of creative energy...

The number of those who approach a problem of communication from within is still too small. The task itself is the vitalising element and no formula can fit two different projects. Now that so many problems bring electronics, space flight, automation, nuclear energy into their sphere of action, it is more than ever essential that the gulf which exists between the phenomenal and the noumenal can sometimes be traversed through the artist-designer's gift of imagination and insight into the unseen.

4

**W. Raven & Company
Limited
c1946-50**

Raven was a small family business manufacturing socks for men and children, in Leicester. The managing director, Bernard Moor, and Schleger became good friends. Bernard was a violinist and had been a member of the Hallé Orchestra in Manchester until he went into business. It was because he was an artist himself that he and Schleger forged such a good friendship and why he respected Schleger's judgement in matters of design and left him to get on with it.

A subtle brown was used for the sock boxes and the first shop counter show-card and remained their house colour. Combined with one of Schleger's most memorable trademarks, a corporate image was created which had classic simplicity, imagination and a not too serious approach when it came to children's socks.

CRAFTANA

SOCKS FOR MEN

RAVENA

SOCKS FOR CHILDREN

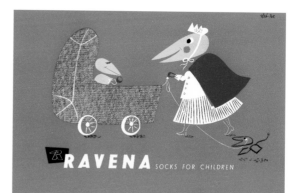

Logo for Raven knitwear
The design integrated the name and the
trademark. It was silk-screened in red, black
and white onto polythene bags so that the
product and logo were seen together.

Woven neck label for knitwear

Box for socks
and various sock labels

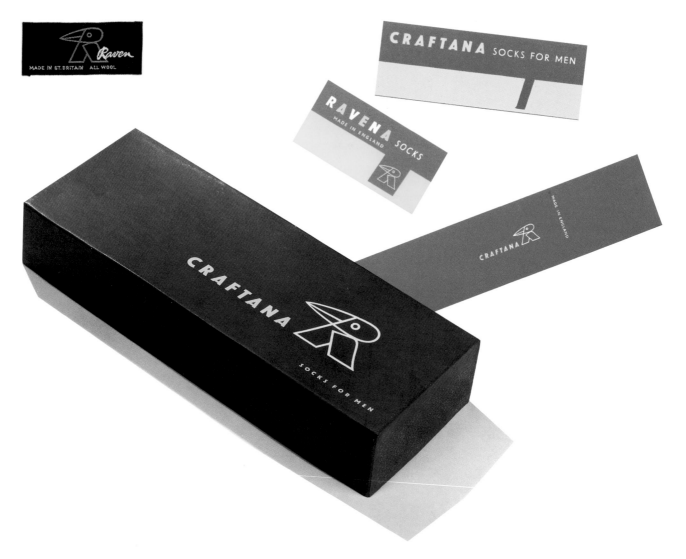

Cover of a quotation folder

Parcel label

Company letterhead and envelope (die-stamped)

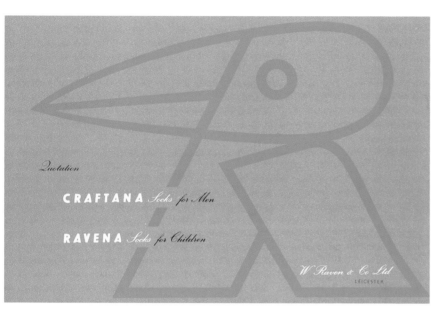

**Mac Fisheries
1952-9**

The Mac Fisheries corporate identity begun in 1952 was, I believe, the first of its kind for a chain of food shops. It was an enormous task and for many weeks when we started on it the studio was full of rather smelly fish. We made a complete model of the newly designed shop interior, with every kind of fish modelled with loving care for the fishmonger's slab, now to be part of a closed shop style.

Schleger was very keen that every shop manager should be aware of what we were trying to achieve, as naturally at first they would be suspicious of this new-fangled thing called design. Bristol was chosen for the test area as it had a good mix of shoppers. All went well there, so managers' dinners were arranged for London and northern and southern areas of England, to explain the new identity which was to be fed into over three hundred Mac Fisheries branches.

Schleger himself said of the scheme, 'The difficulty of interpreting a large organisation to the public is its impersonal character, people are understandably afraid of it. Everyone wants to be treated in a personal way, customers, clients, and housewives … they all want to be given a special service and thought of as individuals. The Mac Fish figure can speak proudly yet remain local, send you to a cookery demonstration, fillet and deliver your fish for you. Handwriting was deliberately chosen to carry on the fish-mongers' tradition of chalking up today's good news on the blackboard, it is distinctive, friendly and gives the feeling of freshness.' With this in mind, handwriting became an integral part of all publicity and was written each time afresh. No handwriting typeface was designed.

The Mac Fish figure was friendly and fun. The humour which permeated the campaign made it easier for the public, renowned for their conservative attitude towards food, to accept the new approach to selling fish. The slogan, *Mac Fish – fresh fish*, was combined with the redesigned symbol, thus making them synonymous.

The Mac Fisheries campaign was an example of what can be achieved when a detailed scheme covering (and relating to each other) advertising, merchandising and packaging is laid down, agreed, and then logically carried out. From 1952 to 1959 over seven hundred different designs completely transformed the firm's graphic face.

Ashley Havinden, managing director of the famous advertising agency W.S.Crawford, wrote to Schleger:

16 December 1953

Dear Hans

I am continually being struck by the excellent publicity for Mac Fisheries. I do congratulate you on this. Not only is all the designing first class, but I think more important still is the co-ordination of your work which is brilliant. That is to say, the advertisements, posters, delivery vans and the shops, all echo the same theme.

As the theme is a brilliant one, I imagine your work is proving a great success to Mac Fisheries. Congratulations on this great contribution you are making to keep good design going in advertising.

As ever yours
ASHLEY

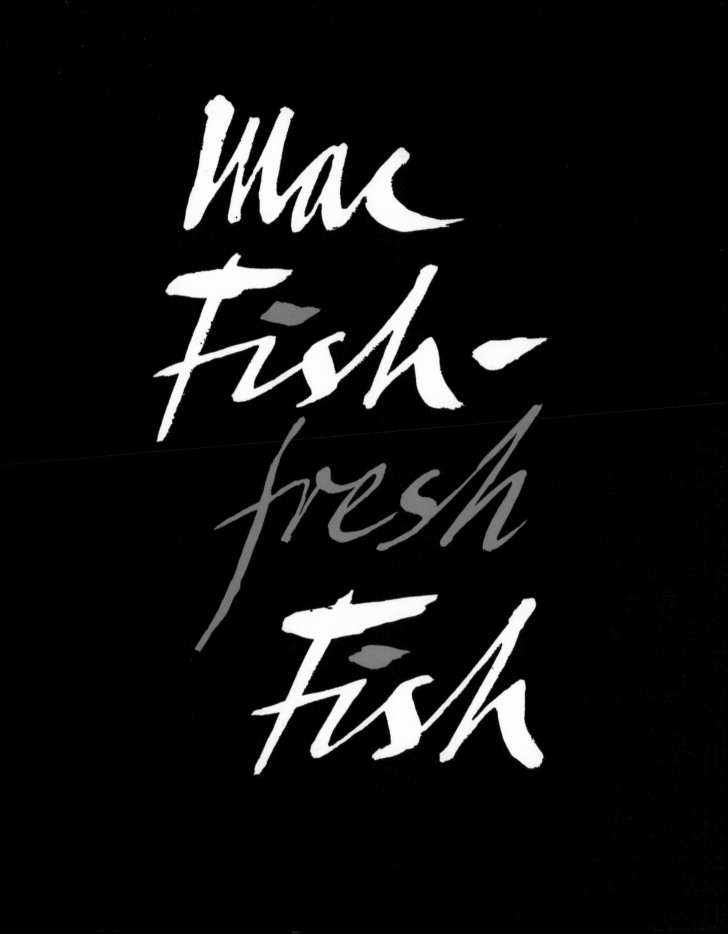

Poster for shop interior

Mac Fisheries asked Schleger to design a new symbol but he thought the existing one (created in 1919, bottom left) was basically a good design and only needed modernising and liberating. It incorporated the St Andrew's Cross from the Scottish flag.

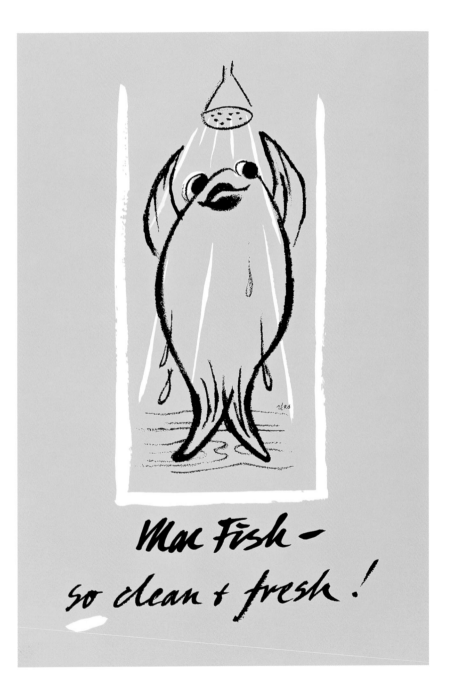

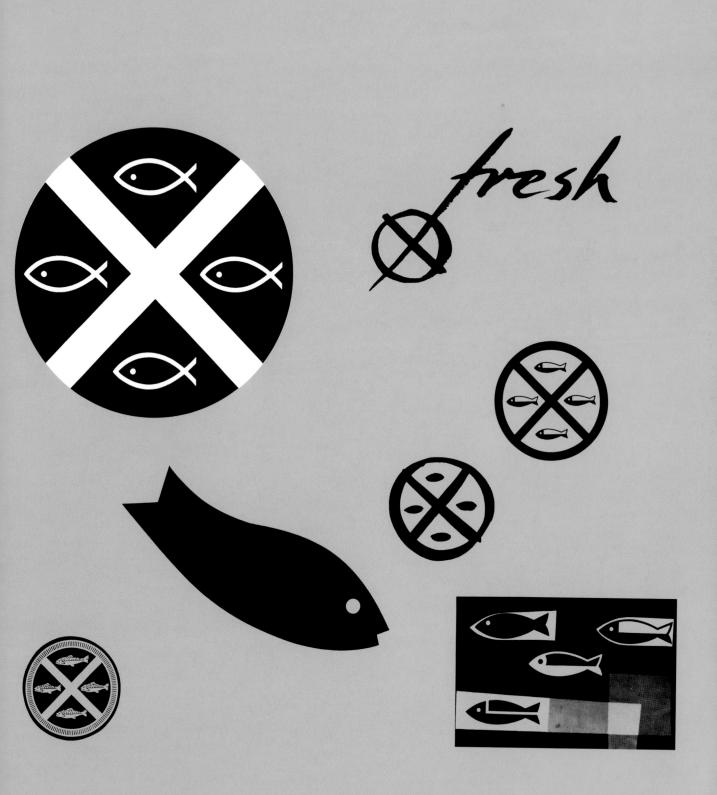

*Newspaper advertisements
mostly seen in local papers
and the first indoor poster for shops*

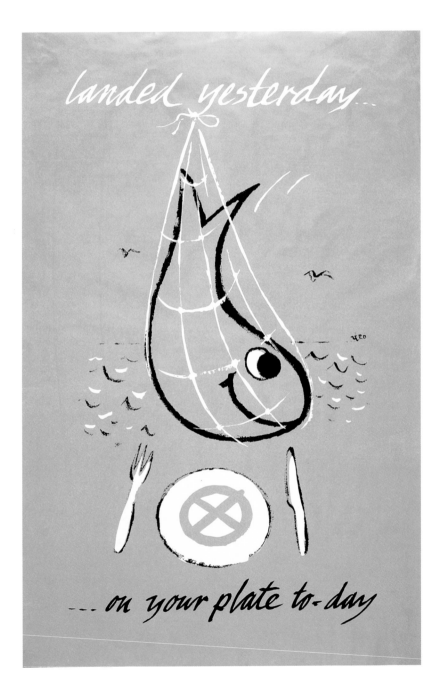

Top shop for Fish
MAC FISHERIES

Mac Fish—fresh fish: no fresher fish any-where, in fact! It's landed one day, on sale at Mac Fisheries next morning. And as you know, *fresh* fish has a flavour all its own.

SHIP-SHAPE SHOP

Your Mac Fisheries is a model fish shop. Everything's clean, and you can see it's clean. Everything's laid out clearly, and clearly priced. Everything you buy is wrapped and wrapped again in clean paper.

Finally, you don't hang about, for the service is brisk. And helpful. And friendly.

TIP-TOP VALUE

Fish is first-class protein, therefore first-class food value. Mac Fish is also first-class money value. Just look at the prices next time you pass Mac Fisheries. And then, if you're wise, you won't pass. You'll stop and go Mac shopping.

Ⓧ *Mac Fish – Fresh Fish*

Mac Fish SHELLFISH
make a lovely surprise

This is the time to feast on shellfish: they're right in season now. Surprise the family with seafood salads, savouries, curries, cocktails.

Delicious, quick, and not expensive.

Ⓧ *Mac Fish – Fresh Fish*
BUY IT FROM MAC FISHERIES

GOOD FOOD
GOOD VALUE

HOW MAC FISH MAKES THINGS EASIER

It's easy enough to spend money: the trouble is to work out where it's gone.

Mac Fish makes your shopping a lot easier – First, because the price is always clearly marked: you can work out in advance exactly what you can afford, before you say a word. Secondly, there are the Mac Fish Special Offers – specially low-priced.

Mac Fish – everything from Mac Fisheries – is always *absolutely fresh.* It's in the shop the day after it's landed from the sea.

Mac Fish – Fresh Fish
BUY IT FROM Ⓧ MAC FISHERIES

Name and price tickets. A special colour for each type of fish helped identification, facilitated choice and reduced the time spent on each sale.

Poster for shop interior, fish boxes, window stickers, carrier bag, invitation card to a cookery demonstration.

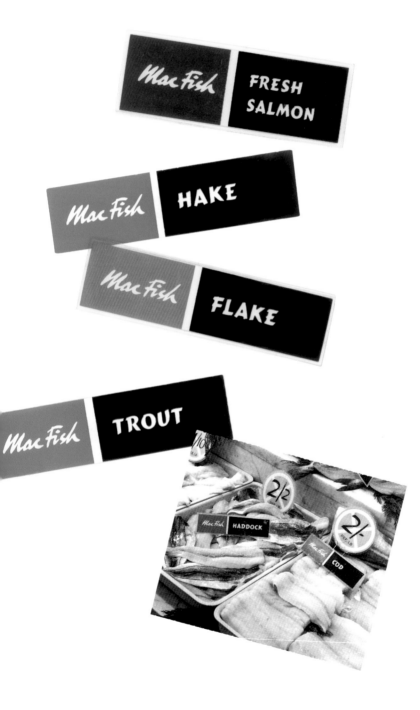

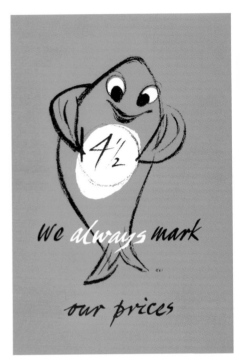

The redesign of the van fleet was important publicity for Mac Fisheries. Daily deliveries were all part of their customer service. The photo shows a van entering the gates of Buckingham Palace to bring a sturgeon to the Queen – it is a royal fish.

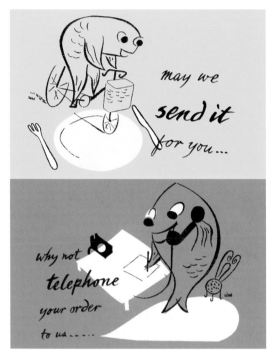

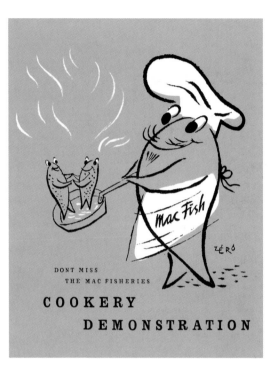

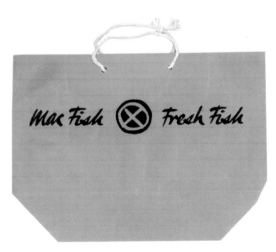

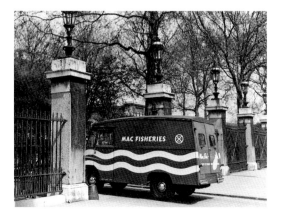

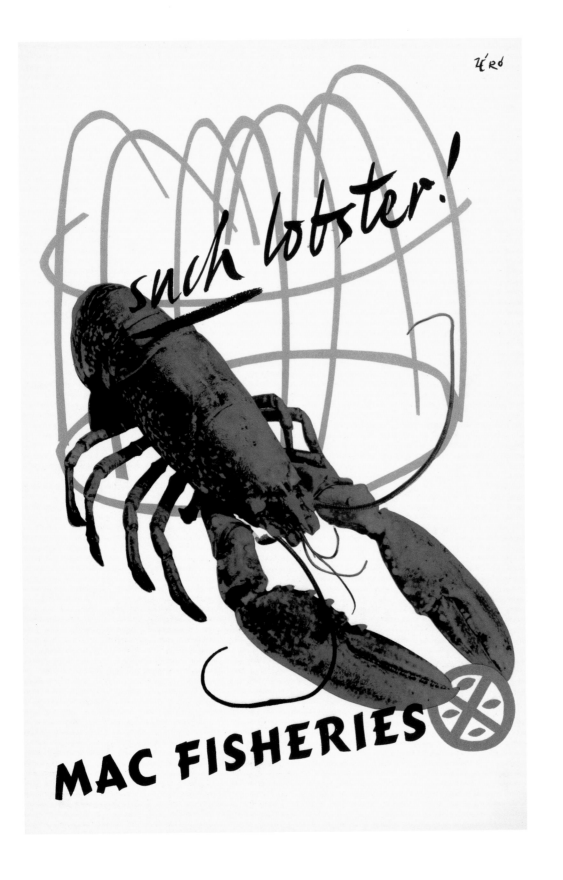

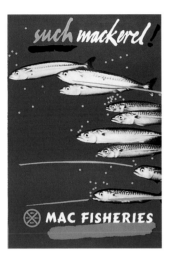

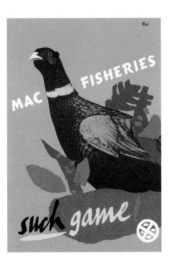

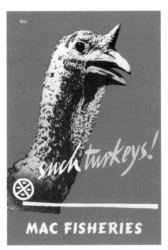

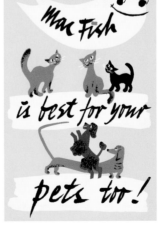

Covers of the menu cards for
Mac Fisheries managers' dinners.
By 1956 the Mac Fish figure
was so well known that it was imitated
in a Punch cartoon.

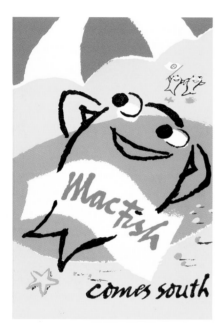

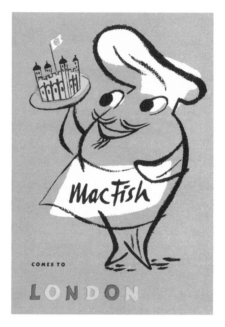

MACFISHERY

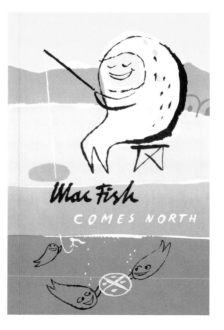

The packaging scheme for Mac Fisheries was innovative in its use of colour for identification instead of for surface decoration. The symbol was used as a colour coding system. Blue, green, yellow and grey for fish, vegetables, fruit and sausages; pink for shellfish and brown for kippers and pastes. Photographs of the frozen merchandise on the outside of the pack, combined with the colour coding system, made for easy identification in the new frozen food cabinets.

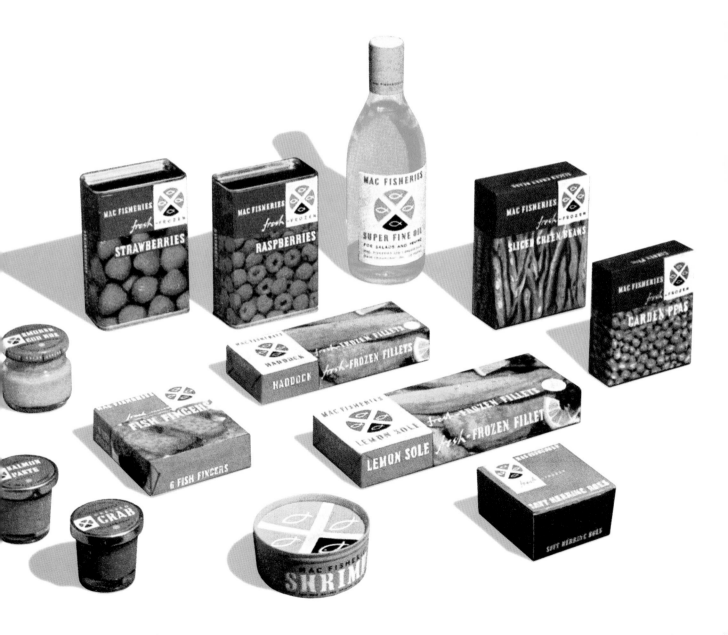

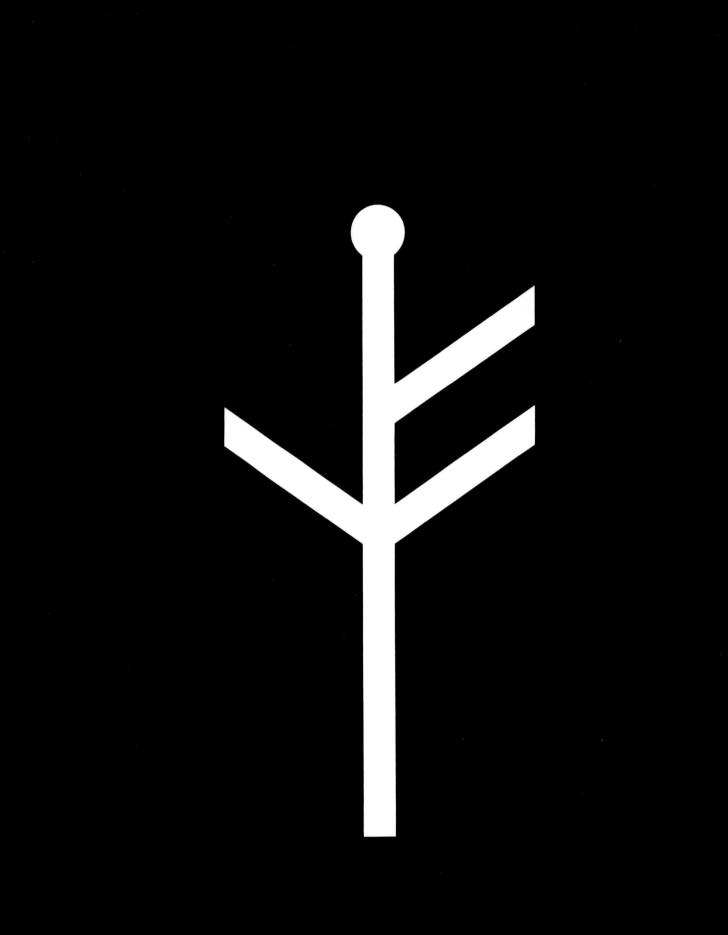

Finmar Furniture Limited
1953-63

Finmar were influential importers of Scandinavian, German and Italian goods; furniture and furnishings, porcelain, glass and kitchen utensils. The goods sold were simple, functional and well designed, intended for a growing section of the British middle class who were taking an interest in modern design. The director of Finmar, P.E. von Stemann, entrusted Schleger with the conception and graphic design of all the Finmar publicity, thus making possible the creation of a completely integrated style and the employment of it with a maximum degree of simplicity.

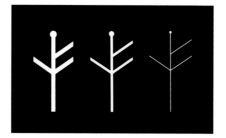

The trademark is an abstract combination of three elements: the letter F, a man and a tree. It was designed in three weights to ensure typographical adaptability.

Paul-Ernst Stemann wrote in 1995, in his own inimitable Danish-English of how the Finmar logo and its consequent 'Face of the Firm' was born:

Hans had a clear conception of the way in which a design should develop and I think it was much influenced by his social awareness and his logic. By designing a logo he formulated Finmar's design policy. He was anchored deeply in Bauhaus theories and tradition. Like so many who have been inexplicably forced to leave their homeland, he was still romantically attached to the Prussia of his childhood.

Hans never took his work lightly. He would go to endless trouble and expense to get it right. The presentation of the final design was an occasion of great importance.

I remember being summoned to the studio when the Finmar logo was ready. There was a sumptuous luncheon prepared, and the assistants — starry-eyed and eager in anticipation of the outcome. There the designs were in many variations. It was like Christmas, when the tree is lit and we come to the presentation of the newly born baby. It started with the luncheon, but it had long been dark and fresh supplies of red wine sent for and placed by the stove before it was over. It was a battle won and a new dawn for Finmar.

Hans' face could shine in childlike joy if he was presented with a beautifully designed object. No detail escaped him and he was deeply appreciative of all the talents needed to create simplicity. He had ample talents himself and the happiness of achievement. There is no doubt that he left the world a richer place than when he entered it.

Greetings card 1957

Coffee Master pack c1959

Pages from the leaflet which
accompanied the coffee maker

Greetings card 1954

Invitation card 1954
An exhibition of the work of
Astrid Sampe showing carpets
and fabrics

Moving card 1953

FINMAR Limited 26 Kingly Street London W1 telephone Regent 8308

Greetings from FINMAR

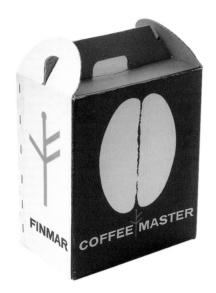

instructions

Finmar's newest addition to its oven-
to-table-range is the Coffee Master.
As more coffee is now being drunk
in Britain than ever before it is natural
that Finmar should look into the
problems of coffee-making.

It is as a result of this research that
we found the Coffee Master.
Developed and designed in Denmark,
the glass is made in Britain.

To our mind the Coffee Master is not
only the best and most economical
instrument for making coffee but it is
as good looking as it is functional.

Because of its attractive packing it is an
especially useful and elegant gift for
all occasions.

Two things are necessary for making
good coffee, so please note.

Follow the instructions 1
for the Coffee Master in every detail.

However good the Finmar Coffee
Master is, the final judgment is in the
quality and quantity of the coffee beans
used. The secret is finding what suits
your taste.

instructions

Fill lower flask with required quantity 1
of boiling water not more than
four fifths full. Place flask on stove

Expand metal spring of filter and hook 2
on to lower edge of funnel. Place the
funnel loosely on the lower flask. Put
coffee in funnel

The water will rise into the funnel and 3
mix the coffee which should be stirred
well. About half an inch, ¾" of water
will remain in the bottom of the lower
flask. Leave the Coffee Master on the
stove for another two, 2 minutes. By
this time the correct vacuum has
formed in the lower flask and all the
aroma will have been extracted from
the coffee in the funnel

Take the Coffee Master from the stove 4
and in a moment the coffee will run into
the lower flask. The grounds will all be
trapped in the funnel. If the coffee
stops running into the lower flask
replace the Coffee Master on the stove
and allow the coffee to rise again
before removing from the stove

When the filter has emptied and the 5
bubbling has ceased, remove the
funnel and serve the most delicious
coffee ever from the lower flask

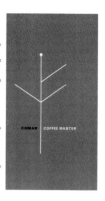

FINMAR COFFEE MASTER

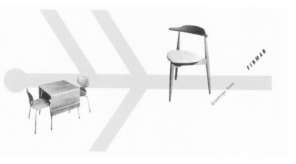

Greetings from FINMAR

FINMAR 26 Kingly St London W1

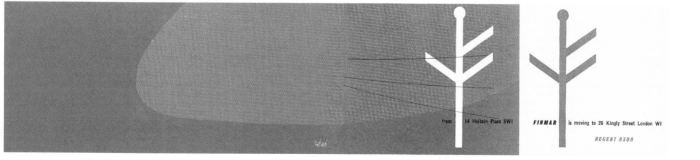

from 14 Holbein Place SW1 FINMAR is moving to 26 Kingly Street London W1

REGENT 8308

Posters, 1957 and 1958
Special displays of Finmar's goods
were shown at Liberty's, London

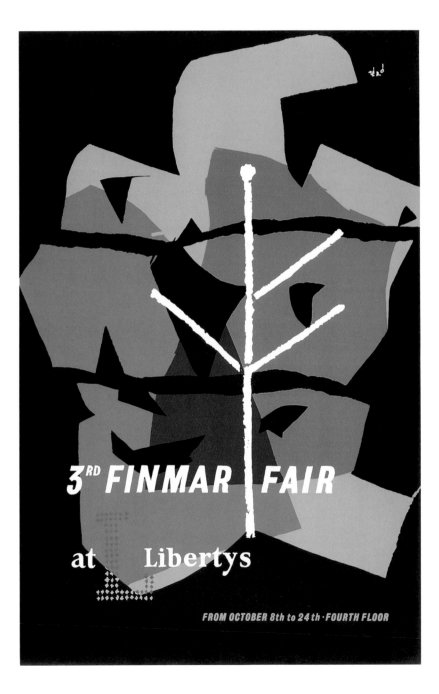

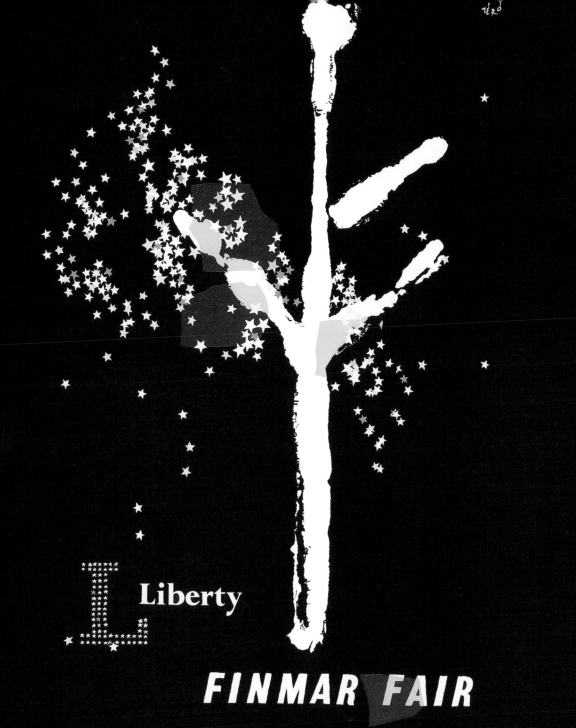

Liberty

FINMAR FAIR

FROM OCTOBER 9th to 25th · FOURTH FLOOR

Label with name and address
on the reverse

Two loose-leaf pages from the
catalogue. All items of furniture were
printed on separate sheets and held
in a black pocket folder.

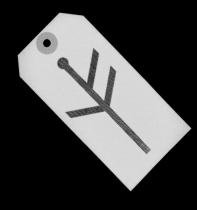

FH 4300 Armchair in solid teak with rubber webbing in seat; seat and back covered with 1½" foam rubber. Designed by Kai Kristiansen, very elegant and comfortable. The shaped arms is a fine example of Danish craftsmanship.

width 2' 3"
depth 2' 4"
height 2' 5"
1½ yards of fabric required.

FINMAR Limited 26 Kingly Street London W1 Telephone Regent 8308

Contourette Roto Easy chair on a swivel base. The armless frame is of steel and metal springs. Upholstered with foam rubber and available in the large range of Finmar fabrics.
The base is polished alloy. The headrest has a removeable cover which is fastened with leather straps.
Dux design

width 1' 11"
depth 2' 6"
height 3' 2"
1½ yards of fabric is required.

FINMAR Limited 26 Kingly Street London W1 Telephone Regent 8308

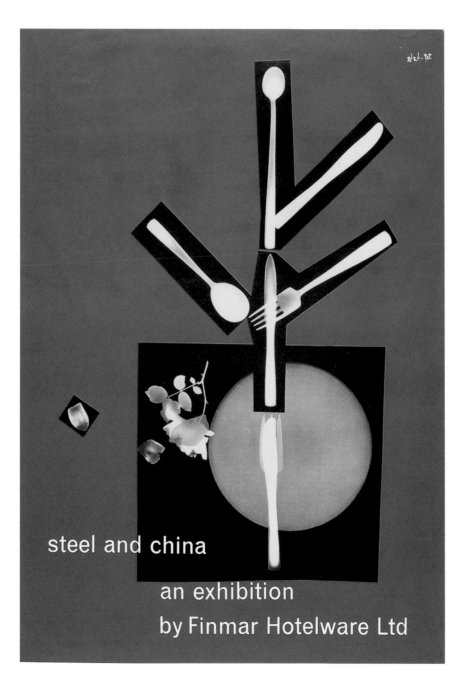

vasa

Vasa 1960-5
Vasa was Finmar's elegant and
sophisticated retail shop in Belgravia,
London. It sold furniture, glass,
ceramics and textiles.

*The wrapping paper was designed
to ensure that each package would
look different. The logo with a red shape
was not on the paper but on specially
produced rolls of sellotape.*

**Edinburgh International
Festival 1966-78**

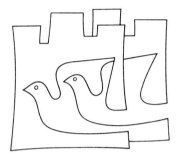

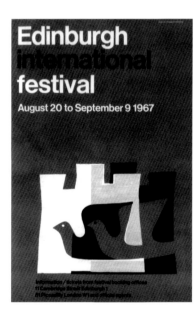

In 1966, Peter Diamand, the new director, asked Schleger to create the Festival's first corporate identity. It was to be used for all the Festival's publicity, including posters, leaflets, the official programme, stationery, tickets and advertisements.

To design a motif which would unify all their activities presented a special problem since the Festival embraced *all* the arts. The castle is a landmark of the city, the birds with which it is combined know no boundaries – gathering and dispersing – they are symbols of freedom and imagination. After a number of years we began to let the birds out of the castle, as it were.

The official programme was divided into sections for opera, recitals, theatre exhibitions etc. Special emphasis was given to these pages and each year we looked forward to designing them. We chose a theme to link them together, such as photographing an image through a multiple lens or abstract marbling patterns. Sometimes we used interesting photographs of performers, dancers or playwrights. This occasionally turned out to be hazardous. Once we had a dramatic photo of the famous and ageing conductor Stokowski and decided to use it for the section on Choral and Orchestral Concerts. Shortly before the programme went to press he became ill and had to cancel. What on earth could be done? Schleger looked at the image and said 'his hands are so expressive, let's retouch his head out and use the photo with just his hands'.
So we did.

EDINBURGH
INTERNATIONAL
FESTIVAL 19 AUGUST–8 SEPTEMBER 1973

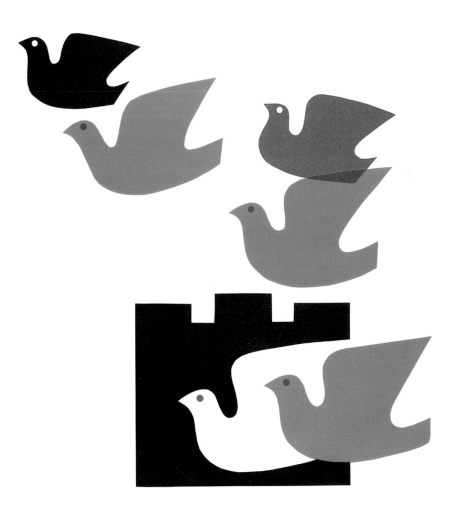

EDINBURGH INTERNATIONAL FESTIVAL
20 AUGUST – 9 SEPTEMBER 1978

	wednesday 23	thursday 24	friday 25	saturday 26
7.30 pm	Scottish Opera Debussy: Pelléas et Mélisande	Edinburgh Festival Opera Bizet: Carmen	Scottish Opera Debussy: Pelléas et Mélisande	Scottish Opera Debussy: Pelléas
8.00 pm	London Symphony Orchestra Claudio Abbado conductor Isaac Stern violin Berlioz: Overture Carnaval Romain Sibelius: Violin Concerto Janáček: Sinfonietta	Daniel Barenboim piano Schubert: Four Impromptus op 142 D935 Sonata in B flat major op posth D960	London Philharmonic Orchestra Edinburgh Festival Chorus Carlo Maria Giulini conductor Ileana Cotrubas soprano Dietrich Fischer-Dieskau baritone Brahms: Tragic Overture A German Requiem	London Philharm Edinburgh Festiv Carlo Maria Giul Ileana Cotrubas Dietrich Fischer- Brahms: Tragic A Germ
11.00 am	LaSalle Quartet Beethoven: Quartet in F major (Arrangement for string quartet of Piano Sonata op 14 no 1) Lutoslawski: Quartet (1964) Brahms: Quartet in B flat major op 67	The Nash Ensemble Sheila Armstrong soprano Schubert: Adagio and Rondo in F major for Piano Quartet D487 The Shepherd on the Rock for Soprano, Clarinet and Piano D965 Messiaen: Quartet for The End of Time	Jessye Norman soprano Dalton Baldwin piano Schubert: Lieder Messiaen: Cinq Poèmes pour Mi Ravel: Chansons Madécasses	Composer's Pre Catherine Gaye Alan Hacker cl Orion Piano Tr music by Moza introduced by
3.00 pm	Fun and Games—recital Diana Rigg, Frank Muir	Fun and Games—recital Diana Rigg, Frank Muir	Fun and Gam Diana Rigg, Fr	
7.15 pm	Malaya Bronnaya Company Gogol: The Marriage	Malaya Bronnaya Company Turgenev: A Month in the Country	Malaya Bronnay Turgenev: A Mo	
7.30 pm	Edinburgh Festival Productions Shakespeare: The Tempest	Edinburgh Festival Productions Shakespeare: A Midsummer Night's Dream	Edinburgh Festiv Shakespeare: A N	
7.30 pm	Royal Shakespeare Company Shakespeare: Twelfth Night	2.30 and 7.30 pm Royal Shakespeare Company Shakespeare: Twelfth Night	7.30 pm Royal Shakespeare Chekhov: The Three public preview	
9.00 pm	Military Tattoo	no performance	7.45 and 10.30 pm Military Tattoo	

EDINBURGH 30th INTERNATIONAL FESTIVAL
22 AUGUST – 11 SEPTEMBER 1976

EDINBURGH INTERNATIONAL FESTIVAL · 24 AUG – 13 SEPT

Edinburgh International Festival
24 August to 13

opera Edinburgh Festival Opera *Figaro*: Barenbo... Cotrubas, Evans, Fischer-Dieskau, Harper. Deutsche Oper *Salome* and *Lulu*: Albrecht, Peters, ... Johnson, Driscoll, Schröder-Feinen, Varnay, van Dam. Scottish Opera *Hermiston*: Gibson, Gayer, Carlson, Langdon.

concerts New York Philharmonic, Israel Philharmonic, Orchestre National de France, London Philharmonic, London Symphony, Scottish National, English Chamber. Abbado, Baker, Bernstein, Boulez, Donath, Gibson, Giulini, Janowitz, Mehta, Previn, Rostropovich, Vishnevskaya.

recitals Arrau, Brendel, Ballista, Canino, Perlman, Pollini, Rostropovich, Vishnevskaya, Yepes, Vesuvius Ensemble. Quartets: Allegri, Amadeus and Tokyo.

drama Prospect Theatre Co, Athol Fugard's Serpent Players, Ronconi's Cooperativa Tuscolano, Royal Lyceum Co, Nottingham Playhouse Co.

dance The Royal Ballet: Nureyev, Seymour. Nikolais Dance Theatre. Exhibitions. Verse and Prose recitals.

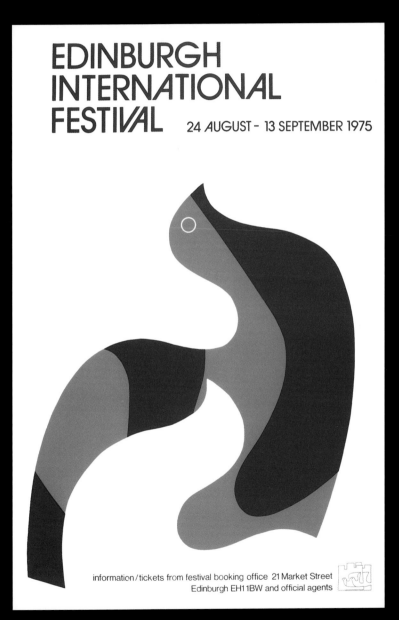

Edinburgh International Festival
Programme covers, 1967 being the first.
In 1969 the Festival had an Italian emphasis;
Schleger used a photo he had taken of the
paving design outside Siena Cathedral.
The front and back covers for 1973 were
from marbling prints produced in the studio.

27th Edinburgh International Festival 1973

official programme/price 50p

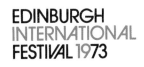

EDINBURGH INTERNATIONAL FESTIVAL 1973

official programme/price 50p

Edinburgh International Festival
Programme cover and a selection of pages
from the programmes. Photos by Schleger:
Cover 1972, Choral and Orchestral Concerts
and Ballet.

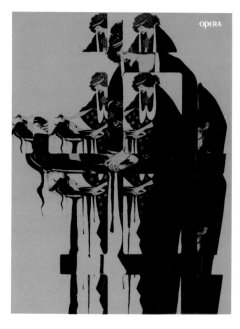

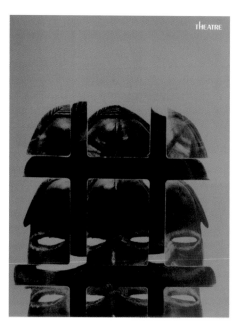

choral and orchestral concerts

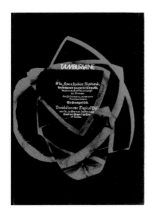

TAMBURLAINE

" MACBETH

OPERA

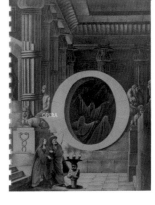

ballet

OTHER EVENTS

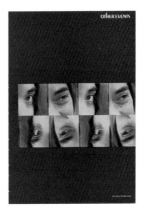

Carlo Maria Giulini
Dietrich Fischer-Dieskau

From the beginning of his career Schleger
had been interested in photography and
had one of the first Leica models to be
produced. Occasionally, we were able
to use his photographs as section pages
for the official programmes. Shown here
and overleaf.

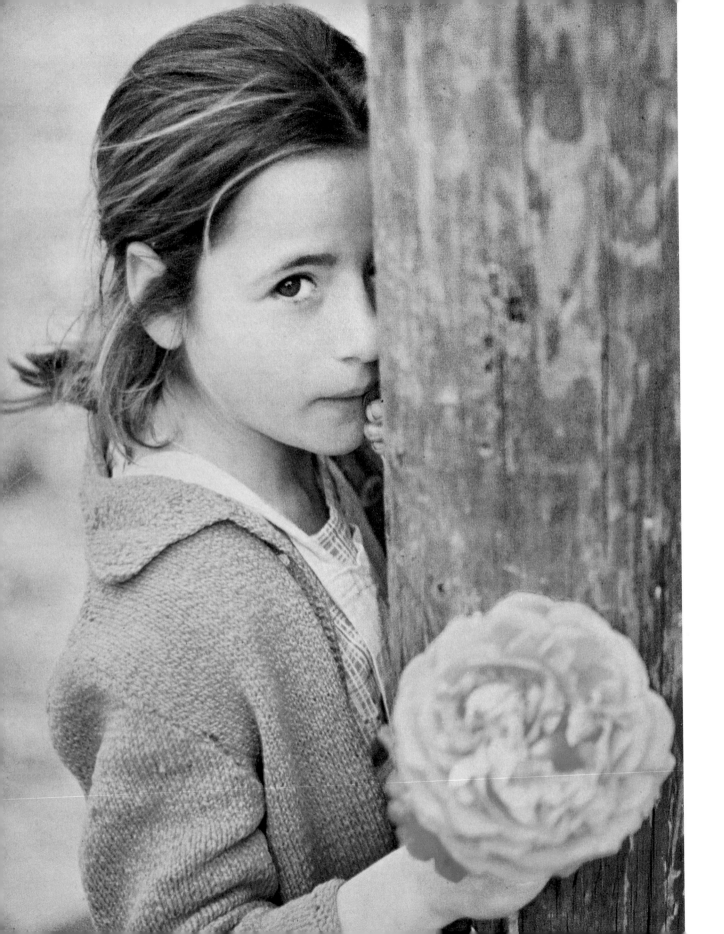

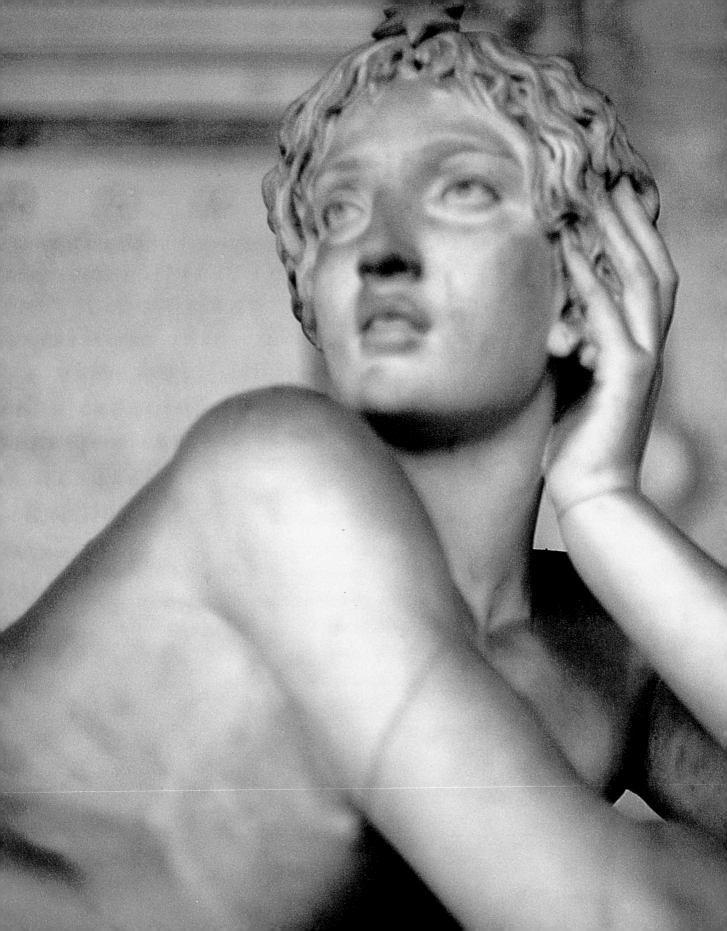

Education – A time for Discovery

Lecture given at the World Conference on Design in Tokyo, May 1960

Hans Schleger

When you think of comparing a human being with a watch, do not forget the watchmaker. Nothing turns of its own accord but somehow the watch has been set to run. Things are not outside and we are here in our shell thinking about them – our thought is living and moving in the things. Unbelief in the spiritual content of the world underlies the greatest impracticability of thought. Rudolph Steiner

I believe that we know less of ourselves and of the world around us than we think we do and that we are too impatient and could be more modest in the demands which we make on our time. This is an age of definitions – a time in which views are held firmly. This attitude has been a disappointing one before. Not all things can be measured. The pedantic approach to the future has become discredited by events. The new generation is disturbed, unsettled and dissatisfied with the inheritance of anxiety which growing and often exclusive occupation with material values has brought.

Education is one of the most responsible jobs that I can think of – because while we may make mistakes, and we all do, there is one mistake which should never be made and that is to teach without making every effort to study the methods which have laid the foundation for good lives. Goethe said that one can make mistakes but one must not build any.

We may well apply to teaching what Mies van der Rohe said of architecture, 'Form is not the aim of our work, but only the result. Form as an aim is formalism and that we reject.'

I have been thinking again about the principles which underlie the foundation course of the Bauhaus and also about those of Froebel. They have much in common. Froebel said that a young person must not be taught creeds or formula. He believed in guiding children into becoming observant and wishing to learn. He said the time for abstractions comes later. First comes the visible world and through it the student will learn to understand the invisible truth. These two can be united by concrete images.

The student does not wait till school-time to use his senses – the unfolding of his faculties begins with the first breath and ends with the last. The assistance given to the development, is education.

Heavy demands are made on the student, the goal is invisible, the way to it tormentingly difficult, or sometimes so deceptively easy to reach, that it frightens. There is a maze in front of a young person's eyes and I believe that it is necessary to help the student to find his way through it alone and yet not unaided. Like in the teaching of the great religions in their early uncodified – mystical – form, it is the student who has to discern and grope until the teacher can affirm that the student has reached a higher level.

This seems a hard way, especially for the teacher, who may long to prevent mistakes and to guide along safe ways, giving instructions in an accepted form of expression before the student has reached the inner assurance which only first-hand knowledge can bring.

A group of students will help each other inter-dependently as a healthy glandular system does the body. The young group is eager and dedicated but also sceptical in order to protect its wax-like receptivity and is consequently often rebellious and resisting. They are asked to explore and find *ways* rather than *techniques* and don't have to listen to yesterday's solutions. And yesterdays can come quickly. Every man finds it difficult to accept a solution to his problem from anyone else.

Students are interested in search. I believe with Ouspensky that 'with astonishing rapidity those principles which only yesterday expressed the highest radicalism in the region of thought have become the basis of opportunism in the region of ideas and serve as blind alleys, stopping the progress of thought ... Truth itself is motion and can never lead to arrestment, to the cessation of search. All that arrests the motion of thought is false... striving toward knowledge does not recognise the possibility of life arrestment in any found forms of knowledge at all. The meaning of life is in eternal search.'

It is the teacher's task to be among growing young people and he has to decide whether he will aggressively consider his student as part of a hostile environment, or whether he will work with his group – travelling on a higher level of experience. Both he and those to whom he is a guide but not a dictator, need constant dedication and courage, and no insatiable ambition to succeed for the sake of success. Ambition leads to the wish for early attainment which is always achieved at the expense of development. A man should not grasp and lose, and act prematurely and destroy what he has. Rather should we study the universal law as others have done before us and participate in the complete scheme of things.

Truth is difficult if not impossible to express and all systems of teaching are conditioned by this, (Clement of Alexandria said that truth is usually presented only in perspective like in a drawing or painting – in a deformed shape.) But it has been found that men who were looking for the truth within themselves are going forward like on the converging lines of a protractor and are coming nearer to one another as they approach the focal point. Man is and remains part of an expanding universe, but he can do much to bring order into that small part of life which is his to live. Everyone's actions influence other people's existence.

Lao-tzu said, 'Who can make muddy water clear? But if allowed to remain still it will gradually become clear by itself. Who can attain a state of absolute repose? Let time go on and the state of repose will gradually arise.' This of course is true only of a healthy man – the neurotic will avoid inner tranquility at all costs.

Many art schools teach in grooves to produce immediate results and they do not educate a person from within into the life we are able to live. During the foundation course on the other hand – and in addition to many other features –

it will happen that the almost seismographic recordings which the student will see appearing under his hands will teach him (and the group) who he really is.

Self-knowledge and paying no heed to the passage of time, bring him nearer to freedom. Doing, working, not only reading and museum study, bring awareness. The student should always be ready, or rather be able to discard what he has done after studying it, instead of believing it to be anything but a revelation of some part of his nature.

Working in this way there will be no danger of becoming what Count Kayserling called the 'chauffeur type of man'. The man in charge of power to which he has no right of ownership. The student should not be in charge of powers which he has neither discovered nor can yet control, of which he has not invented the mechanism and for which he is not providing the fuel. Nor should he feel himself a designer because he has seen and remembered designs.

I believe that living for constant search and growth, living each day, ('and not,' as Moholy said so well, 'leading a memorised existence'), caring for values developed through the work and employing all one's faculties at one's highest level of performance in the work, is a good life.

True dedication drives away insecurity and dependence on biased criticism or approval. It brings vitality and optimism.

While Schleger was in Japan he had a seal made of his pseudonym Zero – as shown above.

Manchester Polytechnic
1972-1980

Schleger was always interested in education and was delighted when the head of the Faculty of Art and Design, John Holden, asked him to become the Polytechnic's design consultant. It was government policy in the 1960s to recommend that in the bigger cities where separate colleges had had their own autonomous identities, they should all come together under one Polytechnic umbrella. In so doing it was thought that a central administration would help to cut costs and as larger bodies, the Polytechnics would have more say in educational policy making. In Manchester the publicity material for this new group of colleges was in complete disarray and needed a direction and visual style of its own. The following are extracts from one of Schleger's first reports, his thoughts on the value of an image for Manchester Polytechnic and the direction that the image should take.

Style is a unity of principle animating all the work, the result of a state of mind which has its own special character.

Le Corbusier

The image represents the face which is formed from within, without artificial make-up. It will serve to attract good staff and students and assist greatly in the establishment of favourable public relations. The image is not a super-imposed graphic style used for its own sake.

The image can help to give identity, to focus attention and interest; it is a visual expression of the specific personality of the Polytechnic. It will transmit a sense of security and dispel resistance because it is based on true statements of performance, on actual human situations and real needs. It will give outward expression to inner conviction.

Leaflets for individual subjects

Cover and double spread from a brochure for the department of Law

It is worth bearing in mind that contrived originality at all costs is a mistake and to strive to be different is misguided. Our needs here are a highly individual blend of many different factors. If the design solution evolves, as it should, out of a thorough consideration of most of them, then this alone will produce the essential personality.

Heavy armour is rigid, soon it is made obsolete by progress. The task is to blend each individual message into the image. That is why a house style should always be in a state of growth and part of a living form of communication.

Identification with real life situations in the Polytechnic through a specific style of photography.

We chose the documentary approach because it gives the veracity we were particularly looking for. It enables us to relate directly to the students, to try and see the Polytechnic through their eyes and be aware of some of the emotional hazards they encounter when embarking on this very important part of life.

Schleger continues...

A symbol must be used with understanding and discretion and not necessarily be added to every available piece of publicity. Used discerningly and with restraint, it will enhance the family feeling Manchester Polytechnic is in the process of creating from within its own walls, to the outside world.

It was only after working on a cohesive style for faculty brochures and leaflets that it was thought necessary to design a symbol – in this instance it did not come first.

Variations of the basic symbol were designed when they were needed:
The *condensed* version for small ads in newspapers.
The *light* version for stationery and brochures.
The *medium* and *bold* versions for signing.
The *outline* version for a franco post.

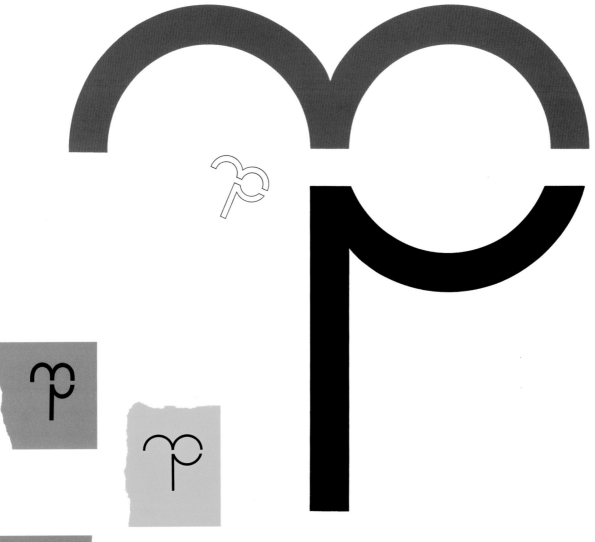

Cover of a leaflet for Waterman's pens

Showcase for fountain pens

Encased pen in clear plastic
Shop counter display

Waterman Pen Company
1952

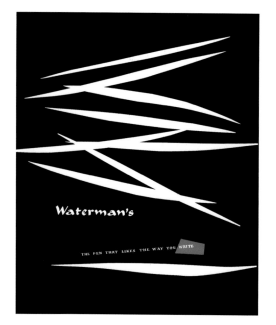

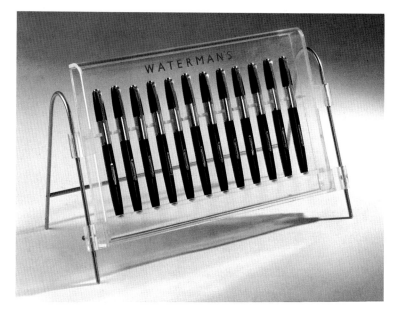

The story of the design of the Grants triangular bottle 1955-6

When the managing directors of a family whisky firm, William Grant & Sons, came to Hans to design a new bottle, they brought a short and specific brief with them. It must be distinctive, elegant, competitive and show the colour of the whisky. It should pack well and have the ability to fit into a bar slot.

Hans felt the triangle was the logical answer. The hand closes around the triangular bottle while a round bottle opens the hand and weakens one's hold. And there was no triangular bottle in the market. We set about sculpting the shape out of clay, making one model after another. Then progressing to plaster of Paris models. To create a shape which would hold approximately the correct amount of liquid, we filled a large bucket of water to the brim and plunged the bottle in, measuring carefully the amount of water it displaced – Eureka! Eventually we were less than a fluid ounce out, when the first prototype was made.

Hans wanted the graphics to be fired onto the glass as shown here and to do away with a conventional label. This would have integrated bottle, identification and contents, and stressed the sculptural quality of the bottle. The vertical position of *Stand Fast* made it readable when the bottle was hung upside down in bars. However, at the express wish of Grants, the label was only slightly modified; we called it a tidying up operation. The label has now been replaced by a busy gold one. Grants has joined the crowd.

When Hans took the new bottle design up to the Grant offices on Speyside in Scotland, there was an atmosphere of excitement and anticipation. The curtains were drawn before the bottle was unwrapped and placed on the table. When the joint managing directors, Eric Roberts and the young Charles Gordon Grant, saw it they knew immediately that this was it. From the commercial point of view it looked good, felt good and looked big. It was a fine design. Then they locked it away in a safe.

Shortly after its launch the bottle was featured in *The Director* magazine and the caption ended, 'the design world criticises the retention of the old label, it should have been redesigned to tailor with the new shape.' Little did they know how sad we all were that the total concept was never completed.

When our first daughter was born, not long after the introduction of the new bottle, the Grant family sent us a case of Krug Champagne – rather than whisky – which touched us very much.

Former Grants Whisky bottle and the new triangular bottle. The triangular bottle has a sense of elegance and originality and appears considerably taller than the more commonplace round whisky bottle.

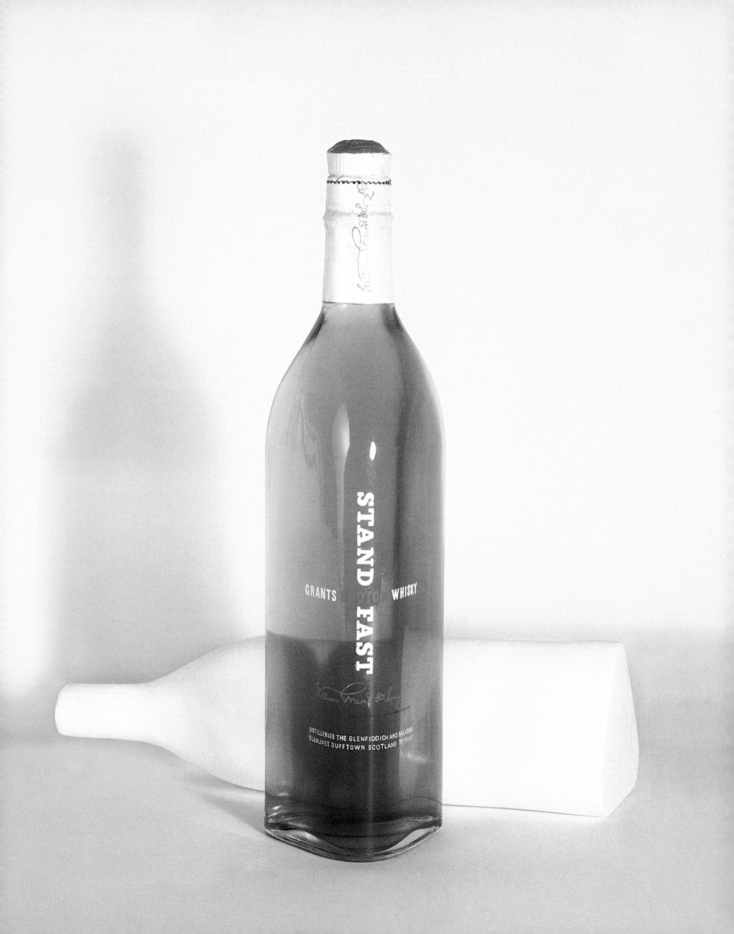

British Sugar Corporation 1961-75

Schleger wrote of House Style: 'I like to come to the problem without any luggage and pre-conceived notions, to discover the situation for myself and work on it simply, on my level of experience... It may happen that one starts thinking in terms of typefaces and trade marks as a first platform for the design policy, but soon this becomes too narrow a base. It can serve however, as if by magnetism, to attract other features around it and so become a nucleus. You can also think of it as an embryo which already has all the relevant parts necessary for it to grow into a strong living organism...

The work of creating a company's image is one of the most stimulating experiences because of its dynamism and challenge, to create order within a framework which gives form through discipline and throws out old and tired concepts...

I try to develop a scheme from within — to contact and interest only the relevant section of the market. I look for the opportunity of producing an indigenous, uncontrived image, expressive of the inner character of the firm and utterly inexchangeable.'

The British Sugar Corporation was Tate and Lyle's biggest competitor and as their name implies, their product was processed entirely from sugar beet grown in the UK. Practicality and simplicity were the design elements used as the basis for the brand image which was developed. White (like sugar) was the predominant colour, which together with red and blue gave a British emphasis. The packs were economical to produce and easy to make up, fill, close, seal and handle. In fact, our choice of white as the background colour for the packs saved BSC tens of thousands of pounds a year in printing ink, especially as granulated sugar packs sell by the million. We began with the design of retail packs.

These are some of the principles on which the designs were based:

The various packs should have a family likeness and provide a good visual identity of the BSC brand.

The packs should help towards acceptance of the products as cleanly produced and *untouched by human hand.*

On the shelf the packs must stand out in the overwhelming visual noise of the supermarket, they must show up well both individually and in groups and have impact without vulgarity.

In the home, all packs should be visually pleasant and be in keeping with what has now become the most modern room in the house – the kitchen.

Drawings for helpful hints or recipes were used on the backs of BSC packs

226

Logo
One of many variations
designed for BSC

*The range of retail
granulated sugar packs
1961*

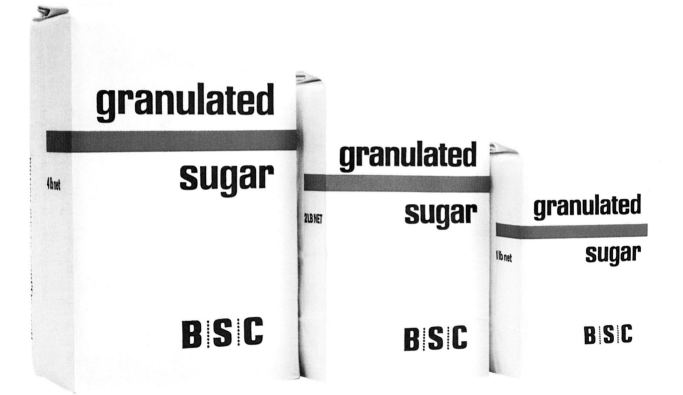

Box for sugar sachets
with transparent cellophane
sleeve as a lid

Boxed miniature packs
given away at sugar factories

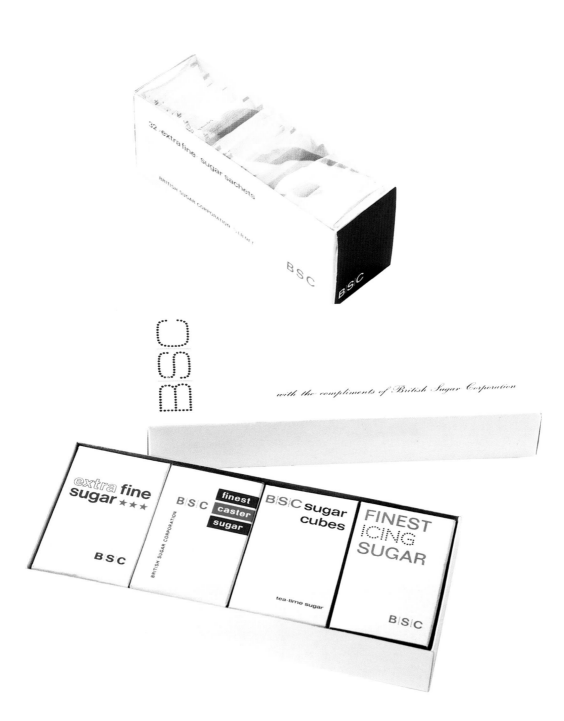

229

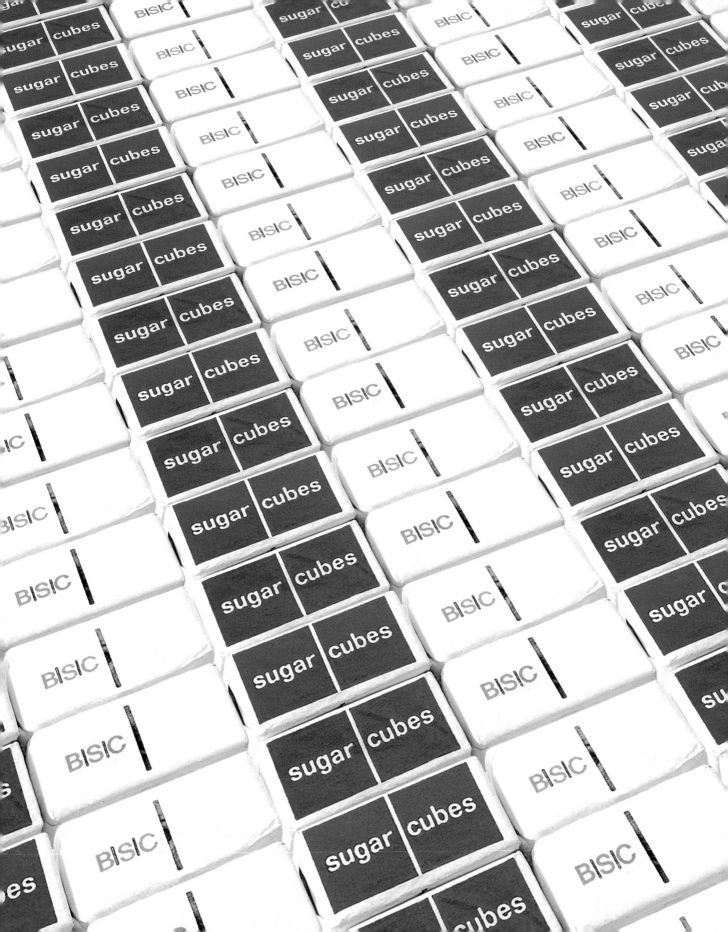

Wrapped sugar cubes

Box for sugar cubes

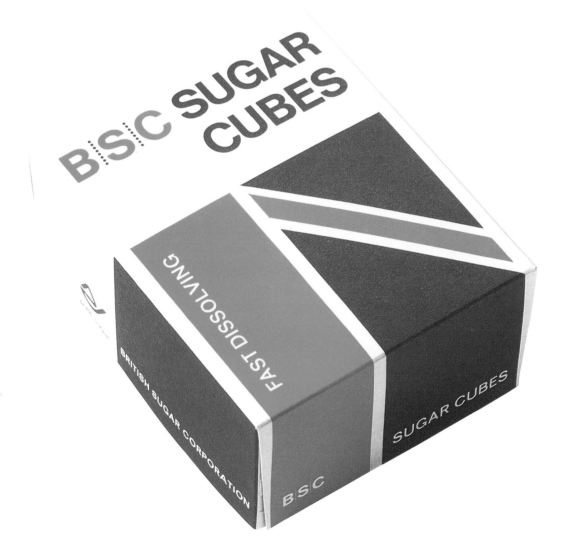

One of a fleet of tankers

*A driver showing the woven
BSC logo on his boiler suit*

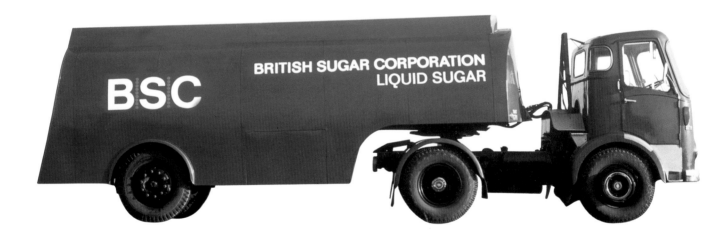

A thick stripe identified commercial
sugar sacks and large dots, agricultural
sacks. They were also colour coded.

Details showing the symbols used on
sugar boxes, designed for quick recognition
in badly lit warehouses.

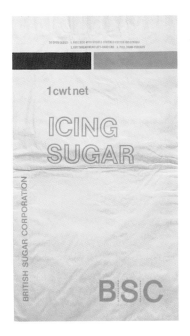

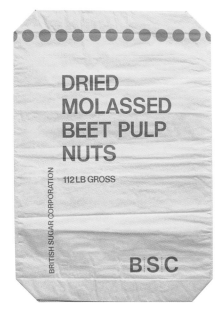

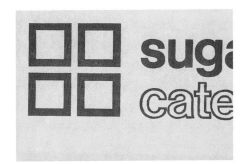

Hans Schleger's
Notes, Opinions and Prejudices
Art & Industry 1949

Little result is to be expected from a fight between the stubborn and doubting client with the equally stubborn designer. Intolerance always works as a boomerang.

*

Relatively few advertisers are taking expert advice and some only do so to obstruct their advisers. This is interesting, considering how differently they behave when their health, property or liberty are at stake.

*

Simple design can be rich and graceful and may convey the feeling of lightness achieved without effort. It is often confused with barren emptiness devoid of content and meaning.

*

Fewer are now the people in power who take chances. Greater is the desire to appease and to give *ad nauseam* what the people said (yesterday) they wanted. Rarer than before — and more remarkable — are men who dare to make unpopular decisions requiring leadership, vision and responsibility, instead of giving superficial reassurance which arrests development and prevents growth.

*

Trees, stones, clouds, textures, the secret life in old engravings and in dreams are tireless teachers … and imagination a wet-nurse.

*

The contrast of masses with sudden wilful detail can reveal a new significance, and add vivid and dynamic qualities to familiar objects. Design can also dissolve static solidity and suggest motion, gaiety and phantasy.

*

Design and image can be used where words would say too much or too little.

Design can be disarming through simplicity. It does more than catch the eye. It can touch and hold the elusive heart. It can give shape to thought and feeling as the glass does to wine.

*

Some manufacturers seem to be bored with their message and with themselves. They do not like their customers or themselves. Cynicism and indifference bar the way to awareness, adventure and discovery. Such people ask the designer to make chickens look like peacocks.

*

Limitation produces form. Self-discipline and the ability to make decisions are of importance while working on any form-problem. Constant observation of people and objects may prevent sterility and repetition. Scientific photography and other recordings have given us knowledge of new form-relationships.

*

Advertising should not be designed by 'us' for 'them'.

*

Surrealism breaches the wall of conscious resistance because its images seem to be strangely familiar. It is for that reason that surrealism becomes an important factor in propaganda. It touches significant but hidden memories, motives and moods.

*

Every individual design problem differs from any other and it may suffer if forced into a traditional or even an aesthetically tempting shape. The solution will draw its freshness from the designer's imagination and love of his work — and its vitality from his concern with the human element.

*

In some hands, design becomes a dangerous medicine and makes the rare appear trivial, the extraordinary banal and the personal mannered.

5

This section consists of a medley of work. The first pages show covers for a variety of design magazines. The cover for *Gebrauchsgraphik*, 1928, was sent to us by Paul Rand, who in the friendliest of ways never ceased to remind us that he had torn it off his one and only copy so that we could have it.

Schleger met Charles and Oona Chaplin by chance, when he took the visual for the cover of the record sleeve for *A Countess from Hong Kong* to show the boss at Universal Films. It turned out to be a rather unhappy accident as Chaplin said he would prefer to have a photo of himself playing the flute on the cover, since he had composed the music for the film. Our lovely design ended up being the cover of the brochure inside the sleeve.

A number of spreads are examples of Schleger's huge interest in typography, for instance the *Pro Industra* booklet and *The practice of Design* book.

The jacket for the book, *Pebble in the Stream*, was designed for Schleger's brother Walter Schlee who had been a successful film scriptwriter in Berlin before the Second World War.

Schleger spent a year as a visiting professor at the Chicago Institute of Design. The Container Corporation of America, who had their headquarters in Chicago, contacted Schleger whilst he was there and asked him to design a series of match folders for them.

Schleger thought that design becomes part of one's life and is not isolated from it, that is why many of the examples have their own story to tell.

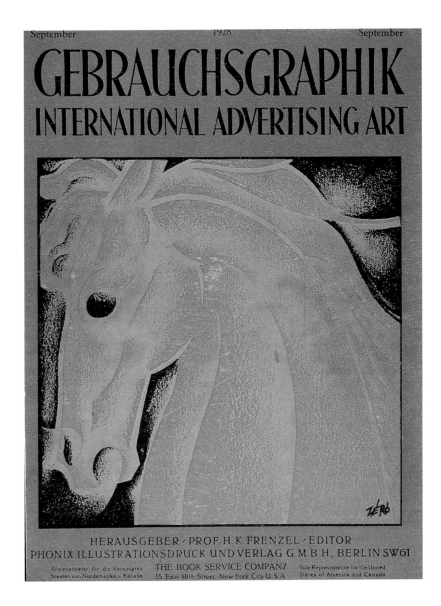

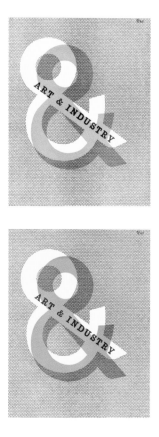

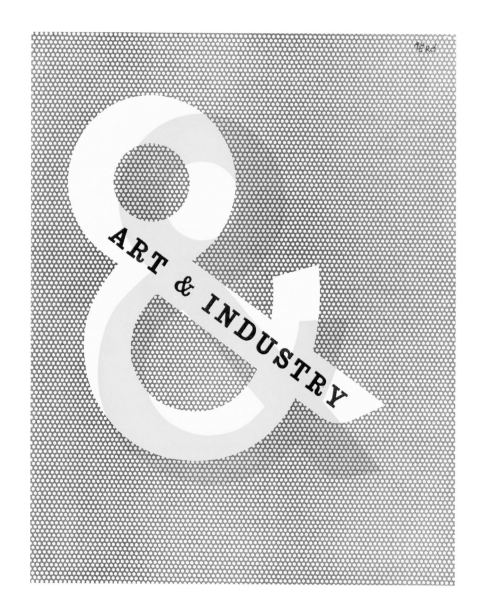

1942-48

Modern **PUBLICITY**

EDITORS: F.A.MERCER & C.ROSNER

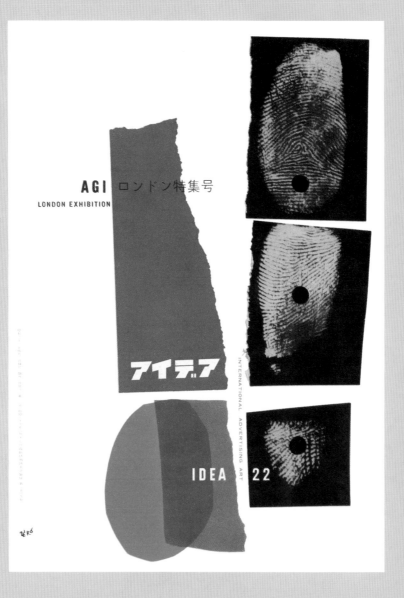

*Cover of a brochure
from the record of the soundtrack of the
film 'A Countess from Hong Kong'
Universal Films
1967*

»A COUNTESS FROM HONG KONG«

Charles Chaplin

Greetings cards
Charnaux Limited
c1935-41

Universal Pictures
1970

Personal card
c1960

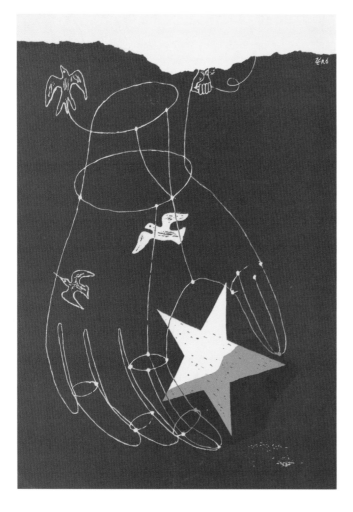

Dust jacket
a novel written by Schleger's brother
and translated from the German
Cresset Press
1939

Cover and double spread
John Donne – collected works
John Westhouse
1946

Or like the heat which fire in solid matter
Leaves behind two hours after.
Once I lov'd and dy'd, and am now become
Mine epitaph and tomb.
Here dead men speak their last, and so do I,
Love-slain, lo! here I die.

SONG

Soul's joy, now I am gone,
And you alone,
(Which cannot be,
Since I must leave myself with thee,
And carry thee with me)
Yet when unto our eyes
Absence denies
Each other's sight,
And makes to us a constant night,
When others change to light;
O give no way to grief,
But let belief
Of mutual love
This wonder to the vulgar prove,
Our bodies, not we, move.

100

Divine Poems

FIRST *Dinner* OF THE FELLOWS

OF THE SOCIETY OF INDUSTRIAL ARTISTS

AT GOLDSMITHS HALL LONDON

Cover, double spreads and stationery
Pro Industra
Commercial design consultants
promoting contemporary Bauhaus
design principles and designers
Berlin, 1930

Ihr Ziel ist: Systematische Absatzsteigerung und
Schaffung einer starken Stellung für ihre Klienten
der Konkurrenz und dem Handel gegenüber. ◉
Der PRO INDUSTRA stehen umfangreiche Kenntnisse
des europäischen und besonders des deutschen
Marktes zur Verfügung. ◉ Die Arbeitsmethode der
ABTEILUNG FÜR REKLAME und VERKAUFSBERATUNG der PRO INDUSTRA soll hier in
kurzer Form erläutert werden.

DIE PRO INDUSTRA UNTERSUCHT:
Stärke und Schwächen des Produktes
ein reiner Packung
Marktanteil des Produktes
Mehrarbeit der Konkurrenz
Bisher propagierte Verwendungs-
möglichkeiten
Verkaufsargumente
Verkaufsmethode
Kaufgesichtspunkten und verlorenen

MARKT- UND WARENANALYSE

NUR planmäßige Werbung kann Erfolg haben. Zu planmäßiger Werbung aber gehört dauernde, enge Fühlung mit der Verkaufspolitik des Produzenten. ◉ Ferner glaubt die PRO INDUSTRA, daß der Klient oft so mit seinem Betrieb und den Einzelheiten der Fabrikation verwachsen ist, daß er ein gleiches Interesse für diese Dinge beim Publikum voraussetzt.

wird DOPPELTER NUTZEFFEKT OHNE GRÖSSEREN AUFWAND erzielt

Dadurch ◉ Die PRO INDUSTRA
verfügt über hervorragende Mit-
arbeiter, die, von diesen Gesichts-
punkten aus, die ihnen anvertrau-
ten Aufgaben bearbeiten.

◉ LICHTREKLAME

Um eine Lichtreklame
wirkungsvoll zu gestalten,
bedarf es reicher ERFAHRUNGEN AUF LICHTTECHNISCHEM GEBIETE
Erhebliche Mittel werden gerade hier noch erfolglos ausgegeben, weil
das Wissen um Zusammenhänge, die erst die Wirkung ergeben, fehlt.

Er ist zu wenig mit dem Stil der verschiedenen Künstler vertraut. Oft
ist es ihm unbekannt, daß sich auch seinem Fabrikat durch zeitge-
mäße Formgebung ganz neue Möglichkeiten erschließen können.

Die PRO INDUSTRA berät Ihre Klienten
in allen technischen und künstlerischen Fragen. ◉ SIE BRINGT
DEM PRODUZENTEN DEN ERFAHRENEN PRAKTIKER UND ERFOLGREICHEN GESTALTER

WEITE KREISE DER DEUTSCHEN
WIRTSCHAFT – besonders die Großindustrie – be-
dienen sich seit Jahrzehnten der künstlerischen Be-
ratung in steigendem Maße. ◉ Leider hält mangelnde
Kenntnis der Materie noch manchen, durchaus
fortschrittlichen, Kaufmann davon ab, zu folgen.

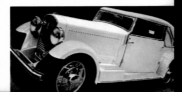

The Practice of Design

Hans Schleger writes on the design of the book

While designing this book the writer realised that he would have to deal with different, or rather additional, problems from those usually encountered in general publishing. These articles had something of the documentary film and of the contemporary exhibition about them. Both these forms of presentation have in fact influenced the shape which the book has taken. And yet it had to remain a book with its advantages, limitations and its own laws. A book devoid of the fireworks of magazine – or advertising – layout.

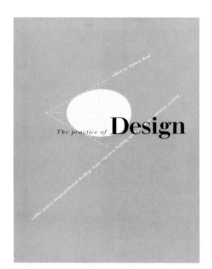

Behind the amorphous mass of manuscripts and illustrations a mental super-structure is built, to hold and give order to these articles in search of unity. Aim, task, and paper influence the choice of typeface and size, of margins, preliminary pages, layout of the *opening*, colour, binding, end-paper, and cover. An experimental dummy is prepared, specimen pages printed, revised and the final framework established. Each section is to have a certain amount of freedom for its individual needs within the rhythm of the whole.

Books often live longer than buildings or monuments… most children give up their very own creative expression, painting and drawing, for writing and reading… and yet the interest in typography and book-design is confined to a small minority. With the revived interest in design may come appreciation of printing and with it a higher standard of production for the growing number of discerning people.

layout The type area with its traditional relation to the margins is the basis of a book. Much is done to carry the reader along without interruption, to leave him alone and with an undisturbed view. Running headlines, quotations, tables etc. are given only slight prominence. Footnotes are taken into the type area, irrelevant features weeded out. Less emphasis is therefore needed for written or pictorial statements.

method Planning a book is a question of conception, selection and design. The solution is conditioned by the task and receives its vitality from it. Formalism, always static, whether symmetrical or not, may lead to a correct, boring emptiness and leave our imagination dissatisfied. One has to guard against chasing after originality at all costs or barren re-hashing of even the best. The machine (and no printer has ever worked without one) will be as obedient as was the first tool man ever made, if one is aware of its limitations and its power.

asymmetry As unfettered by dogma as an airplane carrier, asymmetrical design is an aid to clarity and control. Essentials are concentrated and emphasised where necessary and useful, keeping optical diversions from the reader's eye. Asymmetrical design offers great possibilities – harmony and contrast both have a place in it. The frequent absence of visible support mirrors its kinship with contemporary architecture. Each page is an adventure in design and, like all design, needs self-discipline and experience. Asymmetry, sometimes mistaken for a short-cut to contemporary expression, magnifies every flaw and exposes unawareness or over-consciousness of typographical rules. It is the form of design chosen for this book, because of the specific problem which had to be solved.

The word which we read at a glance does not consist of letters alone, but of black forms and almost ever-varying white shapes between the letters. They are interesting and worth examining. They help to determine the *sound* of the type, they add to harmony or cacophony. Type designers, of course, have to consider their relationship carefully.

The unstable word *modern* is used to describe typefaces with strong vertical emphasis and thin (usually straight) serifs. A further distinction from the types known as *old face* is the absence of calligraphic forms. The modern letter is more geometrically *constructed,* and this may explain its recent popularity. The first modern was shown in France in 1702, but I believe it was Fournier who later used this transient expression. Baskerville's idea of smoothing paper, taken over by Didot, gave these typefaces a fitting background. The rediscovery of *modern* types may have been helped by the invention, towards the end of the nineteenth century, of art paper. While other types often seem ill at ease on it *(their readability, value and beauty are enhanced by softer surfaces, for which they were originally designed)* art paper gives every chance to the modern letter with its sharply contrasting design and brilliance. Unity of photographic reproductions and type in mass-production is now possible through a combination of half-tone blocks with freshly cast type on this smooth surface which brings out every subtlety – though its polished coldness is a drawback.

The best known *modern* type today is *Bodoni*, originally designed by Giambattista Bodoni of Parma. Of great severity, regularity and simplicity, it has been re-discovered, re-cut, thickened, bastardised, standardised and changed by various foundries with varying success. Some founts are excellent in design and of detached, harmonious and unashamedly unornamented beauty.

Walbaum, though now popular in this country, has been used less than *Bodoni* which it resembles. It is charming, though sometimes playful, slightly less impersonal than *Bodoni* and of greater softness. This book has been printed in 11 on 13 point Walbaum Monotype and the heavier face is Walbaum Medium. Justus E. Walbaum was born in 1768, the son of a clergyman. He became an engraver and caster of metals. He learned letter-cutting and the making of matrices and tools. He started his own type-foundry when he was thirty and he and his type were famous when he died in 1839. But the nineteenth century quickly forgot both. Rigid and constructivist to some, his balanced and readable type represents in this book the pleasant manners of an interesting and lucid lecturer.

The colour plates which precede each section are an attempt to create contrast and continuity at the same time, as the curtain does between the acts. Their design blends fantasy and reality of yesterday and today.

I would like to say how pleasurable it was to work on this book with the printers' team of skilled, sensitive, patient and understanding men. It was delightful to open and study page proofs. Credit for the production goes to them and to blockmakers and binders.

Alastair Morton
Victor Skellern
Milner Gray
Norbert Dutton
Frederick Gibberd
Sadie Speight
C G Stillman
J L Martin
F J Samuely
Misha Black
Robert Harling

with an introduction by Herbert Read

The practice of **Design**

Lund Humphries

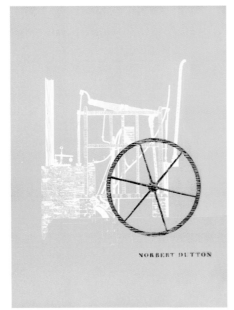

NORBERT DUTTON

Industrial design is not a luxury. It is a necessary factor in the planning which, with the expanding mechanisation of industry, progressively replaces empiricism. Modern assembly-line methods of mass production involve a high initial outlay and a great deal of preparatory work before production begins. Tools must be designed and made; raw materials obtained; automatic machines set up, operatives trained and allocated; component parts fed into the production line at the right times, and in the right quantities. Thus a complex and integrated sequence of operations must be visualised and forecast while the product is on the drawing board. By the time the first machine is set in motion, the creative process is complete.

The difference between designing for production by hand and by machine is, therefore, a fundamental one; a difference not merely in degree, but in kind. The one is a process of *making*, the other a process of *planning*.

Just as the development of industry is a co-operative task, so is the planning of its products. Modern industry can only be run by a fusion of talent, in which administrators, economists, and technicians each play their part. The technicians may be of many kinds - chemists, engineers, or physicists - each charged with a specialised function, and each making a necessary contribution. The industrial designer is equally a specialist. Where the engineer is primarily concerned with the efficient functioning of an article, and the process by which it is made, the designer is concerned primarily with its appearance and its convenience in use. I say, primarily, because such considerations are, in practice, highly integrated: form is inseparable from function, product from process. Broadly speaking, the engineer looks at a thing from the point of view of *making* it, the designer from the point of view of *using* it. In so far as these points of view overlap, the industrial designer is an engineer, the engineer a designer.

Industrial design in the contemporary sense was first practised in the United States, where, under the pseudonym of 'styling,' it achieved an immediate and,

Design a necessary prelude to production

and the designer a specialised technician

The origin of styling

The future of product design

71

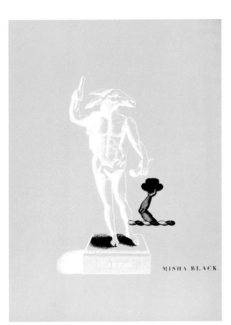

MISHA BLACK

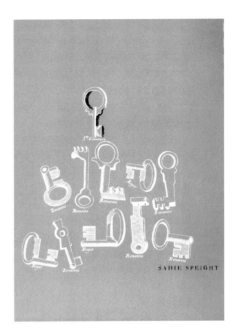

SADIE SPEIGHT

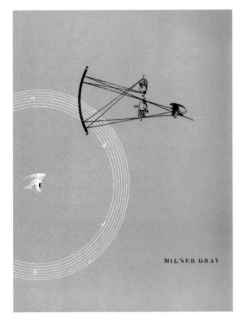

MILNER GRAY

The design profession

Industrial design has been the subject of discussion and enquiry by Government departments, select committees, trade federations, and voluntary societies, ever since the appointment in 1836 of Mr. Ewarts Committee on Arts and Manufactures; all shades of opinion on the subject have been published or enunciated by politicians, policemen, lawyers, teachers, and tradesmen – by all and sundry, including both the obviously interested parties and those who claim to be disinterested. Occasionally, and with proper deference, cautious opinions have been put forward by design practitioners themselves.

A mass of writings and reports, documentations, and case histories lies in wait for the student. But he, poor fellow, will soon find himself lost in a welter of inconsistent terminology from authorities who, even when they agree in theory, seldom show any agreement in the terminology they employ.

In varying contexts the very words *design* and *designer* are capable of such widely different interpretations that they must be qualified before they take on any specific meaning. The following illustration of this common variation of meaning is taken from the advertisement columns of a recent copy of *The Times* – these two advertisements appeared consecutively

Designer Draughtsman, preferably ex-Service man, skilled to design moulds for manufacture of plastic articles by injection, compression, and extrusion; consideration would be given to highly skilled draughtsman without previous experience in plastics; good post-war prospects.

Designer of Memorials wanted to design in spare time; ability to use air brush an advantage.

This confusion extends beyond these two basic terms to all the technical jargon which inevitably accumulates around any specialised activity, and it has consequently become almost customary for writers to preface their articles with their own definition of the words they have used. This practice has led to the invention of a number of terms merely to clarify or emphasise a meaning – terms such as *streamlining, product styling, design engineering,* or *technological*

Chicago Institute of Design 1950-1

Serge Chermayeff was president of the Chicago Institute of Design, having taken over from Moholy Nagy. In 1949 he asked Schleger to become a visiting professor and head of the department of Visual Design. Schleger was unsure whether to accept, for one thing BOAC had just asked him if he would design the interior of their new plane, the Comet. Rolf Brandt, artist / illustrator, friend and teacher wrote to Schleger to persuade him to go. Jack Beddington, who had been the advertising manager of Shell, wrote to Chermayeff about Schleger joining his auspicious list of teachers.

22nd May 1949

Dear Schleger,

I have just heard of the offer you have had from the Chicago Institute of Design and I should like to tell you how happy I feel about it. I have always thought you the ideal teacher. Often during my teaching work here when I come up against a particularly difficult problem, I think how you would solve it and generally that way get a good clue to the solution. Because – though you are probably not aware of it – when we worked together for Westhouse and Peter Lunn I learnt more than I could ever have hoped to learn in years of Art Schools by just talking to you about the job in hand. You have got the rare gift – vital for teachers – of seeing the undeveloped possibilities in other artists and even your tactful but often devastating criticism has always been an encouragement to me because I felt the comparison with the highest standard, the standard of your own work.

I hope you fully appreciate the amount of unselfishness that goes in trying to persuade you to accept the offer from Chicago. But as a believer in 'One World' I am definitely for it!

All the best wishes,
Yours, ROLF BRANDT

24th May 1949

Dear Serge,

Hans Schleger has been to see me and explained some of your difficulties in trying to get him to America. You have all my sympathy.

I have known Hans ever since he came to this country. I worked with him closely for the six years before the war and have seen him frequently ever since, though our paths have slightly diverged.

He is generally accepted here as the leader in all commercial design; he has unquestionably had more influence on the young designers of the country than any one person except E. McKnight Kauffer who is now, as you know, back in America. When I was head of the Shell advertising in this country, these were the two men who really taught me more than any book, experience or people that I knew.

If you eventually succeed in getting him, I am certain that he will have a profound effect on American design throughout the country. The curious thing to me is that my first knowledge of his work came entirely from that which he had done when he was in America and I always thought of him as an American designer. One of his pupils worked for me when I was at Shell and has since become one of the best known children's book illustrators in this country.

It appears to me that Charles Dickens, though never a teacher of English literature, has had a profound effect upon it all over the world and I cannot help feeling that Schleger is very much in his position, though like every great painter in the past he has invariably had pupils in his studio.

How I wish I could see you myself.

With kindest regards,
Yours ever, JACK BEDDINGTON

Brochures
Invitation card for an exhibition
of Hans Schleger's own work
Chicago Institute of Design
1950-1

course descriptions page 8

9

Institute of Design of Illinois Institute of Technology

evening courses 1950-51

foundation and survey

Courses in this group are basic preparation for advanced study in architecture, industrial design, advertising and display, photography and film, painting and sculpture.

Form, structure and organization, materials, tools and their application are discovered through studio experiment. Work in studio and workshop is supplemented by other lecture courses.

The contents may be summarized as:

EXPERIMENT *Free manipulation of media, materials and tools develops a visual vocabulary and an imaginative approach to design.*

CONTROL *Mastery of materials and techniques and a wider range of visual perceptions develop a progressively sharpened technical discipline.*

UNDERSTANDING *Interplay of needs and means, function and form develops sense of order and grasp of the creative process.*

ID 111 **visual fundamentals 1** Basic elements in two dimensional design and their characteristics: point, line, texture, value, color. Spacial illusions: elements within a prescribed picture plane. Light as a creative medium. Elements of the photographic process. Photograms. This course is given primarily for students working toward a degree. Those who wish to work in this area in a more condensed course should see ID 021 visual fundamentals.

ID 112 **visual fundamentals 2** Continuation of visual fundamentals 1. Experiments with different tools and media. Seminar: analysis of developments in visualization of the immediate past as a new basis for communication. Integration with the training process.

ID 113 **basic workshop 1** Development of manual dexterity and sensitivity to space, form and texture. Experimental construction in various materials of differing properties employing basic techniques and hand and power tools.

ID 114 **basic workshop 2** Continuation of basic workshop 1, with emphasis upon technical discipline and precision work. Typical joints and finishes.

ID 115 **sculpture 1** Elements of three dimensional form. Modeling in clay, wire and paper. Volume relationship. Space-volume relationship. Analysis of various characteristics of sculptured form.

ID 116 **sculpture 2** Continuation of sculpture 1. Work in plaster, direct construction and casting. Working drawings.

ID 021 **visual fundamentals 1** Basic elements in two dimensional design and their organization: point, line, texture, value, color. Experiment with different tools and media leads to an understanding of form and space.

ID 022 **visual fundamentals 2** Continuation of visual fundamentals 1.

ID 061 **interior design 1** Lecture and demonstration: the organization and planning of interior space; new techniques and materials; light and color. New concepts in architecture, furnishings and equipment design.

ID 062 **interior design 2** Continuation of interior design 1.

ID 071 **music in history 1** The relation of music of the past to music of our time. An historical survey from tribal song to contemporary compositions, illustrated with examples on recordings and piano. Musical structure explained and style defined.

architecture

illinois institute of technology

design

Institute of Design

the Institute of Design of Illinois Institute of Technology

632 N Dearborn St Chicago

presents an exhibition *'Visual Communication'*

Hans Schleger

Matches for Colour 1951

Extracts from an account of the Colour
Harmony Match folders designed for
the Container Corporation of America
by Hans Schleger.

The Container Corporation of America
is a large organisation with plants in
twenty-five States and headquarters in
Chicago. Under the leadership of their
chairman Walter Paepcke it has created
and sustained a high standard of design
for industry. It is now a widely recognised
fact that CCA's enlightened and advanced
design policy has helped to make the
concern the almost undisputed leader in
its field. CCA have gone beyond publicity
for the sake of immediate success, have
become and remained patrons of artists
and have been instrumental in raising
the level of American advertising and
design in general...

An example of this creative policy was
recently given when the director of
CCA's design department, Egbert
Jacobson, asked Hans Schleger to design
a match folder for the Corporation.
Schleger was at the time Visiting
Associate Professor for Design in Chicago
and had held an exhibition of his work
at the Illinois Institute of Technology.

In America match folders are given away
as advertising in such abundance that
they have become a nuisance: things that
have to be cleared out of one's pockets
where somehow they seem to get.

Schleger searched for an idea which
would change this situation. The thought
that he might be able to carry the problem
beyond the production of just another
surface design greatly interested him.
He solved the problem with typical
directness by devising a series of match
folders which would be wanted, kept,
collected and used with pleasure.
Discarding the idea of decoration he
gave the folders an added function.

Some time before CCA had produced
their outstanding and scholarly volume
The CCA Color Harmony Manual. This
is based on their own 943 Standard
Colours. They can print any of these. All
colours have a name and number and can
be ordered by letter or even by telephone.
An amazing production which sells at
over a hundred dollars a copy...

Schleger saw an opportunity of bringing
this service to a wider public and showing
the possibilities and the versatility of the
system. He suggested that he would
design a series of colour-related match
folders, to be distributed at certain
intervals. This would make it possible
gradually to acquire a 'popular' edition
of the costly manual.

The match folders, each one printed and
marked in one of the Standard Colours
and giving the name and number of that
colour, could now be collected and/or
used with enjoyment because they were
simple and beautiful.

So far folders in sixty hues have been
produced and it is hoped to extend the
scheme. The fact that the Container
Corporation has been able to manufacture
these folders with exact colours printed
on rather inexpensive paper is an
advertisement in itself. At the same time
it publicises the scientific research work
of the Container Corporation and their
general attitude of service.

Michael Johnson, Art & Industry, 1953

*Inside each match folder are the
name and Ostwald number of
the colour on the cover, and inside
the lid of each container is printed,
'The covers of the ten matchbooks
in this carton are printed in 10 of
the 943 colours standardised in
The Color Harmony Manual.'*

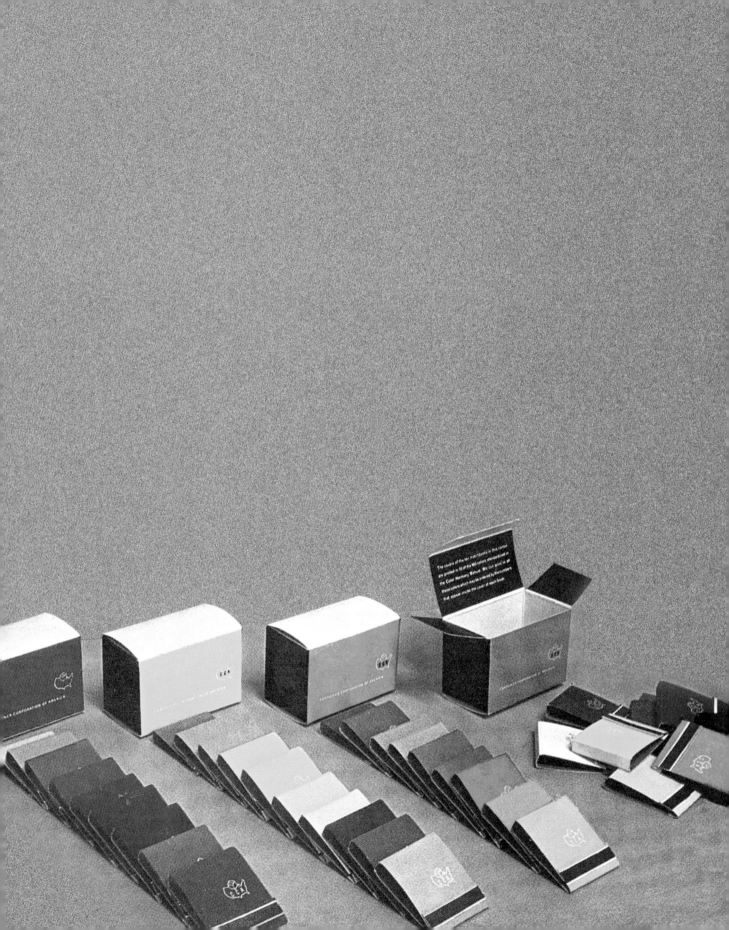

Leaflet
Dobbs Fashion House
New York
c1925

Structure and space were very important elements in Schleger's work. As Paul Reilly once wrote, he was an architect *manqué*. The examples of work shown here are from very different times in his life, New York 1925 and London 1963, and yet they are two sides of the same coin, the same principles apply to both. Schleger was always aware of the style of a period; he was influenced by it but never copied it. He was able to draw from it an essence, a subtlety which was very much his own interpretation and at the same time essentially fulfilled the client's brief. In New York the majority of Schleger's clients were fashion houses. It was they who were prepared to risk a more modern approach to advertising.

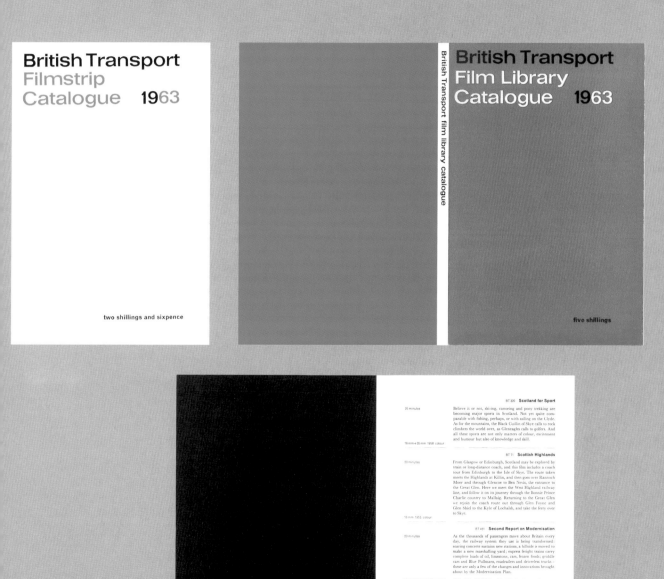

Cover and double spread
Film Library Catalogue
British Transport
1957

Sketches on blotting paper
and an advertisement
promoting the catalogue

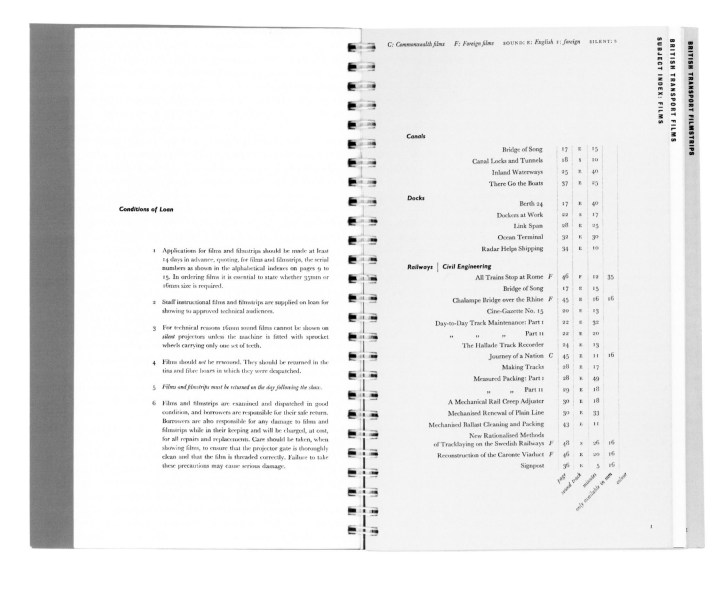

British Transport film library catalogue 2/6

International recognition* has been won by many British Transport films

All are available on
free loan
from Films Officer
British Transport Commission
25 Savile Row London w1

Write for catalogue listing **over 100 films on travel & transport subjects**

✳ *ten British Transport films have been shown at the Venice International Film Festivals of 1950 to 1954*

If history stirs a responsive chord in man's imagination, a museum is a thrilling place.

Here, in three-dimensional reality, the past becomes alive and tangible and the Railway Museum presents an inspiring record of the birth and growth of the greatest achievement of the Industrial Revolution which changed the face of Britain and the world.

Taking history as a whole, railways are of comparatively recent origin, but in human retrospect they are already old. Generations of men have achieved greatness in railway service and have taken their rightful place in the annals of fame, and the outworn assets of the formative years have emerged from the obscurity of obsolescence into the eminence of antiquity.

The museum's valuable collections are in two parts. Historic locomotives and other heavy material are housed in the Queen Street section. (A few of these are illustrated and described in this leaflet.) The other section contains many smaller relics. Both sections are within a few minutes' walk from York Station and from each other – *see sketch-map on back cover.*

The North Eastern Railway Station York 1877

Queen Street Section

It was steam which sustained the spectacular growth of railways in the nineteenth century and in this country its monopoly has only recently been seriously challenged. Now we must face the fact that steam locomotives belong to a dying race. The noble family has begotten its last generation and further development is, to say the least, unlikely. Here, in the Queen Street section, representatives of the earlier generations are honourably retired. Compared with their present-day counterparts, some are decidedly odd, but it must be remembered that they were the wonder of their age and each in turn helped to maintain Britain's lead in mechanical design and achievement. Each exhibit represents a stage in development.

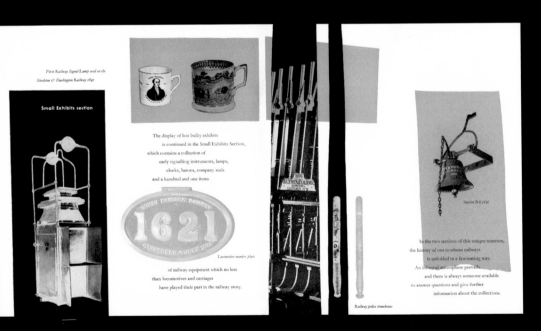

First Railway Signal Lamp used on the Stockton & Darlington Railway 1841

Small Exhibits section

The display of less bulky exhibits is continued in the Small Exhibits Section, which contains a collection of early signalling instruments, lamps, clocks, batons, company seals and a hundred and one items

Locomotive number plate

of railway equipment which no less than locomotives and carriages have played their part in the railway story.

Railway police truncheons

Station Bell 1856

In the two sections of this unique museum, the history of our northern railways is unfolded in a fascinating way. An informal atmosphere prevails and there is always someone available to answer questions and give further information about the collections.

*Promotional leaflet
for overseas visitors
British Transport
1955*

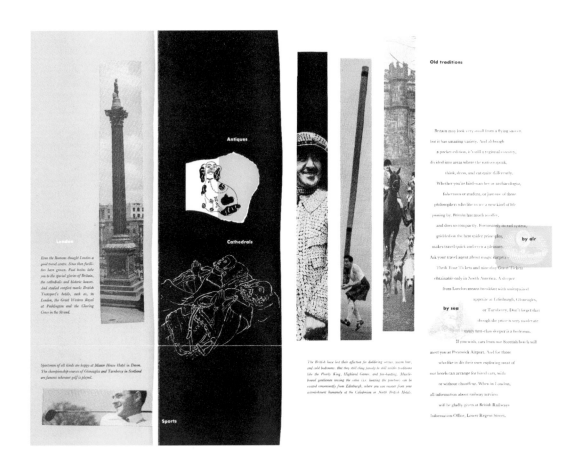

Booklet for sales and technical service
Forestal Quebracho Limited
An extract from the Quebracho
tree is used for tanning leather
c1960

Forestal Quebracho

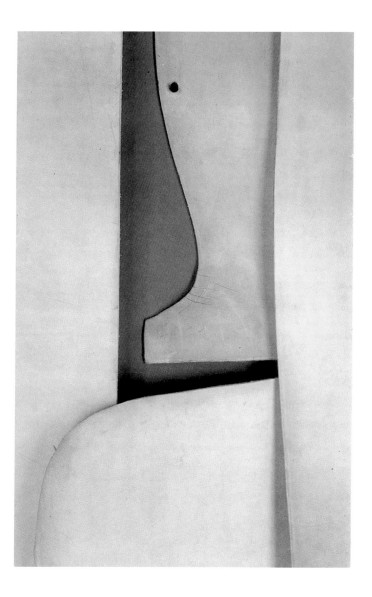

rapid tannage

Many methods of rapid tannage generate considerable volumes of tanning liquors of intermediate strength which are surplus to the tannage and must be used up in other parts of the tannery. This does not matter where hides are rounded into butts before tannage since rapid tannage of the butts can be carried out and the surplus liquor used in a conventional tannage for the offal. However, where the tannage of whole hides or half hides is practised it is necessary to use a method in which all the tannins offered are consumed within the tannage system leaving none which must be used up elsewhere. This difficulty can be overcome by carrying out the tannage in a drum employing concentrated liquid or powdered Quebracho extract. However, this type of process could cause drawn grain and it is usually necessary to carry out a pretannage treatment prior to the drum tannage with Quebracho extract. A method of rapid tannage applying this principle is described below under the heading of Tannage R1.

The problem of surplus liquor can also be overcome if the initial tannage takes place in a pit of strong liquor and then the tannage completed in a drum with some of the liquor from the pit which has been fortified either with concentrated liquid, solid or powdered extract. This system which is described under the heading of Tannage R3M, operates well providing a few precautions are taken to ensure that the liquor in the drum is kept in good condition.

Sometimes, however, it is preferred to carry out a rapid tannage in pits and the strong liquor withdrawn from the pits can be used in other parts of the tannery. For these conditions Tannage R2 is described below.

No matter which method of rapid tannage is employed it is important that an efficient deliming treatment prior to tannage should be given. Suggested deliming methods are given below.

47

265

Hans Schleger as I remember him

Ken Garland

In a way, I knew Hans Schleger long before our first meeting in 1956. He revealed himself to me in the design of a remarkable book, *The practice of Design* (Lund Humphries, London 1946), and in the endnote he wrote to explain his approach to its planning and production (pp.250-3). I came upon the book in 1951 as a callow twenty-one-year-old with a confused notion of becoming a commercial artist, or perhaps an illustrator, or maybe a photographer. Schleger's clear view of the role of a graphic designer combined with the fresh, elegant layout of the book itself were indeed a revelation. At a time when most designers of illustrated books were still wallowing around with flaccid variants of symmetrical typography without form or logic, here was a work which was firmly, logically constructed in an appropriately asymmetrical style. Furthermore, at a time when others were trundling out heavy-handed, historical reworkings of nineteenth-century steel engravings, Schleger had demonstrated, five years earlier in his chapter openings to *The practice of Design*, how the same material could be used in a sensitive, witty and modern way, with the result that, even today, they look as effective as they did on publication over forty years ago.

I know of no designer working at that time in this country who was equally at home with a hand-drawn poster, a complex corporate identity programme or an exacting piece of typographic design. The span of his ability was so wide that it was hard to believe the same man was responsible for such a range of works; and in fact I didn't at first realise it was the same man. Soon after his arrival in New York from Berlin, he had chosen the pseudonym Zero with which to sign the fashion drawings and other illustrations that were his main source of income at that time. He continued to sign any drawn or painted work with this pseudonym but used his real name for graphic design and typography. Because of this I was convinced there were two persons: Zero, an artistic old buffer in his late fifties, probably with shaggy hair and wearing a paint-streaked smock, rather overbearing in manner (the Augustus John of poster design, perhaps) and Hans Schleger, a youngish fellow – mid-thirties or thereabouts – with a solemn, studious manner, soberly dressed and given to discussing the finer points of typography in a low, earnest voice. Apart from a rather grudging admiration for one another's work I could not imagine that these two would have anything else in common. Such a misconception suggests, perhaps, an extraordinary level of ignorance, even for a student, but it should be remembered that in the early 1950s there was no design history and very little access to any information about continental or American graphic design. The only thing I knew about the Famous Foursome of British poster design – Games, Eckersley, Henrion and Zero – was the flamboyant signature displayed at the bottom of each poster. When, in 1952, *Graphis* magazine published an article headed 'Zero' but describing the career of one Hans Schleger, you could have knocked me down with a 6-point hairspace. There, cheek by jowl, were rumbustious posters and advertisements for Martini, and cool, laid-back spreads from *The practice of Design*. Some urgent rethinking

was called for. Was he a sort of Jekyll and Hyde creature, changing from natty pinstripe to painter's smock, with matching change of temperament, in the twinkling of an eye? An intriguing proposition, but one made untenable almost immediately when, also in 1952, the first fruits of Mac Fisheries corporate identity emerged. Here was a seamless fusion of the two: a style that appeared free yet was disciplined, vigorous yet subtle. With the launching of the Finmar corporate identity the following year, Schleger's rare ability to embrace in one style so many modes and variations was fully confirmed. Work on the Mac Fisheries style continued until 1959 and on Finmar until 1963. There have been many more ambitious, more compendious — and, some would say, more grandiose — corporate identity schemes than these two in the last thirty years; but none, I think, more sympathetic, more inventive or more endearing than these, and none more fun to work on, as Pat, his wife and close associate, told me later.

To get back to our first meeting; we were to talk about his recent design for the Design Centre symbol (p.102), in connection with an article in *Design* magazine, of which I was then a very new art editor. The meeting was to be at a restaurant of his choice; the food was excellent, as it was on every subsequent time we lunched together, since he always chose the venue; and he picked up the tab, as he always did, diving on it like a hawk on a field mouse. But the abiding memory of that first meeting was of how sparkling, how entertaining, how unstuffy and how invigorating he was; and most of all, how he wore his fifty-eight years so lightly, as if he were still only twenty-eight.

And that's how I think of his work; he was such a youthful designer, wasn't he?

Select Bibliography

Sources: books, magazines and periodicals

Barmas, John · 'Men of Vision: Hans Schleger', *Sales Appeal*, November/December 1952

Crawford, W.S. · *How to succeed in Advertising*, London, 1931

Frenzel, H.K. · 'H.K.Frenzel discusses emigrant artists in New York', *Gebrauchsgraphik*, Berlin, February 1926

'Zero – Hans Schleger, New York', *Gebrauchsgraphik*, Berlin, June 1928

Gowing, Mary · 'Zero – Hans Schleger', *Art & Industry*, London, May 1948

'Zero – Hans Schleger', *Advertising Review*, vol 1 no 3, 1954-5

'The creative mind in advertising: Hans Schleger', *Art & Industry*, London, December 1956

'Hans Schleger – Zero', *Graphis*, no 93, Zurich, January/February 1961

Him, George · 'Hans Schleger – Zero', *Graphis*, no 188, Zurich, December/January 1976-7

Johnson, Michael · 'Matches for colour', *Art & Industry*, London, June 1953

Rand, Paul · 'Hans Schleger – Zero', *Graphis*, no 188, Zurich, December/January 1976-7

Read, Herbert, ed. · *The practice of Design*, Lund Humphries, London, 1946

Reilly, Paul · 'Zero – Hans Schleger', *Gebrauchsgraphik*, Munich, January 1956

Rosner, Charles · 'British Commercial Art', *Graphis*, no 31, Zurich, 1950

Schleger, Hans · 'Hans Schleger chats about New York', *Gebrauchsgraphik*, Berlin, February 1930

'Ullstein the jester', *Gebrauchsgraphik*, Berlin, February 1931

'Interview of the month: Hans Schleger', *Gebrauchsgraphik*, Berlin, December 1931

'Plus a little something others haven't got!', *Gebrauchsgraphik*, Berlin, May 1933

'Olympia London 1933', *Gebrauchsgraphik*, Berlin, September 1933

'Tom Purvis: the man and his work', *Gebrauchsgraphik*, Berlin, November 1933

'Hans Schleger's Notes, Opinions and Prejudices', *Art & Industry*, London, March 1949

'The Function and Limitation of the Trade Mark', *IPA News*, London, June 1962

Schreiber, Leopold · 'Zero', *Advertising and Marketing Review*, London, 1949

'Zero', *Graphis*, no 41, Zurich, 1952

Whitford, Frank · 'The Berlin of George Grosz', Exhibition Catalogue, Royal Academy, London, 1997

Books selected from Schleger's library

Bayer, H., Gropius, W., and Gropius, I. · *Bauhaus 1919-28*, Charles T. Branford Company, Boston, 1952

Gropius, Walter and Tange, Kenzo · *Katsura*, Zokeisha Publications Ltd, Tokyo and Yale University Press, New Haven, 1960

Johnson, Philip · *Mies van der Rohe*, Secker and Warburg, London, 1953

Kepes, Gyorgy, ed. · *The New Landscape in Art and Science*, Paul Theobald and Co., Chicago, 1956

Education of Vision, Studio Vista, London, 1965

Moholy-Nagy, Laszlo · *Vision in Motion*, Paul Theobald and Co., Chicago, 1947

Packard, Vance · *The Hidden Persuaders*, Longmans Green and Co., London, 1957

Steinert, Otto · *Subjecktive Fotografie*, Brüder Auer, Bonn, 1952

Tolmer, A. · *Mise en Page*, The Studio Ltd, London, 1931

Tschichold, Jan · *Die Neue Typographie*, Berlin, 1928

Further Reading

Le Corbusier · *Towards a new architecture*, The Architectural Press, London, 1946

Itten, Johannes · *The Art of Color*, Reinhold Publishing Corporation, New York, 1961

Design and Form: the basic course in the Bauhaus, Thames and Hudson, London, 1964

Ozenfant · *Foundations of Modern Art*, Constable and Co. Ltd, London, 1952

Rand, Paul · *A Designers Art*, Yale University Press, New Haven, 1985

From Lascaux to Brooklyn, Yale University Press, New Haven, 1996

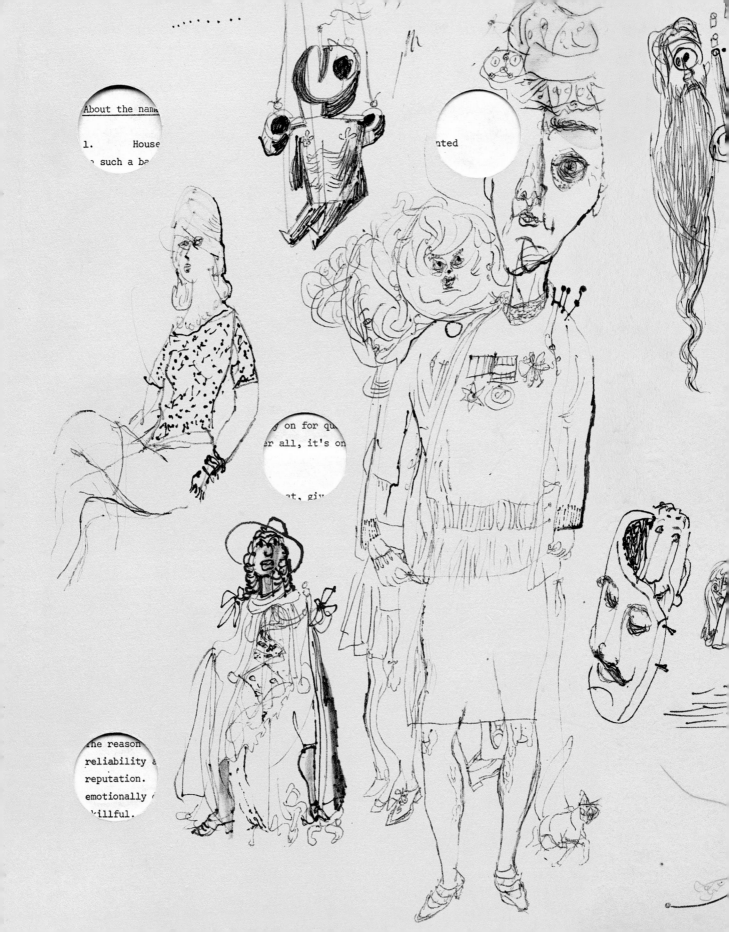

About the name

1. House
 such a ba

nted

on for qu
er all, it's on

t, giv

The reason
reliability a
reputation.
emotionally
killful.